Between Matter and Method

Between Matter and Method

Encounters in Anthropology and Art

Edited by Gretchen Bakke and Marina Peterson

Bloomsbury Academic
An imprint of Bloomsbury Publishing Plc

B L O O M S B U R Y
LONDON · OXFORD · NEW YORK · NEW DELHI · SYDNEY

Bloomsbury Academic
An imprint of Bloomsbury Publishing Plc

50 Bedford Square	1385 Broadway
London	New York
WC1B 3DP	NY 10018
UK	USA

www.bloomsbury.com

BLOOMSBURY and the Diana logo are trademarks of Bloomsbury Publishing Plc

First published 2018

© Selection and Editorial Material: Gretchen Bakke and Marina Peterson, 2018

© Individual Chapters: Their Authors, 2018

Gretchen Bakke and Marina Peterson have asserted their rights under the Copyright, Designs and Patents Act, 1988, to be identified as Editors of this work.

All rights reserved. No part of this publication may be reproduced or transmitted in any form or by any means, electronic or mechanical, including photocopying, recording, or any information storage or retrieval system, without prior permission in writing from the publishers.

No responsibility for loss caused to any individual or organization acting on or refraining from action as a result of the material in this publication can be accepted by Bloomsbury or the authors.

British Library Cataloguing-in-Publication Data
A catalogue record for this book is available from the British Library.

ISBN: HB: 978-1-4742-8920-7
PB: 978-1-4742-8923-8
ePDF: 978-1-4742-8922-1
ePub: 978-1-4742-8921-4

Library of Congress Cataloging-in-Publication Data
A catalog record the this book is available from the Library of Congress

Cover design: Adriana Brioso
Cover image: Spatial Intervention (1), 2002, by Nicole Six & Paul Petritsch. (© DACS 2017)

Typeset by RefineCatch Limited, Bungay, Suffolk
Printed and bound in Great Britain

To find out more about our authors and books visit www.bloomsbury.com. Here you will find extracts, author interviews, details of forthcoming events and the option to sign up for our newsletters.

Nightly Jelly filled her notebooks: scraps of fact, fiction, essay.
　　　　　　　　　　　　　　　　　　—*Fay Weldon,* Splitting

Contents

List of Illustrations		viii
List of Contributors		ix
This is an Introduction, or, *What is happening?* Natasha Myers		xii
Formless Matters: A User's Guide Gretchen Bakke, Marina Peterson		xiv
1	Labyrinth of Linkages—Cinema, Anthropology, and the Essayistic Impulse *Rachel Thompson*	1
2	Mattering Compositions *Kathleen Stewart*	21
3	On Misanthropology (punk, art, species-hate) *Shane Greene*	35
4	Notes Toward Critical Ethnographic Scores: Anthropology and Improvisation Training in a Breached World *Joe Dumit*	51
5	Becoming Sensor in Sentient Worlds: A More-than-natural History of a Black Oak Savannah *Natasha Myers*	73
6	Art, Design, and Ethical Forms of Ethnographic Intervention *Keith M. Murphy*	97
7	The Recursivity of the Gift in Art and Anthropology *Roger Sansi*	117
	Another World in This World *Stuart McLean, Kathleen Stewart, Lina Dib, Joe Dumit, Rachel Thompson, Keith M. Murphy, Marina Peterson, Craig Campbell, Gretchen Bakke*	131
8	A report from the archives of the Monument to Eternal Return: Comgar *Craig Campbell*	141
9	Wind Matters *Marina Peterson*	159
10	The Comparative Method: A Novella *Gretchen Bakke*	171
11	Audible Observatories: Notes on Performances *Lina Dib*	191
	This is an Index *Shane Greene*	207
12	Blubberbomb *Stuart McLean*	209
	This is a Title *Gretchen Bakke, Marina Peterson*	227

Illustrations

	Flipbook, by Rowan Campbell	1–227
1.1	The Dregs of Her Ammunition	4
1.2	Points of Entry and Exit	8
1.3	How We Weep and Laugh at the Same Thing	10
1.4	Everything and Nothing Else	12
1.5	Map as Score for a Film	16
1.6	QR Code to *Extinction Number Six* (2011, 16:9, 148 min)	17
3.1	Allin in Performance Mode	40
5.1	High Park, Parkside Drive Gate	74
5.2	Compositions and Decompositions	79
5.3	Still Falling	80
5.4	Coming Undone	82
5.5	Dances with Light	87
5.6	Vibratory Milieu	89
5.7	Energy Diagram of Queen Anne's Lace	91
8.1	COMGAR Workplan, figure 1	145
8.2	COMGAR Workplan, figure 2	154
9.1	Sound Analyzer	164
10.1	Japanese Pesos	173
10.2	Cassette Tape	176
10.3	Bookgun	179
11.1	Pitman Park, Bellaire, Texas, 2016	196
11.2	*Sonogram of a Forest* (2016), monoprint	201
12.1–12.4	Filippos Tsitsopoulos, *The Madrigal of the Explosion of the Wise Whale*. Four channel video installation (2010)	210
12.5	Filippos Tsitsopoulos, *The Madrigal of the Explosion of the Wise Whale*, at Papay Gyro Nights (2012), the Old Kelp Store, Papa Westray, Orkney	214
12.6	Filippos Tsitsopoulos, *The Madrigal of the Explosion of the Wise Whale*	223

Contributors

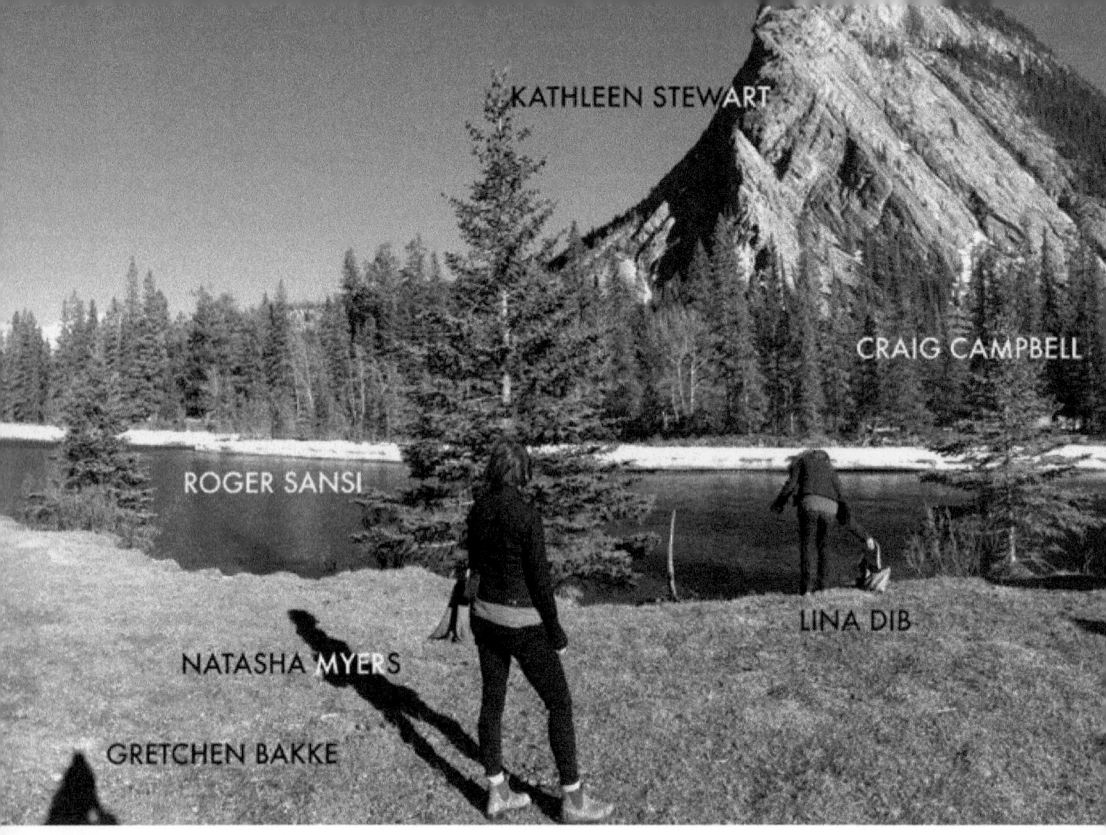

Gretchen Bakke is a professional writer and editor living in Montréal and Berlin. She holds an assistant professorship in Anthropology at McGill University. Her research focuses on the arts in Slovenia and on electrical infrastructure in the United States.

Natasha Myers is an anthropologist of art, science, and ecology. She is an associate professor of anthropology, director of the Plant Studies Collaboratory and the convenor of the Politics of Evidence Working Group at York University.

Roger Sansi is Professor in Anthropology at Universitat de Barcelona, Spain. He studied at the Universities of Barcelona and Paris and he received his PhD in Anthropology at the University of Chicago (2003). He has worked at Kings College and Goldsmiths College, University of London.

Kathleen Stewart teaches anthropology in the form of writing workshops at the University of Texas, Austin. Her books include *A Space on the Side of the Road: Cultural Poetics in an "other" America* (Princeton), *Ordinary Affects* (Duke), *Worlding* (forthcoming, Duke) and, with Lauren Berlant, *The Hundreds* (forthcoming).

Lina Dib is a multidisciplinary artist and anthropologist. Her installations and compositions range from the experimental to the ethnographic and investigate socio-technical and ecological change. She is an affiliate artist at the Topological Media Lab at Concordia University in Montreal and research fellow at the Center for Energy and Environmental Research in the Humanities and Social Sciences at Rice University where she also teaches.

Craig Campbell is Associate Professor of Anthropology at the University of Texas, Austin. He is a founding member of the Ethnographic Terminalia curatorial collective. His book, *Agitating Images: Photography Against History in Indigenous Siberia* (University of Minnesota Press, 2014), explores, through archival photography and historical research, the early points of contact between Bolshevik Revolutionaries and Indigenous peoples in central Siberia.

Stuart McLean is Professor of Anthropology and Global Studies at the University of Minnesota. He studied English literature at the University of Oxford and then went on to obtain a PhD in sociocultural anthropology from Columbia University. He is the author and editor of a number of books.

Rachel Thompson is a musician, filmmaker, and PhD candidate in Anthropology at Harvard University. Thompson holds an MFA in Visual Arts from UCSD, and an MA and BA in Music from Wesleyan University. As an arts educator and media producer, she has worked at the Walker Art Center and the J. Paul Getty Museum.

Shane Greene is beholden to the title of Professor of Anthropology at Indiana University Bloomington and was once even Director of the Center for Latin American and Caribbean Studies there. He has written two books: *Customizing Indigeneity* (2009) and *Punk and Revolution* (2016).

Keith M. Murphy is an associate professor of anthropology at the University of California, Irvine. He is a linguistic and sociocultural anthropologist interested in the relationship between language, aesthetics, and human experience. He is the author of *Swedish Design: An Ethnography* (Cornell, 2015).

Marina Peterson is Associate Professor of Anthropology at the University of Texas, Austin. Her work explores entanglements of sound, sense, and urban infrastructures below and above ground. She is the author of *Sound, Space, and the City: Civic Performance in Downtown Los Angeles*, and co-editor of *Global Downtowns* and, with Gretchen Bakke, *Anthropology of the Arts: A Reader*.

Joe Dumit is an anthropologist of passions, brains, games, bodies, drugs, and facts who functions as chair of performance studies, and professor of science and technology studies and anthropology at the University of California, Davis. http://dumit.net

This is an Introduction, or, *What is happening?*

One thing that is happening is an attempt to imagine anthropology rubbing up against the arts, and the arts rubbing up against anthropology. What can be generated in the friction between the two? What lies between an anthropology of the arts and the artfulness of an ethnographic method? These are the questions potentiated in the papers here, which I read as excitations, elaborations, experiments, and ways of stepping into not knowing and being willing to fail.

Another thing that is happening is a question of whether an artful anthropology might be able to conjure another world within this world. This conjuring is not to renounce the frictions and horrors, and deaths and destruction, nor to slide into a utopian, or romantic, mode. The aim is not to craft a micro-utopia, but a way of calling up the otherworldliness already in this world, as Stuart McLean put it so eloquently. If we tune in, what muted registers of being and becoming might we begin to access?

"Make-a-think" is one formulation that came up through our conversations. I hear this in the fullest meaning of the verb "to think", in its material-semiotic-affective-synesthetic dimensions, full of and exceeding gesture, language, thought, or concepts. I hear it as a conjuring practice, an incantation, the kind of tuning in required to do the work of channeling other worlds in this world. Here "a conjurer" is not to be mistaken for "an intact liberal subject" with the privilege to pull meaning into being and the power to make that meaning hold. A conjurer is not a master choreographer, or composer, or conductor with an intact repertoire. A conjurer, in the sense that we explored in this gathering, required a yielding, a softening, an attunement. Becoming sensor, recursively, is an act of improvising with worlds in the making.

A sensor is many things. Military sensors are pre-tuned to pick up the differences that they think matter. This is not the model we are working with here. An artful anthropology requires recursive attunements to figure out what might come to matter here or there, or now, or now, or now, or what mattered then. A prefabricated sensor would not be of much use to the ethnographer who takes responsibility for crafting a field and stepping into a partly fictitious world in which they do not yet know what matters. Recursivity and responsivity are the

grounds for an artful ethnographic practice, an anthropology informed by the arts and art practices, and by the experiments of other practitioners. Recursivity, responsivity, and attunement are tools that we may need in order to make-a-think, to conjure a new kind of think, another kind of thought, a thought that can dismantle some worlds and world other worlds alongside, inside, and athwart worlds already worlding.

What is happening in this gathering are a range of ways we see ethnographers in the act of recursive attunement: through the mimetic form of writing in Katie Stewart's essay to the blubbery excesses of Stuart McLean's efforts to keep pace with the mythical flow of whale imaginaries. To Gretchen Bakke's efforts to hold together so many stories of norms and their defiance's and defeat, or Craig Campbell's sensory attunement to story, fantasy, and plants in his design of a collectivist garden as an art-based intervention in a post-socialist utopia.

It is not necessary that this other world in this world has a micro-utopian form. Worlding is non-innocent. All worlding is an act of violence. And so the worlds we conjure may be haunted by horrors, ghosts, harm. Art-making practices help throw into relief the moral economies of goods and bads we take as given. Artful ethnographies might help us break the frame, shake up the ground we thought was solid under our feet.

– Natasha Myers

Formless Matters: A User's Guide

Gretchen Bakke and Marina Peterson

An unusual book, *Between Matter and Method* might be easy to mistake for an edited volume, especially given that its primary contents are indeed a series of single-authored essays. It is however a work in common—a multi-authored musing on the nature of creative action, and a set of essays (as in trials or attempts) toward bringing what we feel (respectively and each differently) matters to anthropology as a discipline unfolding. Imagine an origami swan flattened back into a piece of paper. Imagine a whale putrefying on a beach. Imagine ethics. Language. Story.

More prosaically, our aim was to reorient the terms of interdisciplinary encounters between artists and anthropologists. To accomplish this we brought together a select group of anthropologists who incorporate critical and creative dimensions of artistic practice into their research methods and ethnographic writing: Bakke, Campbell, Dib, Dumit, Greene, McLean, Murphy, Myers, Peterson, Sansi, Stewart, Thompson. All are accomplished ethnographers whose work is driven by concerns with creative practice, made manifest in their conceptualizations of arts, aesthetics, and anthropology, in their interdisciplinary collaborations with artists, and in their writing. Some also work on the arts in a conventional sense, but this was not, in the end, what mattered.

In framing the volume we—the editors—were more interested in borrowings of artistic *process* emergent in contemporary anthropological practice. Likewise, there was an alignment regarding the hoped-for after-effects of this process. Just as an artist's method is integral to how he or she makes an object, a sound piece, or a performance that also does "work," which is to say that it reveals something not already evident in the world, so too are many contemporary anthropologists seeking to produce something that does its own work, in and on the world. Thus this volume differs from much recent work on the intersections between anthropology and art, insofar as our emphasis is on a critical conceptualization of process rather than on subject matter or outcome.

Between Matter and Method embraces the inchoate and (seemingly) illegible, resisting both form and container. Moreover, while it draws from previous lineages

insofar as it takes aesthetics as a fundamentally social category, it is committed to an understanding of art as social process with forms and qualities as inherent to not separable from worlds.

These were the ideas guiding the project. What happened then, once the participants had been approached, and (much to our delight) agreed to contribute, we said to them: Write the piece that you always wanted to write. Write the thing that's bothered you. It's a book about art and anthropology. Then they did. We all did. In the meantime we also wrote a grant that funded us to go to the Banff Centre for the Arts in the Canadian Rockies for a week (thank you Social Science and Humanities Research Council of Canada!). There we workshopped the papers. Nearly everybody said: I am not an anthropologist of art. Then they presented. Art is there, anthropology is there. Mostly issues relating to matter are there. Everyone wrote about matter, matters, mattering. Most also wrote about method, methods, methoding. The Anthropocene is lurking about the edges of it all. There was a kind of collective desire for bloat, for breaching, for sensors, for unmaking, for doings that don't map onto productivity or reproductivity. There was fat, shit, whales. It's a weird book. Matter and a kind of dense playfulness are what bind it. That, and Georges Bataille, who crops up everywhere. The question we turned to after two days at Banff was: "What is happening?"

We had talked, walked, and talked; sat, eaten, listened, and laid on the floor together; and maybe we were a little tired, a little punchy. Something was happening, and it took shape, then, in and through words. Some things—ideas, words, objects, events—had percolated to the surface, had resonated across pieces, had lodged themselves into our minds, had come into focus, skittering across surfaces or drawing things together. We had words—words on a whiteboard, words written, some later wiped away. We could select from what remained. Orange and green and brown words, plucked from the scribbled and erased board, the palimpsest board, generative as sounds and as thoughts. We wrote for twenty minutes. Fast. Each of us threading a thread through the words that remained. There was silliness in all our seriousness.

The resulting pieces, edited in minor ways for clarity, have been scattered throughout this book, though most are gathered in the section entitled "Another World in this World." Someone had written this phrase on the board and no one had erased it. These short pieces foam around what we had been doing, as a still emergent process, as writing, as practice. It became clear that, just as our essays and our free-writing play with form, the book should as well (thank you to Bloomsbury, and especially our editors, Jennifer Schmidt and Miriam Cantwell, for allowing

us this play). We won't claim artist status as such, though many of us are also artists—sound artists, visual artists, musicians, dancers—these practices inform our writing. Some of the writing is about these practices even, but we imagine that if anthropologists could give creative form to what they (we) do as anthropologists one way that it might look is like this. This is our stab at giving shape to that imaginary. And though not all of us feel we have a writing practice, or aspire to experimental nonfiction, in all the pieces something is definitely happening in the writing.

After Banff, we all went back to our four corners and rewrote what we had. So though there is a kind of fibrous connectivity between things there is no real order. Throughout, the essays interweave conceptual arguments with case studies, making strong arguments for modes of analysis and interpretation that emphasize emergent qualities and processes over essentialisms and ontological claims.

Walking Route

The book opens with **Thompson**'s "Labyrinth of Linkages," a rich and nuanced introduction to the overall project, in particular the "space of resonance" between artistic practice and anthropological endeavor. An essay about the essay, it is also the textual partner to an essay film made by its author. In emphasizing "*method over genre*," Thompson insists on the essay as "an open-ended investigation" that moves in and out of the "material at hand." The essay asks, "What method does the matter demand?"—a method that is investigative and ambulatory rather than definitive. **Stewart** hones in on the "method of mattering"—"a concrete conceptuality of objects, events, and bodies"—that takes shape across skittering surfaces of affect, of attunements that draw together worlds of people and things, of stories and ways of making sense of things that don't seem to make sense. Stewart's writing *enacts* a mattering of bodies and words, of "ordinary contact aesthetics of being in a world with other things and people."

Skittering off in another direction, a mattering of bodies takes shape quite literally as the grotesque of shit in the performances of GG Allin, whose punk aesthetic of misanthropy raises the profound question for anthropologists: must we like people? Here **Greene** adopts something of a punk (academic) voice in writing, minus the misspellings of his epigraph.

Dumit improvises with and around theory, using notecards as a form that allows a written dance around a quote presented as object. As objects, the quotes are openings, presented as a means of moving from one practice to another,

across sets of social norms and affordances. The cards themselves are a game, a process, but they are not random or indeterminate. Rather, moving from a discussion of improvisation in comedy and dance into race, he draws out the politics of improvisation—a racial politics that is world making, and from which anthropology might learn. **Myers**'s essay is about an oak savannah in Toronto that has become a city park. In part concerned about the colonial nature of ecological restoration and the erasure of Indigenous land care practice, she writes toward a sensorial multispecies ethnography, providing a guide to becoming sensor. She attunes herself to the inexorable unstoppable slowness of the vegetative, and takes us with her, into interactive practices that open our sensorium to the engagements of people ways with plant ways. The outcome is an enacted methodology that is ethical all the way down.

Murphy turns to the work of designers and architects to ask about the role of intervention in anthropology. Why, he muses, do anthropologists not allow intervention? How is this built into a code of ethics, and what would it mean to intentionally intervene in one's field site—or to acknowledge the ways in which we are already doing so? This, Murphy suggests, puts pressure on notions of "objectivity," a logic of stasis and determinacy that we are all in some way here pushing against. **Sansi**'s discussion of the gift is a continuation of his larger project that emphasizes what contemporary artists and anthropologists have in common. Both Murphy and Sansi draw out commonalities between anthropology and what is now referred to as social practice art—artistic modes of engaging people, and engaging "the social" as such. For both, engaging artistic modes of sociability and social engagement are productive for considering not only a reflexive critique of anthropology, but the possibility of disciplinary transformation.

"Another World in this World" gives pause. It intervenes in the book form by presenting process through writing and image. We've gathered most of the texts generated during a twenty-minute writing exercise—on our last day in Banff, Alberta, Canada ("hungry mountains lurk in the background," [Greene])—written in response to the question: "What's happening?" Some pieces toggle between form and formlessness, between getting stuck—at dead ends, with hardened concepts—and moving through. Others play with form, explicit as they index this impulse across the book. Two of these pieces stand as an introduction and an index to the volume as a whole. Writing, reading, guffawing, questioning was all of a moment, much like other academic convenings. Here, however, we amplify the gesture, the unformed thought, the twinkling of exchange—all themes that run throughout the book. Our hope is that, taken together, these can resonate as something ongoing that is re-engaged and re-entered by this group

and with others, as the substance of anthropological practice and of thought as creative, common work.

 A tour de force of world making, **Campbell**'s essay is based on a grant application for an artwork in the form of a collective garden. Burying the ruins and giving sprout to futures both built and grown, it plots a post-Socialist, turnip-filled theme park, where cartoon characters scamper around Lenin's forearm, poking up from underground. This buried monument to a Soviet past marks a turn toward the future, forming the center point of small-scale private agriculture open to all who care to garden. **Peterson** gives us a series of short prose poems that play with the exclusions and margins of the techno-rational formulations of noise pollution. Attending to the physicality of the ephemeral, she engages what Barthes refers to as "formless," dwelling "in the vagaries, the gaps ..., where the sensible moves back into sense." **Bakke** falls off the deep end, giving us a scholarly novella about the comparative method in two registers: science fiction and history of technology. It is about social norms and self-making, breakfast cereal and the poverty of the young. Whales figure prominently. **Dib**, a practicing sound artist and anthropologist, records a park and plays it back in the park. This is an essay about that process, about sound and materiality, about a sensorium of concrete, rain, touch. It is about getting lost, dwelling in surfaces, listening and letting sound still. **McLean** ends the book with a BOOM. An exploding whale, an artist becoming octopus, becoming lobster, becoming prawn, a festival on a remote island, the sea pressing in. Fat. Art. Artfat. This is the soul of the book.

Labyrinth of Linkages—Cinema, Anthropology, and the Essayistic Impulse*

Rachel Thompson

*And so she turned her attention to the discrete actions of men,
in search of an alchemical approach to the writing of time.
Hers was to be a tale of criss-crossings, ventriloquism,
and puppets without strings.*

Extinction Number Six and the Year Without Summer

In 1833, while venturing north from Buenos Aires along the River Paraná, Charles Darwin was astounded by the number of fossilized remains embedded within the grand estuary deposit of the lowland Pampas region. Darwin heard from local residents about *the hill of the giant* and *the stream of the animal*. He was also told of "the marvellous properties of certain rivers, which had the power of changing small bones into large; or as some maintained, the bones themselves grew."[1] Within *The Voyage of the Beagle,* Darwin likens the region to a vast mausoleum of extinct creatures. Thoughts of the *Beagle* were perhaps not far from the mind of Dutch anatomist Eugène Dubois when, in 1887, he declined a professorship in Amsterdam and set sail for the Indies, in search of material proof of that elusive missing link. Denied funding from the colonial government for paleontological pursuits, Dubois sought a military solution, enlisting for eight-years' service in the Dutch East Indies Army—Medical Officer, Second Class. He detested the work, but at least it would provide passage. He would take up fossil finding on holidays and off-hours. First in caves, later in rivers.

Dubois is one of several historical characters—mythical and actual—that populate my peripatetic essay film *Extinction Number Six.* Comingling

aspects of literature, anthropology, history, and criticism, the film follows an eccentric narrator's search for the (im)material traces of Java's colonial, mystical, and paleontological past—a journey haunted in equal measure by the 1815 eruption of Mount Tambora and the still murky events of the 1965 Indonesian coup and subsequent anti-communist massacre. The film is structured according to a hybrid literary-musical form—four chapters with an overture and epilogue, within which all manner of seemingly disparate materials and events are brought into meaningful relation. Each chapter corresponds to a period of political rule in Java, and later Indonesia: the first—to the brief British occupation during the Napoleonic Wars; the second—to Java's waning dynastic rule; the third—to Dutch colonialism; and the fourth—to the birth of the Indonesian nation.

Extinction opens with a frenzied account—told through still images—of the European fallout from a volcanic eruption half a world away on the island of Sumbawa, due east of Java. Sulfuric particles from Tambora's cataclysmic eruption, carried west by stratospheric currents, set European skies aglow in 1815, while their lingering presence the following year blocked from the Earth the radiant heat of the Sun. Temperatures slumped from Tunisia to Britain. Hungary received brown snow in June, while in Italy it fell red throughout the year. Swine in Switzerland were slaughtered for lack of fodder. All manner of things were eaten: sorrel, moss, and cat. While the resulting climate irregularities lead to widespread famine throughout a continent still reeling from Napoleon's long war, they also sparked the writing of Shelley's *Frankenstein*, Byron's "Darkness," and the previous year produced those turmeric-tinged sunsets over the Thames, so fervently depicted by Turner. Through her slightly occluded, yellowed glasses, the narrator views this sulfuric discharge, and the litany of misfortune that followed in its atomized wake, as a metaphysical declaration of defiance—dispatched from the colonies. She read from Governor Raffles' report that in Java, some took the sound of Tambora's detonations to signal their deliverance from colonial rule, while others held that Ratu Kidul, Queen of the South Seas, was firing salutes from her supernatural artillery. They called the ashes *the dregs of her ammunition*, the deposit of which was three feet at Sangar, one foot on Bali, and about the thickness of a dinner knife at Batavia.[2]

Our narrator soon awakens stiff-legged and bleary-eyed from a dream of these atmospheric oddities, emerging as if from a prolonged hibernation. Attempts to trigger locomotion in the legs grant her no such ease of movement. She'd sat too long in a reclining chair—her passport expired. Confined to small quarters, sleeping only in spurts, she's gorged herself Quixote-like on a vast

collection of colonial-era treatises, and seems to have downloaded a perfectly palindromic number of images from Indonesia, in the hopes of solving a puzzle she cannot quite name. She began with five archival images—a set of rabbit holes into which she intended to burrow. But her collection soon grew to unwieldy proportions. While for a time it sufficed to take a flight of fancy through an ever-shifting accumulation of materials, it proved impossible to reach the end of the universe within a single sleepless night. So after a lengthy period of hermetic reclusion, she sets off in search of "an alchemical approach to the writing of time," one capable of confronting—as Kidlat Tahimik might say—the *perfumed nightmare* of the entire colonial enterprise.[3] Animated by Benjamin's assertion that "the past can be seized only as an image that flashes up at the moment of its recognizability, and is never seen again," her journey is driven by a restless search for these fleeting images.[4]

Propelled by an essayistic impulse—that roving, ruminative, shape-shifting, authorial energy—*Extinction Number Six* strikes an off-kilter rhythm, by turns frenetic, digressive, and occasionally languid. As the narrator's path cuts across spatial and temporal bounds, heaps of visual and textual materials pile up in her wake. On the surface, the film seems to traffic in proliferation and plunder. Yet beneath the growing stockpiles, something else is afoot. The narrator presents as a positivist, an empiricist, with an insatiable appetite for collection—yet her reasoning is often queer. A surfeit of reading and a deficit of sleep cause her to jump the grooves along which normative thought tends to travel. As materials, ideas, and concerns accumulate within the film, one may sense at first that things simply do not add up. But soon this semblance of disarray gives way to the emergence of patterns and linkages, as we acclimatize to the manner in which the narrator spins her tales. Seed bombs are dropped, take root, and then sprout before she cycles back round to catch these new specimens in her web. As the film progresses, meaning accrues less through direct assertion than through points of convergence and elision—through echo rather than enunciation.

Essayism

In what follows, I sketch the contours of one possible zone of resonance between art practice and anthropological inquiry by considering the essayistic impulse at work in the creation of *Extinction Number Six*, along with its subsequent role in my centrifugal passage from the realm of cinema towards the field of

anthropology. I ask, what might the essay film—as a method of research, mode of production, and form of audio-visual inscription—share with anthropological pursuits? My intention is not to prescribe a particular method of borrowing from one to the other, nor to draw a verbal Venn diagram delineating clear boundaries or the dimensions of common terrain. Rather, in the spirit of the cinematic essay, I'll work through strategies of suggestion, insinuation, and montage, so as to configure a space of possible resonance between these two inquisitive endeavors, a zone where neighboring objects might oscillate in sympathetic vibration. While the label "essay film" has been used to describe a subgenre of documentary, or a melding of non-fiction and experimental cinema, like its literary counterpoint, it continues to defy generic codification. I argue for a view of the essay film as *method* rather than genre—as a modality marked by the intricacy of its stylistic maneuvers, its micro-structural exertions, and its restless, ever-meandering flow. It's a verb more than a noun. While I cannot here fully contend with the essay's slippery nature, I'll briefly sketch its somewhat peculiar behavior, along with its passage from literature into cinema.[5]

The essay is at heart an open-ended investigation—a fragmentary, wandering, though far-from-aimless form of prose. Meandering, meditative, yet remarkably resourceful, the essay forever multiplies its points of entry and exit onto the material at hand. It is an ambulatory form of inquiry, always on the lam from threats of boredom. While at times it traverses a vast terrain, the essay concentrates its energy within nooks and crannies. As it migrates from one center of attention to the next, the essay presses neither toward wholeness nor the resolution of loose ends. Its sketch-like form, however, is not an affectation, but rather reflects a decidedly skeptical disposition, conscious of the limits of human knowledge. More than recording the end result of critical thought, an essay documents a performance of thinking-through.

Many writers have penned essays on the essay, commenting on its essence while enacting its very form—Huxley, Woolf, Lukács, to name but a few. In his 1958 "The Essay as Form," Adorno grants the essay an impassioned exegesis. He speaks of the essay as "classed among the oddities," as possessing "a childlike freedom that catches fire, without scruple, on what others have already done."[6] The essay's borrowings, however, should not be confused with reckless plunder, for they evince a Benjaminian devotion to a practice of critical citation, seeking to obviate the need for quotation marks. After praising Benjamin as an inimitable master of the *how* of expression, refusing to separate method from material, Adorno describes the process by which an essay assembles itself:

concepts do not build a continuum of operations, thought does not advance in a single direction, rather the aspects of the argument interweave as in a carpet. The fruitfulness of the thoughts depends on the density of this texture ... In the essay, discretely separated elements enter into a readable context; it erects no scaffolding, no edifice. Through their own movement, the elements crystallize into a configuration.[7]

A literary fugitive, the essay traffics in transgression. It cannot be pinned down like moth to mounting board. Within the essay's fields of force, intuition takes the upper hand. In defiance of a positivist procedure that would render content indifferent to form, the essay asks: what method does the matter demand? The essay loosens our contemporary, disciplinary-bound understandings of method by returning to the Ancient Greeks. Before Latinate logicians of the sixteenth century conferred upon the term a sense of systematic, orderly procedure, *methodos* referred more broadly to a pursuit of knowledge or modes of investigation; to the development of a *hodos*—a path or way. Adopting a de-calcified, de-codified manner of query, the essay "takes the anti-systematic impulse into its own procedure, and introduces concepts directly, 'immediately,' as it receives them." The concepts, Adorno concludes, "gain their precision only through their relation to one another."[8] Perhaps the engine of essayism might best be characterized as an impulse or drive—an unmethodical method, as Adorno would have it.[9] An impulse that strives toward the configuration of constellations, or the weaving of Weberian webs of significance, which if brought under the gaze of a microscope might be prove to possess fractal or recursive tendencies.

Above all would-be essayists hovers the enduring presence of Michel de Montaigne, patron saint of the essay, who T. S. Eliot described as one of the least destructible authors. "You could as well dissipate a fog by flinging hand-grenades into it. For Montaigne is a fog, a gas, a fluid, insidious element. He does not reason, he insinuates, charms, and influences; or if he reasons, you must be prepared for his having some other design upon you than to convince you by his argument."[10] At the ripe old age of 38, Montaigne locked himself away in a tower, to assess that which he had learned in life. A self-imposed seclusion all the better to let the mind run rampant—free to partake of the widest of explorations. A quick jaunt through the contents of his collected essays—a veritable brick at over 1280 pages—gives but a fleeting impression of the nomadic, unfettered quality of his thought: *On idleness*; *On liars*; *On prognostications*; *The doings of certain ambassadors*; *To philosophize is to learn how to die*; *Nine-and-twenty sonnets of Estienne de La Boëtie*; *On the Cannibals*; *On the custom of wearing clothing*; *How*

we weep and laugh at the same thing; On solitude; On sleep; On the inequality there is between us; On smells; On drunkenness; On practice; On books; How our mind tangles itself up; On not pretending to be ill; On thumbs; On a monster-child; On three kinds of social intercourse; On the lame; On physiognomy; On experience.[11]

As Montaigne riffs on the Ancients, the prognosticator spies hints of Rousseau, Nietzsche, or perhaps Borges. Within the author's attempts to grasp human nature, through suspension of prior certitudes and subversion of rigid rationalism, thought becomes inseparable from style. Philosophy collapses into literature. Universals tussle with endless particulars. An anachronic reading might find within these trials the un-sprouted seeds of several strands of anthropological inquiry—albeit a conferral more than a discovery. In *The Story of Lynx* Lévi-Strauss cautiously casts his countryman as the father of armchair cultural relativism—as a subversive skeptic with a penchant for ethnographic comparison.[12]

Although sequestered for many years, later in life Montaigne did journey beyond his château, in search of a cure for his debilitating kidney stones. In his travel journal he wrote not only of his passage through the spa towns of Europe, but also of the progress—through his body—of those excruciating calcifications. In the end, it wasn't the stones that did him in, but rather a case of quinsy and paralysis of the tongue—a cruel irony for a man who regarded conversation as "sweeter than any other action in life." And if forced to choose, Montaigne declared, "I would, I believe, rather consent to lose my sight than my hearing or speech."[13]

Montaignean Montage

Given this disavowal of vision, and our current location in the south of France, we may now properly enter the cinémathèque. In 1948 filmmaker-critic Alexandre Astruc first asserted the notion of *caméra-stylo* (camera-pen) to argue that cinema was becoming a language. Born as a fairground attraction, cinema was now developing into a means of expression as supple as any other art form. Through film, the artist could express her thought, however abstract, or translate her obsessions exactly as in the contemporary essay or novel. "The cinema will gradually break free from the tyranny of what is visual, from the image for its own sake, from the immediate concrete demands of the narrative, to become a means of writing just as flexible and subtle as written language."[14] Lingering in France, we find that a decade later, film theorist André Bazin is the first to speak

of an essayistic strand of cinema, within his review of Chris Marker's *Letter from Siberia*. He describes the work as "an essay documented by film ... an essay at once historical and political, written by a poet as well."[15] Bazin contrasts Marker's work with documentary films, in which the image constitutes the primary cinematic material. "With Marker it works quite differently. I would say the primary material is intelligence, that its immediate means of expression is language, and the image only intercedes in the third position, in reference to this verbal intelligence."[16] For Bazin, Marker's work ushers in an utterly new notion of montage, one in which the connections are forged from ear to eye, rather than from one image to the next. In Marker's montage, an image does not simply refer to the one preceding or following; here an image "refers laterally, in some way, to what is said."[17]

Within my own work I seek to build a similar sort of horizontal montage, having arrived at cinema after butting up against the limits of language, entering through the opening forged by Marker. I conceive of montage not only as a practice of editing and juxtaposition, but as a manner of thought, which begins as a form of inquiry before morphing into a mode of articulation. Much more than a brute form of juxtaposition, montage encompasses methods, with near infinite permutations, for configuring relations across distance. For setting in motion the play of dissimilars—whether of concepts, sounds, images, or words. Through the play of montage, discrete fragments of disparate matter are mutually transformed through their generative collision. Montage may be defined less by the motley materials gathered than by the intervals traversed or the gaps spanned. It is the suture, the glue. More than a rigid doctrine, montage is a critical, ludic activity—an angle of approach toward idiosyncratic assembly. In partaking of a Montaignean montage, I engage cinema not to illustrate through audiovisual means an argument already settled in the verbal realm. Montage, rather, becomes a way to actively puzzle through a set of thorny, vexing knots—a process that commences with research, is mobilized during shooting, and leaves its final mark during editing and post-production.

Attunement, Ambulation, Delusion, and Dissolution

What then might an essayistic impulse, engaged in feats of acrobatic montage, share with anthropological pursuits—whether in the field, the archive, the library, or at the writing desk? Certainly a sensibility or an attitude—an

attunement to the world in all its tangled, chaotic multiplicity. Another strand of essayistic/anthropological affinity might be found in the relation of drive to friction and obstacle. To carry this thought further, I'll borrow a phrase from Viktor Shklovsky, who borrows in turn from Lev Tolstoy, in the naming of his final work on which he spent twelve years—*Energy of Delusion: A Book on Plot*. Throughout this wide-ranging and singular book, combining literary criticism, with aphorism, memoir, and poetic musings, Shklovsky describes the *energy of delusion* as: the energy of free search and conflicting drives; the precision of mistakes; footprints leading to truth; the energy of trials, experiments, and investigation; the energy of comprehending ocean currents, the realization that they have multiple levels; and Tolstoy's method for assembling plots.[18] It is the same phrase through which Tolstoy, in an 1875 letter, excuses himself to hunt rabbits, when he can't seem to progress on the agonizing work of *Anna Karenina*. "Everything seems to be ready for the writing—for fulfilling my earthly duty, what's missing is the urge to believe in myself ... I'm lacking the energy of delusion; an earthly spontaneous energy that's impossible to

invent. And it's impossible to begin without it."[19] It was while devouring Shklovsky's confounding book that the crude beginnings of *Extinction Number Six* began to form.

Another provisional answer might trace the kinship between the essayistic impulse and fieldwork—anthropology's emblematic yet much debated method—focusing on their shared pursuit of ambulatory forms of inquiry. As I now make my home within a department of anthropology it would be fitting to take Boas, Malinowski, or perhaps Lévi-Strauss as my guide. But as a relatively recent immigrant to the discipline, I instead cast my net sidelong toward that which first drew me to anthropology: its commitment to empirical, participatory modes of research and its willing confrontation with ambiguities of meaning, as they rise up from the playful, if at times polemical, tussle between theoretical and experiential ways of knowing. Joining this spirit of oscillating inquiry to a penchant for pursuing knowledge on-the-move—whether around the block or across the sea—allows me to convene a more motley crew of chosen ancestors, including philosophers, geographers, naturalists, novelists, and perhaps the odd sculptor. When I speak of this propensity for movement, I have in mind both macro and micro versions of itinerant thought—far-flung voyages of scientific exploration, along with those simple circuits through the neighborhood, which trigger the flow of creative contemplation. Eschewing chronology, teleology, and any sense of implied hierarchy, I'll draw not a genealogical tree, but rather a seating chart for a séance-cum-symposium. The theme of the evening? Open-ended inquiry in relation to the natural world and the creatures dwelling within it—human and otherwise.

Plato can pace about while Pliny the Elder holds forth on the impulse that did him in: the desire to seek a closer look at the pyroclastic flows that buried Pompeii. Melville, the fellow sailor, will speak not of the whale but of his passage down the Mississippi. Linnaeus and Audubon shall talk avian taxonomy, while Richard Long, a sculptor who uses walking as his medium, will urge Rousseau to join him in his plight to register his trace upon the ground. Sontag shall give her definition of a polymath—having an interest in everything and nothing else.[20] Turner, known to his friends as Mr. Avalanche Jenkinson, owing to his zeal for foul weather, will try to convince Samuel Clemens to think better of him, to retract his statement that a certain of his paintings resembled "a tortoise-shell cat having a fit in a platter of tomatoes."[21]

Bringing biology and descent briefly back into view, I've recently thought that if three men could somehow pool their genes and create a new human, I might

like to be the offspring of Patrick Keiller, Chris Marker, and W. G. Sebald, with Viktor Shklovsky as the in vitro alchemist. Please allow me this flight of fancy and know that it does serve a purpose in my plot, for with only a hint of hyperbole, I could tentatively divide my life in three: before, during, and after the reading of Shklovsky's *Energy of Delusion*. At the outset of the book—which the author attempts to start not once but thrice, through a trio of successive prefaces—Shklovsky declares that the history of literature is a "compilation of the history of delusions." The author is not afraid of getting lost, "because talent will not only show the way out, but talent, one may say, demands delusions, for it demands strain, nourishment, material, it demands a labyrinth of linkages into which it has been called to investigate."[22] While the word *talent* as Shklovsky deploys it carries a rather grandiose ring when repurposed as a term of self-reference, one could easily substitute the word *impulse, energy,* or *drive* and retain much the same meaning. After the third preface, Shklovksy asks the reader, "How shall we start? We still have some time. We must explain how all of this came about, from where all these 'delusions' originated ... we're giving the history of linkages, if you will." For Shklovsky the delusion is closely linked to the difficulties against which the author must strive. It's an itch that desires a scratch—not fleeting, but sustained. Shklovsky later recounts the extended durations Tolstoy required to study his characters. He carried "them not for nine months, like a woman bears a child, but for years."[23] In a letter to his aunt, Tolstoy "writes that he has adopted Anna as a daughter, she has become his own."[24] We should briefly note that in addition to "energy of delusion," Shklovsky also borrows from Tolstoy the phrase "labyrinth of linkages"—yet reinvents it. We'll bracket that for a moment and cycle back to it at the end.

Content→Form

Having considered the shared practices of ambulation and attunement, I'd like to propose an anthropological engagement with an energy of delusion—the motor that drives all cinematic essays. I am not advocating for delusions as defined by the dictionary or the DSM,[25] but rather for that energetic strain, as configured by Tolstoy and then Shklovsky. I'm suggesting the anthropological adoption of an authorial energy that would strive to achieve the dissolution of content into form—the abiding dualism against which all art strains. What might such a reorientation of form's relation to content entail for anthropology? Perhaps a

more thorough grappling with the question: what method does the matter demand? To think of method beyond the field. To apply the same rigorous creativity to the fashioning of fieldwork strategies as to the method of formal composition—whether in text, sound, still image, or film. To move beyond contemplation of novel methods for the collection of content, to experiments in the configuration of anthropological analysis *through* form. This is not about excessive ornamentation, or a navel-gazing obsession with writerly style. It's a call to re-think how we forge our linkages, how we trace our constellations, so as to maximize the generative, analytic tension in the hitching of one datum or idea to the next. It's about a principle of construction that would permeate the entire anthropological endeavor, from conception to publication. It will require strain and an exhaustive dedication to the spirit of search. It calls for a commitment to the ongoing creation of radical methodologies that strive toward adequate forms, rather than making do with prefabricated hooks for the hanging of our disciplinary hats.[26] We can learn from the cinematic essayists—Vertov, Godard, Varda, and the gang—as well as from Warburg with his *Mnemosyne Atlas* and his library structured by "the law of the good neighbor". Or we might pursue Benjamin's riddle put forth in Convolute N, "to carry over the principle of montage into history. That is, to assemble large-scale constructions out of the smallest and most precisely cut components. Indeed, to discover in the analysis of the small individual moment the crystal of the total event. And, therefore, to break with vulgar naturalism."[27] Might this break have something to do with Gretchen's fattening of form, or Katie's distended fermentation of a seriously weird realism? Perhaps not. Who am I to say? I do know that within this book, we're searching after modes of attunement and forms of representation beyond what has been deemed disciplinarily natural or neutral. No, not a magic realism, Natasha is quick to counter, or a retreat into micro-utopias. Rather a discernment or sensing—perhaps beyond or before words—of an otherworldliness already present in this world, a worlding neither immune nor innocent of violence, horror, and harm.

As for the engagement I've proposed, I'm not yet sure what the final form of such a project might take—I'll report back in a few years. For now, I'm seeking ways to *transpose* my manner of thought and action from the realm of cinematic essays to a literary strain of anthropology. I have in mind a lo-fi approach, something to be achieved with paper and pen. It's a channeling I'm after; a conjuring of cinematic behavior in textual form. Rather than speculate any further, I'll close with a return to *Extinction Number Six*, to

tell you how my narrator spun her threads, and thus fashioned and fattened her forms.

Changing Small Bones into Large

As mentioned at the outset, *Extinction* follows an unnamed narrator's search for the (im)material traces of Java's colonial, mystical, and paleontological past. Her journey is haunted in equal measure by the 1815 eruption of Mount Tambora and the still murky events of the 1965 Indonesian coup and subsequent anti-Communist massacre. The narrative arc of the film took shape over a year of reading, writing, and diagrammatic drawing. What began as an untidy, spatialized list of concerns, gradually evolved into a map of the territory through which my narrator would chart a course. While the map covers a wide swath of historical time, I knew this non/fiction film would not follow a neat, chronological progression. I imagined I could knit together its threads in multiple configurations, yet sought a particular pathway, or mode of encircling these fragments—one that would suggest to viewers something of the narrator's associative movement through these seemingly disparate shards. This was a map as a score for a film, tracings of a queer form of historiography.

And what of my relationship to this unnamed narrator? Rather than a head-on collision with the materials at hand, I chose a set of oblique strategies for my angle of approach—beginning with the conjuring of a non/fiction narrator. While she may borrow my vocal cords and speak in the first person, her function is not autobiographical. Rather, I am her ventriloquist and she my dummy. Hers was a role I consciously played throughout various stages of the project—from research to filming, through writing and editing. The narrator was a medium, offering both freedom and generative constraint. Dizzy from her sleepless reading, she's gotten it into her head that if she could only place herself *physically* in sites of historical import she might somehow glean from the aether the material traces of events long past. Carried by her thought, the narrator moves through space and time without inhibition, allowing her to follow the visual rhyme of seemingly disparate images. Whether in the form of bones or dust, the matter she encounters never quite suffices. And so she turns her gaze to marks on the land and changes in the seas—to accretions, erosions, and transformative floods.

Briefly note my substitution, at the beginning of the last paragraph, of a forward slash (/) for a hyphen (-) in the conjoining of 'non' and 'fiction.' A small gesture

seeking to shift the nature of their relation. While the (-) negates or annuls the fictive, the (/) offers a more permeable membrane, a threshold across which sediment and fluid may travel, depending on their viscosity. A quiet reminder of the complex relation between notions of truth and the fashioning of narrative sense—be it story, history, nonsense, or an amalgam of the three. The use of non/ also denotes a constraint placed upon the unnamed, unseen narrator.[28] She would not be allowed to freely invent. Her stories would be bound by the details of my readings and experiences—her zone of freedom was the manner of her weaving. She is an engine that knits but cannot choose her threads. As compensation for the encumbrance, I gave her a set of star charts upon which to plot her constellations. Depending on her route, she might end up with a ram or perhaps a spoon. Although asked to draw pictures in the sky, she was not given the benefit of an aerial view. She kept her nose to the ground, like a myopic hound to rabbit's scent.

In her role as ventriloquized dummy, she was fed a steady diet of colonial and imperial discourse, ranging from the Romans to the Brits to Reaganite Republicans fighting the axis of evil. As half-digested materials spill forth from her mouth, she appears to communicate only through bursts of seemingly disparate information. But it is at once through and beyond these fragments that her utterances register. Via their subterranean connections that only she can forge, or the lines of flight she must travel in order to hitch one datum to the next. Once again, it is the glue, the gap that asserts itself quietly amid the din of frenetic activity. As Shklovsky might advise, we must not get caught on a single image, a single stop, but rather shift our attention to the labyrinth of linkages into which the narrator has been called, for it's the method of her movement that matters. For the curious, I'll admit there is a bull-headed creature corralled in her maze, but it's a long journey to the center and I'm all out of string. You'll have to take a gander yourself:

Shklovsky wrote that "art, in the multiplicity of its experiments, in the long search for methods, is creating paths along which all of mankind will pass in the future. The delusion of art is the energy of search. It's not a dance, or a shamanic spell where the shaman moves with heavy iron bells hanging from his body. Art in its endless search for perfection knows only one thing—not how to end, but how to see."[29]

Notes

* Think of the images peppered throughout the text as ciphers or runes. Circumscribed delusions. Itches at which the text must scratch. Polyvalent pivot points. Each providing one freeze-frame cut through the labyrinth of linkages traversed in the text. The method is montage at a standstill. An exercise in *caméra-stylo*, albeit pinned to the page. The materials are pilfered, but it's not a reckless plunder. These palimpsestic collages embody the release of a Benjaminian drive to cultivate the art of quoting without citation, now transferred to the image realm. Don't concern yourself too much with clever games of identification. In pursuing the point you might miss the glue.

1 Charles Darwin, *The Voyage of the Beagle* (New York: P. F. Collier & Son, [1839] 1909), 169.
2 Sophia and Thomas Stamford Raffles, *Memoir of the life and public service of Sir Thomas Stamford Raffles* (London: John Murray, 1830), 243.
3 The phrase refers to the unclassifiable 1977 film *Perfumed Nightmare* (Philippines)—written, produced, directed by, and starring Kidlat Tahimik.
4 Walter Benjamin, "On the Concept of History," in *Selected Writings, 1938–1940* (Cambridge: Harvard University Press, 2003), 390.
5 My initial essayistic forays were sparked through conversations with filmmaker, theorist, and pedagogue Jean-Pierre Gorin with whom I studied and taught at UCSD. His influence is peppered throughout this text. In the spirit of essayistic play, the present text riffs on, repurposes, and responds to fragments of Gorin's "Proposal for a Tussle," his unpublished opening comments to a program of essay films he curated for the Vienna International Film Festival in 2007 under the name "The Way of the Termite: The Essay in Cinema, 1909–2004."
6 Theodor Adorno, "The Essay as Form," trans. Bob Hullot-Kentor and Frederic Will, *New German Critique* 34 (1984): 152.
7 Ibid., 160–1.
8 Ibid., 160.
9 Ibid., 161.
10 T. S. Eliot, "Introduction," in *Pascal's Pensées* (New York: E. P. Dutton & Co., Inc., 1958), xiii.
11 Michel de Montaigne, *Essays*, trans. J. M. Cohen (London: Penguin Books, 1993).
12 Claude Lévi-Strauss, *The Story of Lynx*, trans. Catherine Tihanyi (Chicago: University of Chicago Press, [1991] 1995). See Chapter 18 "Rereading Montaigne."
13 Montaigne, "On the art of conversation" in *Essays*, 286.
14 Alexandre Astruc, "The Birth of a New Avant-Garde: *La Camera-Stylo*," translated in *The New Wave: Critical Landmarks*, ed. Peter Graham (Garden City: NY: Doubleday and Company, 1968), 18.

15 Andre Bazin, "Bazin on Marker," trans. Dave Kehr, *Film Comment* 24(4):44.
16 Ibid.
17 Ibid.
18 Viktor Shklovsky, *Energy of Delusion: A Book on Plot*, trans. Shushan Avagyan (Champaign, IL: Dalkey Archive Press, [1981] 2007), *passim*.
19 Letter quoted in Shklovsky, 2007:9.
20 Uttered during an onstage dialogue with Umberto Eco at NYU in 1984.
21 Mark Twain, *A Tramp Abroad* (Project Gutenberg e-book, 1880), ch. 24.
22 Shklovksy 2007: 39.
23 Ibid., 46.
24 Ibid., 39.
25 Diagnostic and Statistical Manual of Mental Disorders.
26 Certainly such experiments with content/form are already pursued by anthropologists loosely operating under the banner of "literary anthropology." In the present we may point to Michael Taussig, Kathleen Stewart, Daniella Gandolfo, or Stuart McLean, to name only a few. For those who prefer a more distant referent, we may invoke Hurston, Turner, or the Lévi-Strauss of *Tristes Tropiques*.
27 Walter Benjamin, *The Arcades Project*, trans. Howard Eiland and Kevin McLaughlin (Cambridge: Harvard University Press: 1999), 461.
28 The narrator is only glimpsed once—fleetingly and from a distance—at the beginning of the film, parked on a fallen log in full turmeric-tinged get-up, with camera obscuring her face.
29 Shklovksy, 109.

References

Adorno, Theodor ([1958] 1984), "The Essay as Form," trans. Bob Hullot-Kentor and Frederic Will, *New German Critique* 34:151–171.

Astruc, Alexandre ([1948] 1968), "The Birth of a New Avant-Garde: *La Caméra-Stylo*," translated in *The New Wave: Critical Landmarks*, ed. Peter Graham, Garden City, NY: Doubleday and Company, 17–23.

Bazin, André ([1958] 2003), "Bazin on Marker," trans. Dave Kehr, *Film Comment* 34 (4):44–45.

Benjamin, Walter (1999), *The Arcade Project*, trans. Howard Eiland and Kevin McLaughlin, Cambridge: Harvard University Press.

Benjamin, Walter (2003), *Selected Writings, Volume 4, 1938–1940*, trans. Edmund Jephcott et al., eds. Howard Eiland and Michael W. Jennings, Cambridge: Harvard University Press.

Darwin, Charles ([1839] 1909), *The Voyage of the Beagle*, New York: P. F. Collier & Sons.

de Montaigne, Michel (1993), *Essays*, trans. J. M. Cohen, London: Penguin Books.
Eliot, T. S. (1958), "Introduction," in *Pascal's Pensés*, vii–xix, New York: E. P. Dutton & Co., Inc.
Extinction Number Six (2011, US, 144 min), [Film] Dir. Rachel Thompson, Weird Weather Productions.
Gorin, Jean-Pierre (2007), "Proposal for a Tussle," unpublished opening comments for "The Way of the Termite: The Essay in Cinema, 1909–2004," curated by Gorin for the Vienna International Film Festival.
Letter from Siberia (1957, France, 60min), [Film] Dir. Chris Marker, Paris: Argos Films.
Lévi-Strauss, Claude ([1991] 1995), *The Story of Lynx*, trans. Catherine Tihanyi, Chicago: University of Chicago Press.
Perfumed Nightmare (1977, Philippines, 93min), [Film] Dir. Kidlat Tahimik, El Cerito, CA: Flower Films.
Raffles, Sophia and Thomas Stamford (1830), *Memoir of the life and public services of Sir Thomas Stamford Raffles F. R. S. &c: particularly in the government of Java, 1811–1816, and of Bencoolen and its dependencies, 1817–1824, with details of the commerce and resources of the eastern archipelago, and selections from his correspondence*, London: John Murray.
Shklovsky, Viktor ([1981] 2007), *Energy of Delusion: A Book on Plot*, trans. Shushan Avagyan, Champaign, IL: Dalkey Archive Press.
Stevenson, Angus and Christine A. Lindberg, eds. (2010), *The New Oxford American Dictionary*, Third Edition (2010), Oxford: Oxford University Press.
Twain, Mark (1880), *A Tramp Abroad*, Project Gutenberg e-book.

Mattering Compositions

Kathleen Stewart

I was living in the coal mining camps in West Virginia when Reagan was elected. Right away everyone knew that something was happening, that we were *in* something. Right away the stories started about the people who were getting kicked off social security disability. Why *her*? She's a widow with diabetes, no running water, no income. Why *him*? He's crazy and one-legged; he's got *no*body. It was as if, overnight, at the hands of a national election, the compositions of life here had hinged onto an impossible and senseless world, leaving people literally "turned around". I remembered this same sudden tipping point, where the world seemed to hit an edge, from a few months earlier when a terrible car accident involving drugs, drag racing and wife swapping (or some kind of kinship twisting, no one really knew what) had left five children dead and everyone else walking into walls in their own homes, as if they suddenly couldn't remember where the doorways were.

The hinge of Reagan's election brought a kind of clarity too. Suddenly, abject poverty itself was on display, plain as day. Now you saw that the old people were buying cans of dog food for their suppers; they'd be spotted at the camp store with just maybe six cans of dog food on the conveyor belt and that was it. Young people were living in cars; the stories traced their daily movements over the hills: where they were spotted parking, how the baby's dirty diapers were piling up in the back seat.

It was as if the elemental had come into direct contact with a life leveled by a plane of intensity. As if the environmentality of the world itself flooded the social-material-aesthetic landscape with stories, gestures, car parts, the overflowing creek, and gunshots in the night. Everything was implicated and of a piece, as if a curtain had descended on the place, creating an otherworldly stage on which history veered off into a state of nature and the sociality of talk honed itself down to the story of leakage and fleshy planes of impact. People became

bodies moved. Every misbehaving body part was a cutting edge of something becoming a phenomenon. Every story became an ambient map of a harsh new world in a state of uneven emergence. The very stuff of things, bodies, and words had coagulated into a method of mattering.

Of course this wasn't new, just clearer for a minute as the extreme trajectories of possibilities now took a certain shape. This was a place already blanketed in the expressivity of shock. Events bloated with possibilities had long littered the landscape like phantom limbs. History was no distant structural determination visible in outline but an energetic series of points that hit like bullets. Everyday aesthetic-material compositions were chords struck on deaths in the mines, slow starvations, house fires that killed everyone inside, marauding gangs of teenagers in the woods, the horrors of the body without medical care, the mass devastations of industry-wide mine closings, twenty or thirty years of mass migrations of whole generations fleeing in search of work, and the harsh excitements and hardships and marital battlefields of area-wide strikes. Whatever happened in this place honed down to hard points scored across bodies, machines, and places in the hills. Sociality was rendered heavy and diffuse. Events circled through the narrative elements of character, gesture, dialog, timing, a certain look.

Cascading scenes of devastation touched the question of life, giving it an energy, a rhythm, a palpable excess. Wild incipient trajectories could set people off. There were phantasmagorical eruptions. A teenager going on a week long burning spree taking out barns and outhouses and ending up living under a rock. Or racist violence in the dark, in the woods, in a space of condensed displacement—a white on black rape, all men, an escape and a long night's walk back to the safety of a segregated camp. Never an official confirmation of any kind. Throughout it all, the kind of utopian thinking that comes of hard drinking or hard religion flickered on and off like the blue lights of a TV set left on at night.

Reactive circuits threw up life forms that settled on the place as a mode of living through things. When the big mines closed and people were getting killed in the deadly little punch mines, snake handling boomed in the churches. For the sinners, there was drinking and drugs and sucking the gas out of other peoples' cars with a tube. The place was overfilled and in the habit of proliferation. People said the place smothered them but they "wouldn't never want to leave." They ran their mouths; they visited, they watched things arrive in the company of others. They had the common habit of "making something of things". They shared ways of being "torn up" or "getting used to" things, forms of neighborliness, labors of all kinds, and ecstatic forms of experience under the signs of religion, dream, or

addiction. There was theft and violence and care. The distant state came down in raids. There were daily forms of collapse and endurance.

When the union died one day in the middle of a strike, a stunned defeat settled on huddled bodies. The bodies wheezed, they reeled. People fell out in mass outbreaks of "the nerves" and "the dizzy." They said it was like they were being pulled down by a hand that grabbed them in the middle of their back. When the fast-food chains in town became the only place to work, the beat-up pickups went and the beat-up Ford Escorts came. When the idea hit that the young people would have to leave to find work in the cities, parents prepared their girls by training them in martial arts so now there are a lot of black belts in West Virginia and Cincinnati. Wal-Mart happened. Oxycontin happened. Tourism didn't happen. Falwell's moral majority didn't happen either; the little metal stands full of pamphlets appeared in the back of churches but after years of standing there untouched, they finally faded away. When the talk shows started, young people who were overweight or "didn't talk right" were flown to Hollywood to be *on* the shows. Freakiness was not, here, a spectator sport.

A worlding had taken root as habits of watching, waiting, "running your mouth," and "foolin' with things"—all active, practical compositional arts that incited, recorded, and performed collective shifts in modes of being. The repetitive animations of prolific storytelling aestheticized and accumulated a world like a field of mineable resources. Every act was a way of sensing out what was happening. Every glance noted the worldly capabilities of people and objects. Bodies sitting together registered the weight of the world. Their restless mobility and tinkering with things laid down the rhythm of daily life. Their intense states, like the ruins of homesteads in the hills, marked the living out of impacts as a form of attachment to life itself.

Here, I write in an effort to return to this method of mattering that surrounded me when I was doing fieldwork in West Virginia as an enigma, but one that had a lived sensibility I couldn't help but sense myself. It seems to me that this sensibility is akin to what Karen Barad calls "mattering" and what Isabella Stengers calls a "vivid pragmatics."[1] It also brings up what object oriented ontologists would call a robust realism in which objects withdraw from phenomenological and representational efforts at reduction and paraphrase[2]. Here I try to follow how the expressivity of a vivid, actively mattering world like this both underscores certain kinds of thought and makes thought dense and oblique[3] with labors, the constant scanning of possibilities, and an attunement to the amassed detritus of cruel or surprisingly gentle events. It seems to me that this kind of mattering is a method

under pressure in which the point of thought is not to represent or to judge but to reanimate what is coming into states of matter and mattering in bodies, stories, acts, and events. It may be that a theorist of mattering needs some singular skills and capacities such as timing and staging to be able to follow the serendipitous and digressive lines of energetic surfaces, concrete abstractions, and substrates and airs. This may be a world in which what matters, first, is that objects and persons are cooked down to a capacity to listen to the muscled melody of things.

When I opened my now 35-year-old field notes to begin, things fell out: a pile of pink receipts from Lilly's Professional Pharmacy for Riley Hess's black lung medications; a note from Greta, the nurse at the poor people's clinic, instructing his wife to keep the receipts for Medicare claims; an also pink receipt, probably mixed up with Riley's archive all those years ago, for a jacket I bought in Ann Arbor for $12.99; and Jerry Henson's American Health and Life Insurance Company naming me as the beneficiary: Katie Stewart (Friend), the F was capitalized. These droppings affected me not because they mapped onto memories already lodged in my head but because they were themselves disturbances in a field registering a strange archive of social-affective-aesthetic imprints.

They reminded me that I had dropped the ball in my efforts to get Riley's disability benefits. They took me back to the scene of Jerry handing me that beneficiary card. I barely acknowledged it; he didn't quite announce it; there was an indirectness about the situation. I must have dropped it in a file or a box without really registering it and never thought about it again, certainly not when Jerry died about a year later, at forty something, of complications from the flu. He had also brought me boxes of canned fruits and vegetables he had put up because I was leaving the field and, as he put it, I could pay anything I thought they were worth; I could send it once I got set up back in Michigan because he knew how hard it was and he didn't want me to be hungry. I was driving out of the mountains the next day, when my car overheated and died. It was Jerry who came and pulled it back to his place. I must have taken a bus to Michigan. Over the next months Jerry bought a matching, also wrecked, Dodge Dart, and the two cars sat side by side in his yard, creating lines of affinity, possibility, and labor to be done in an old Dodge Dart world. My line of thought ended with a stray image of the time my colleague, Betsy Taylor, helped Jerry gather fifty-three kittens and cats from his house and yard and took him and the cats to the animal shelter in town. The droppings on my office floor conjured this method of mattering that accumulated, left traces, and registered in certain ways and to degrees.

When I was in the field, there was always so much to keep up with that field notes were busybodies making beelines at a worded explosion. People were

sensing out the crystallizations and dissolutions of what happened. Events flickered like an apparition or landed hard like a shard in a thigh muscle. They etched onto things, maybe taking a limb or a child. Materialities swelled into modes of address. A life in composition cooled into the shapes of cars and cows, of smoke and mud and words, maybe a ghost, visible only from the waist up inciting talk and touch.

Life stories came in bits and pieces of abandonment and loss peppered with the compositionality of habits and signposts leading onward in a world "got down." His father left the family when he was two or three. He was adopted and had a third-grade education. He drank a lot before he married at nineteen. He had eight kids. She had thirteen kids; her uterus hangs down out of her body; when I call her to ask about getting some firewood she opens with a ten-minute rapid-fire monologue on how she plants by the signs. He worked in the mines, in lumbering, on the railroad. One son drank himself to death in Chicago, a daughter died of diphtheria, another daughter is nervous; she tingles. She had three marriages. She has numbness. He always takes a red-hot shower. He says most of the accidents in the mines are caused by carelessness. The spewing rock down there smashed his finger and broke a toe. There was no job or safety training down there. They'd go to their cars to drink; they'd smoke in the mines. Don't drink in the mines because the air pressure makes you sick. Once there was a fire; it made a loud whooshing sound like a train coming. He stayed in until he realized the foreman didn't know what he was doing and then he got out. Many lost houses, cars, furniture, during the last strike. This one will be easier because people will have tax returns.

This kind of talk was so much what life was about that it would be a disservice to reduce it to a referent in meaning or truth. Things hit the mouth. The social was a compositional rise to "make something of things" followed by the stilled call and response of just sitting. There was nothing but this. Any attempt at a summary meaning of life ended up as an open-ended litany. In April 1982, my notes record the following events people I ran into were talking about: someone broke into Della Mae's and stole fifty dollars, pickled eggs, and pinto beans; someone burned Charlie's house. Someone broke into a woman's house in Rhodell; someone broke into Kelly's service station and the health clinic; Pete Shrewsbury and a boy from Killarney were arrested; someone pulled the wire on the water pump so there was no water in Rhodell; Ronnie Alexander died of pills and liquor; Sam Tanks' son beat him up bad; Elanda Hamlet was almost raped by William Street; Zackie Shrewsbury spent the day in court and Etta Spangler's husband was indicted for grand larceny.

It was as if everyone was trolling a world already organized, moving, and expressive. The collective weight of the things that happened unfolded in partial and striking form in the elongated time of a visit. A visit was like dropping into a trough of stories, learning to sustain some series of social openings onto bizarre possibilities. People seemed to be talking about what could happen or what could have happened to produce the singular effects now partially sensible as ruins or a kind of resonance. People seemed to use their bodies as experimental instruments of story, checking to see what might happen if someone said this, or did that.

One day I was in the Sophie Laundromat. A man walked in and gave the attendant what looked like a Mother's Day card. They talked while she kept an eye on the customers—"Better put in your softener, girls." They started with lawn mowers because he was having trouble with his; then there was every kind of machine, electric and gas, push and pull, old and new, machines from Sears in Beckley and hybrid home-growns, all the various parts that go to different makes and models, and how you can fashion each part out of something or other because they break down, and so and so did one thing to fix something but they didn't know if it worked. They talked about what this army of machines and parts does to arms and legs and lower backs and lungs as evidenced in the body of so and so or that one who had that leg. Then the woman said, "Well, have you got all your cleaning done?" "Ha?" "Have you got your cleaning done?" "No, she's not done." I realized that she was trying to get information about what this man's wife, perhaps her daughter or her daughter-in-law, was up to. "Well, are y'all looking for any company to come in?" "No, we're not looking for any company."

He said he had to leave but then immediately started up again talking about someone named Harold who had been fixing up his house, tearing off the roof. "He told me he likes his job." "Yeah, they said he likes it." Then he mentioned the man's boy with some reference to stealing. She said, "Ya, they have to get after him all the time. They stole my granddaughter's wallet, threw it off the cliff." Then they talked about exactly where the wallet was found and where it must have fallen—in those brambles there. It had her social security card in it.

They were checking in not only on what was happening in precise intimate places but also on the ways things traveled in words and across bodies of all kinds.

The man again said that he had to get going. Then he started to talk about a man who had been married recently. "This makes his third." "Oh," she said, "I thought it was his first." "Oh, no." "Well, I remember once he was fixin' to marry

that woman lives up in the trailer but I thought she turned him down." "Oh, no, first he was married to that one and they had a kid, they lived together only six months, then he married that one from Egerie and they lived together only six months and *she* had a baby." The woman tried to get the story straight: "She had the baby after they lived together only six months?" "No, it was *hers*. She *had* that baby."

Then the man finally walked out. The woman finally glanced down at the card and then read it.

In the field, I was always mulling over the same basic question: what are they talking about? I circled around ways to ask them: What do you mean when you say. . . .? What is it like when you . . .? Why do you say that? Why do you think people "run their mouths" all the time? What do you get out of Miss Whittaker's testimony when no one can understand a word she's saying? All such questions prompted the same response: "I don't have no ideal, Katie" and then people would have to find a way to start again as if I had interrupted them.

My fingers were tapping the keys and people were talking about my secret spy typing in there late at night. That was *my* method. *Their* method was to come by and just sit, just talk, shoulders touching, maybe offer a little tip but one so small and matter-of-fact in comparison to the overwhelm to which it responded that it presented as a philosophy devoid of even the fantasy of "subjects" and "objects." If their method was a kind of social contact, sociality itself was a rhythm marking the beat of a saturation. It was like sticking your finger in a dyke or sidling up to a brick wall with a little purr. People seemed to be drawn to "getting something out of" the alchemy of a self-sensing world as witnessed in any number of things, including the inhuman gestures of demons and angels, the excesses of drug addicts and racists, the endurance of the unbelievably injured, or the oddly still curious tilt of a head.

A visit always started with people "placing" each other even if they knew each other well or had never met. "Placing" was a speculative leap into possible connections, no matter how unlikely or extenuated; even neighbors or kin, even those who just walked in without knocking and sat down at the kitchen table, went through some process at the beginning of a visit that was like throwing a deck of cards on the table and picking up a random hand to play. A visit was like a very slow rumination on the state of things at the moment in the scene of sitting together and looking out at the world. It was like setting a stage for contact with some matter at hand. Visits always ended with slow repetitions of phrases like "I don't have no better sense than that" or "I don't know what all, but I just

couldn't help but say *somethin'*." A visit combined the dreamy and the material, turning the substance of the world itself into the stuff of thought brought close to hand.

One day, when I arrived for a visit, Audie and her daughter, Julie, were squatting in the sun calmly squishing caterpillars against the side of the house. We went inside the hot porch to sit and Audie got us all warm lemonade. Audie figures the caterpillars came from that apple tree forty feet away; she pictures them somehow making their way across the lawn. Like snakes, they make her sick. She says there was a snake on the road that was so big that when she tried to run it over, her truck skidded off the road.

We were looking out together across the lawn of the caterpillar march. She started up again. Someone's trailer blew up. It might have had something to do with three young men in wheelchairs who were always together. We veered off into the stories of the accidents that left the young men handicapped and then into her series of verbal still lifes of the three men together in their wheelchairs in front of a trailer staring out at the road. It tore her up when her first daughter left. She still comes around, but that's worse because Audie gets used to having her around and then she leaves again. If *Julie* ever takes a notion to leave, Audie will just have to take a notion to live alone. She's got trouble over a woman at work who won't pull her weight. Audie doesn't care about the extra work, she likes the work, and it's not hard work, but with this woman doin' all *this* Audie can't get out of the bed. Because where she works they don't *need* no bossing. They just decide together how to work and they fill in for each other if they need to. When I left, Audie and Julie went right back to squishing caterpillars against the house.

Even casual talk among strangers meeting in public places would drop into the space of story and stick on something with some kind of weight. A man I met at a drugstore told me I should have the mole on my face removed. Moles are dangerous. You could get a cut and then get blood poisoning from them. He'd had warts (which were not like moles) on his hands and he'd had a girl rub Vaseline into them. That was what someone had told him to do. The Vaseline was what had done it but it might not have worked if he'd rubbed it in himself.

In the ordinary contact aesthetics[4] of being in a world with other things and people, anything could set off speculation. Thought was like a wind tunnel of associations landing on things. One Sunday during the public prayer of a church service, Irene whispered to Sue that she'd seen a calf on Sue's land and it looked dead. We left to see about the calf as soon as there was a break. We passed a

burning house. Sue said they must have set it. I asked her who set it but got nowhere. The house had been empty for a long time. I heard later that it had been donated to the fire department and that *they* had set the fire to train some new men. But when Sue said "they" must have set it, I remembered a few months before when Hatcher's house burned down and Lou and Al said Hatcher must have set it because they were able to get a lot of the furniture out and the next day he was already renting Lacey Meadows place like he'd already had it all set up. Ray had been at that fire, which he enjoyed. He said he had seen the firemen bringing the furniture out, but not in a way that expressed any opinion about whether he thought the fire was set. Refrains like the accusation that a fire was set sat next to matters of fact as if the worded opinions had the same status as the sight of furniture coming out of a house. There was no getting to the bottom of things and things weren't personal either. They were talking about what can happen and what it takes to be its sensor. That meant actively "foolin' with things," prolifically generating contact zones that demanded sensory-social-aesthetic capacities.

Ray is running his mouth. He moved in with Tracey in Odd to get away from his brothers, who were known for their drinking and fighting, though he was notoriously the worst. He says he won't leave Odd until they carry his corpse out. He's never sick except he had all that cancer and they cut him all the way down, around and up his back. He never sleeps. Cold doesn't bother him. He works out on the ground in shirtsleeves when it's ten degrees. He takes the good with the bad. You have to. He's some kind of mechanical genius and he always seems to be talking about sex, hunting, tracking scent. When Bobby went by to see about his truck, Ray and his sons had hundreds of parts spread out all over the dirt and they were screaming at each other. But by the afternoon, the truck ran perfectly.

One night in Amigo, the camp where I was living, I awoke in the middle of the night to see a geyser shooting out of the dirt road in front of my house. The other women who lived on the alley were already out there with their shovels digging the frozen ground into troughs to divert the water. Tammy went in to call the emergency water line and came back laughing about how she had tried to sound like she was calling from under water, drowning. They knew no one would come. Then they stood around in the dark talking about the story of a woman who had died that day. They decided her husband had killed her. They remembered all the times they had seen her, the bruises, her bright red hair, she was as sweet as she could be; men abused their wives because they were big babies. Sue's husband, Jimmy, was a plumber. He would have to fix the water main; the whole camp

would have to dig it out first. There would be black coal dust in the water now. Patty needs her kitchen pipes fixed but Sue won't tell Jimmy to do it because she doesn't like to speak for him. She doesn't mind if people know she was divorced when she was young, she doesn't care what people say, but she's not going to try to tell anyone what to do. Maybe that's because telling someone what to do would be not just rude but an interruption of a method in its throes. A method of people getting some kind of purchase on the surplus of propensities that propelled things by inserting themselves into possibilities.

Now, at Reagan's election, someone said Reagan was in the mafia and the government was a conspiracy aimed at making war in South America for money. Patty tried to buy half of a cow but the woman wouldn't answer her questions about what the cuts would be so Patty thought the woman might be trying to sell *her* the cow but sell *someone else* the hide and the fat would be turned into hamburger and somehow it didn't add up so Patty didn't buy it even though the price was right. She thought about this from different angles for a long time, wondering what might be going on. If I tried to take a walk on the road people would stop to pick me up, not out of kindness or malice but in the throes of speculations spit out of truck windows at me—a mélange of half-images of what might happen: prostitutes were the women who walked streets; there was a tunnel up ahead that I should go to the mouth of but don't go through it, just stand in the mouth and see if I get a feeling.

What were they talking about? Things would compose into sharp and singular forms even while they were also decomposing or retracting. Talk tracked the edges of possibility as ricocheting impressions or narrow little tunnels of sense that exposed the real as a rhythmic alternation that shimmered and dimmed. Things were dangerous, deadly, but there was also a kind of satisfaction that came of being saturated by a scene of potential impacts and reprieves. The kind of satisfaction that comes of getting a blessing from a testimony delivered in an incomprehensible language. So when Reagan was elected the place reacted; bodies were set in motion; people watched and talked and sat together in a closeness to each other and to the charged world that was their ambit, almost as if drawing themselves into matter to see what was happening to the atmosphere and air of the place itself.

Young Christians were giving up things like coke or sugar or bowling. People were being healed in the water; they said maybe it was from the impurities in the water, or because angels jumped in it, but the water itself had healing properties. A man who has a plate in his head woke up screaming; he was seeing things.

Maybe a screw was coming loose the way Julie's mother's had. He had been taking diet pills. He taught Julie to drive his truck when she was afraid to. Another man was having falling down spells, he was cured of the depression when he figured out it was devils and he drove them out. A man didn't qualify for black lung benefits even though he was so sick with it because he had worked six months too little, according to the company paper trail. Things made no sense but they were *in* the senses and undeniable.

A concrete conceptuality of objects, events, and bodies unfolded and recoiled in an overwhelm of tendencies and associations, openings and divisions. As in Foucault's philosophy of incorporeal materialism, found objects and the things that happened held the potential for realignment and reorganization. They spurred on the sayable, the seeable, their mixed media compositions of words and things were shaky and capable of shaking things up. The method of mattering here was a mode of contact between disparate elements moving in and out of sync. Every singularity of story and event suggested the partial, though striking, coherence of an energetic milieu in motion. Sitting together, people "ran their mouths" as if they were the metronomes of the world. They sensed out of what was happening not as an end point or a norm, but as a generative re-upping of the capacity to "make something of" things. A strange, practical realism of potentialities that are irreducible to fact or meaning and therefore given to the phantasmagorical and the hard mattering of things.

Anything could set things off. A Greek man came into the camp selling hot watches and everyone acted very cool. Several bought things, including Gary. He said he didn't need the pen any more than he needed a hole in his head but then he told a story about going to the state fair as a teenager and selling watches for ten times what he had paid for them. He followed up with a long sad story about his wife throwing him out and taking everything they had except her ring. She threw that ring at him and he had to hock it to get a bus ticket. In the pawnshop, a woman was saying that her husband had bought something that was supposed to be real gold but it turned out to be a cheap object. No one was upset by these stories. Gary also mentioned he wished cocaine wasn't so expensive and no one seemed shocked by that either, though this was no "sinner" crowd. They were just registering all the possibilities in things.

When I sat down to write this, the papers dropping out of my notes seemed to be formal, written remnants of efforts to settle things—to establish a Medicare claim or to create a future with a beneficiary designation. But, like the everyday flood of stories, these papers might also be seen as methods of mattering that

initiate more than they foreclose: a conjuring of possibilities, a tentative venturing forth into foreign landscapes, a precise and practical performativity aimed at somehow turning bureaucracy and power into matters at hand. Literacy, here, was not only limited but something to fool with as if it were a physicality or a musicality. Writing was an instrument directed at the official world of the courts, benefits offices, medical institutions, religion, and the zone of the unions and the mines. But what mattered was its expressivity. The religious rhetoric of the end times struck a chord through ecstatic music, trance, collective prayer, tears and the physicality of "getting sugar." An illiterate man dreading his day in court put his arm in a cast to directly communicate to the judge that he was unable to sign his name. Activists going to the state capital to testify against strip mining had to be "carried" there in fear that they wouldn't be able to talk; one man wanted to go home and get his teeth; the others surrounded them, touching and murmuring, until they were called to the stand where they were taken over by the fluid oratory of a preacher or a union leader.

My question was always "What are they talking about?" It was as if they threw words at the world looking for some kind of purchase, even as the words themselves magnetized all kinds of things, creating a proliferation of moving lines. It was as if they had to conjure the expressivity of what surrounded them and as if the exhaustion of that accumulation was itself an end point or satisfaction. So they talked, following the lines of possibilities, and then just sat together. Being satisfied was being saturated.

Sometimes in church an old, illiterate man would shout out a biblical passage he had memorized. Others would take up the call with responses of longer, more dramatic memorized passages of blood or destruction until the room settled into a satisfied stillness. Once I showed a community action documentary that featured several African American residents of the camps. The stars showed up at the grimy, windowless, cinderblock hut, nominally designated as the town hall, wearing white furs and sparkling shoes. The audience was just sitting; no one "paid them any mind" as they walked proudly to the front row to take up seats in the folding chairs. Then an old man stood up, moved to the aisle, and launched into an uninhibited high-stepping clog dance that lasted about thirty seconds. No one even looked at him. It was almost as if these performances came from an elsewhere such as the stardom of the academy awards or a past time of clog dancing and a time in which there were public places for performances other than the churches. But it's also as if something simply sparked out of the charged, straight-faced, atmosphere of the room. There was no finality, no summing up,

no decision about meaning or character or anything else. Just implication, complication, a folding of things into each other that inspired something musical in nature, something artful in the shit storm of life. A slow, unfolding, experimental and ethical pedagogy of expression that opened the question of living beyond and living on.

Notes

1 Karen Barad, *Meeting the Universe Halfway: Quantum Physics and the Entanglement of Matter and Meaning* (Durham, NC, 2007). See also Isabella Stengers, Brian Massumi, and Erin Manning, "History through the Middle: Between Macro and Mesopolitics—an interview with Isabella Stengers" (2009), *Inflexions: A journal of research creation*, 3 (2009). Available online: http://www.inflexions.org/n3_stengershtml.html.
2 Graham Harman, "Realism without Materialism", in *SubStance* 40, no. 2 (Issue 125, 2011):52–72. See also Graham Harman, *Weird Realism: Lovecraft and Philosophy* (Winchester, UK, 2012).
3 Graham Harman, "DeLanda's Ontology: Assemblage and Realism." *Continental Philosophical Review* 41 (2008):367–83.
4 Jason Pine develops the concept of a "contact aesthetics" in *The Art of Making Do in Naples* (Minneapolis, 2012).

On Misanthropology (punk, art, species-hate)

Shane Greene

Man is not on this earth to be happy or honest. He is here to realize his powers and take what he wants. To obtain and destroy all obsticles (sic) and to surpass the stagnation in which the existance (sic) of almost all individuals drag on. . . . We must all except (sic) death within ourselves.

GG Allin

Anal obscenity, pushed to such a point that the most representative apes even got rid of their tails (which hide the anuses of other mammals) completely disappeared from the fact of human evolution. The human anus secluded itself deep within flesh, in the crack of the buttocks, and it now forms a projection only in squatting and excretion.

Georges Bataille

Introductory Thoughts on Misanthropology and Species-hate

I've been wrestling with this idea lately, trying to formulate some thoughts around some disagreeable sentiments and unpleasant circumstances really quite familiar to us. I mean us humans, complex as we are. I want to talk about our hateful side or possibly just the basic horridness of human existence.

I've decided I will call this "misanthropology" and I'm just getting started. I think the term has the potential to sum up the sad insignificance and stubborn self-destructiveness of the human being. In theory, it might speak to any number of things, emergent scientific projections about human extinction scenarios, old anthropological debates about the logics of self-destruction present in blood feuds or witchcraft accusations, or for my purposes some sort of generalizable

punk rock nihilism. I'm not the only one thinking what it might mean to stick "mis" in front of "anthropology" in order to ponder human endings or just the basics of species insignificance (cf. Farman, 2014). With zombie paranoia also on the rise, talk of the Anthropocene is in a state of displacement by declarations of the "misanthropocene" (Clover and Spahr, 2014). In fact, in the first—and the only necessary—of twenty-four theses on the "misanthropocene" Clover and Spahr declare: "First of all. Fuck all ya'll" (2014:3). Well, fuck Clover and Spahr for their California-based, bad-ass efforts at poetic hipsterism and so on and so forth.

To be clear: I'm starting my branch of misanthropology by arguing a particular punk performer is just one really bad example of an entire misanthropological phenomenon. I mean bad in the sense of truly awful (as Keith noted) and not in the sense of good or cool or sweet or awesome. "But what about the problem of scalability?" several people asked (Natasha, Keith, Gretchen). Someone suggested I think of this as a specimen inside a species approach (Katie? Craig?). That sounded good; so I'm going with that, though admittedly for any longer engagement I'd have to accumulate quite a few more specimens.

Zoom out for a second. Basically, my current curiosity makes me wonder if there is a universal tendency for humans to hate themselves, some sort of collective detestation of one's own kind that leads us toward (eventually) bitter ends—though regular anthropology always repeats the refrain: "Yes, there are universals but one must show how they manifest differently across culture." I think of "species-hate" as one possibly central concept in an emerging misanthropology, something relatable to but slightly different than the more individually psychological versions of self-hate one finds in DSM disorders. To the extent that there's a psychic dimension, I'd be inclined to relate it to Freud's death drive, part of some collective movement to return to the meaningless inorganic matter from which we came but placing more emphasis on overtly negative action rather than a collectively unconscious process. Maybe we move toward a collective death because we openly hate ourselves.

I also want to think of species-hate more like a social anthropologist would, as something involving collective practices and shared spaces, however much it manifests through individual psyches. Could we think of it as a less celebratory take on Durkheim's social fact? One facet of our *sui generis* human sociality is this collective conundrum of hating what we are, loathing what we do, lamenting why we do it, and hating others because they do it too. So, to make a slight adjustment to the above: Fuck all ya'll because fuck me too.

Though it will be impossible to fully separate misanthropology from misanthropy (you got me there, Keith), I'll insist that the latter rings more familiar

because it often highlights, if not explicitly fetishizes, a singular anti-social figure, often without making explicit how his or her misanthropology is collectively constructed. This familiar figure of the isolated misanthrope—e.g. the notable negativity of individual thinkers (Schopenhauer, Nietzsche, Foucault), the farcical attitude of individual writers (Molière), or the radical self-deprecation of individual performers (Amy Schumer)—circulates more widely than discussions of "misanthropy" as a collective practice or shared space. So, my misanthropology here starts with a particular punk figure, only to expand outward toward the misanthropological collectives he was involved in constructing.

What might a misanthropology be good for anyway? For starters, it provides relief from long-standing humanist tendencies to "love" our species too much, a problem to which anthropology has contributed a lot. Use of the term "hate" sounds harsh and is likely dangerous. Yet, however much the etymology of the word points toward ill will directed at an Other, if directed collectively inward or if its objects are relatively indiscriminate, other possible interpretations arise. There's even a certain kind of humility in so far as species-hate could be connected to some form of collective self-humiliation. There's nothing more humiliating than a species bent on offing itself, whether via short aggressive bursts or just that slow, painless burn of extinction working itself out over devolutionary time.

Humanity surely has a general lack of confidence issue: Why can't we ever solve our own problems if we're supposed to be on the path to Enlightenment? Why the hell do we keep creating even bigger problems, most recently the likelihood of total ecological collapse and a mass extinction event involving our own kind? Ever notice how everywhere you go there's some local version of an apocalyptic fantasy in which humans are destroyed once and for all? At the moment, one popular version involves a grotesque zombie take-over in which all attempts to resurrect human civilization fails. Instead, we are forced to hunt squirrels and bide time looking for the remaining bullets till, inevitably, we get devoured by the empty shell of our former selves.

As intrepid inheritors of Enlightenment humanism, some may not get on board with a misanthropology. It is directly counter to the gaggles of attention spent on presumably more "positive," or at least achievement-oriented, human attributes: the rise of collective consciousness and diverse modes of sociality; the complex acquisition and development of language/culture; evolutionary adaptation to varied environmental contexts; the building of complex societies and struggles to move through history, presumably with forward motion; the material capacities for global expansion. But I am committed to finding ways to talk about

species-hate that avoid reducing it to random weirdos, cult-of-personality nihilists, or oversimplified accusations of the "you're such a hater" sort.

If there's an emerging opposition between species-hate and Marx's species-being, it's not entirely an accident. The latter presumes some seminal social seed buried within us that some day results in the full realization of our most awesome human potential. This is ironic since Marxism has really been more useful for demonstrating humanity's extraordinary capacity to find better and better ways of alienating human social capacities and honing the human skill of exploiting the crap out of each other. With species-hate, I propose instead that it is really stupid to keep betting on any fantasy that involves a happy human ending; the faster we become comfortable with the idea of humans reveling in our idiocy until we self-destruct the better.

From the outset, I will flag some extremely thorny theoretical problems I am postponing, in part due to the restrictive space of this chapter and in part because I just haven't had time to fully think it through yet.[1] The most obvious is how to separate species-hate—hate that is all-inclusive, points inward and not just outward, and is relatively indiscriminate in its object—from those other modalities of group hate that form such a tremendous part of human histories: racism, misogyny, classism, homophobia, xenophobia, religious prejudice, and so on. I'll ask the reader to trust (or not) I am aware of the enormity of this problem, since much of my previous work has dealt critically with race and class in particular (as Marina noted). For now, I will say that most critical theories of race, gender, class, and so on presume these other manifestations of hate are directed at a particular social group for complex historical, social, and political-economic reasons. While these continue to be truly central anthropological concerns, surely our thinking should not be limited to *always* starting with these same sociological categories or assuming they must inform every analysis from beginning to end. That effectively limits the imagination, however real our social problems are.

I want to think it is at least theoretically possible that a form of human hate exists that might be broadly shared across the human experience, rather than start from the assumption of what we already know, i.e. that there are many forms of group hate tied to specific historical, social, and political-economic structures and logics of "superiority." In fact, however unpleasant it sounds, the species-hate I imagine is a collective dilemma of detesting ourselves to the point of wanting to bring about a collective human end. So, in the long run it is more of an equalizer.

As per usual, the tricky part is how a misanthropologist might go about trying to 'prove' species-hate exists. I've chosen a punk performer from the eighties and early nineties named GG Allin. I identify in his performances, and the collective spaces they constructed, a form of species-hate so visceral and with objects so indiscriminate, that one can't easily categorize it as group hate directed at a predictable Other (though admittedly Keith disagrees). In my understanding, GG Allin hated everybody equally, starting quite prominently with himself and those most immediately around him. This is despite the fact that he also melodramatically declared himself some sort of messiah, like in the "GG Allin Manifesto," a poorly written text he penned in prison in 1990 in which he sees himself as a central figure in the "real underground" of rock-n-roll (Allin, 2013). Rather, as I understand it, his performative space was really about embracing a specific collective ethos. It was an enactment of species-hate not as "spectacle" for an awed public, but as an open invitation to participate in the practice of hating oneself and everyone else equally, in concert with punk's do-it-yourself democratization principles and anarchic practices.

Part I: Not Accepting Jesus Christ Allin as your Savior

A lengthy biographical analysis is beside the point, but a bit of detail about the person behind the performance is required to understand how GG Allin emerged within the US punk scene and the collective spaces he belonged to within it. Originally from New Hampshire, "GG" is a nickname. It was presumably granted to him by his older brother, Merle. According to punk legend, Merle could only mutter those two syllables in place of his little brother's original birth name: Jesus Christ Allin. Yep, GG's father had a religious obsession so deep it compelled him to break the Anglo taboo of not naming children after the Christian messiah. His mother, the parent with more concern for social perception, changed it to the more ordinary Kevin Michael a few years later. She also took the boys away from the fanatical father.

Merle was also one of GG's most loyal band mates, playing bass in various punk groups that GG fronted. Among others, GG sang in The Jabbers, The Scumfucks, The Cedar Street Sluts, AIDS Brigade, and The Murder Junkies, his last band before he died. Merle still operates a minimalist operation that survives on GG's underground cult status decades after GG's fatal heroin overdose in 1993. In addition to more predictable subcultural paraphernalia (T-shirts, caps,

Figure 3.1 Allin in Performance Mode.

posters, etc.), Merle sells more symbolically charged items: old microphones that GG busted on his head; letters between GG and jailed serial killers; bloodied mannequins that GG touched at some point; a tattered, dingy dress GG wore on this or that occasion. Merle also still tours as The Murder Junkies and apparently needs cash, since he appears to be slowly selling off his small archive of the GG grotesque via a GG Allin Facebook fan page that has about 170,000 followers (including yours truly).

Although GG emerged in the late seventies amid punk's heyday, he never achieved anything resembling the notoriety of those acts that now constitute, however ironically, the punk "canon," e.g. The Ramones, Sex Pistols, The Slits, Patti Smith, Siouxsie and the Banshees, The Clash, Germs, and so on. He also never gained the visibility of the various hardcore bands that become emblematic of punk's DIY rebirth in the eighties, e.g. Black Flag, Dead Kennedys, Bad Brains, The Exploited, Fugazi (cf. Azerrad, 2003). There is more than one reason for this. His music is just really bad, even considering punk's low-to-no standards. Allin himself once described his music as "toilet shit" (*Maximum RocknRoll*, 1987) and

most would agree. His lyrics covered topics of extreme taboo and without any appreciable poetic intent or demonstration of cleverness. He went from the more tame message of Bored to Death (a Jabbers tune from the late seventies) to the extreme literalism of Sleeping in My Piss, Suck My Ass It Smells, Commit Suicide, and I Wanna Kill You (songs released a decade later on a solo LP titled Freaks, Faggots, Drunks, and Junkies). The only "mainstream" attention he ever received resulted from brief appearances on the scandal talk show circuit in the early nineties. He visited Geraldo and Jerry Springer to provoke shock, declare himself a savior for a sold out rock-n-roll, and be put on public display as a freakish moron present in underground rock culture.

By the end of the eighties, GG Allin shows consisted of the following: random brawling with any and all members of the audience, with no discernible martial skill and frequently resulting in his hospitalization; cross-dressing with the least ostentatious of drag outfits (e.g. non-descript, dingy dresses and clownish make-up); total nudity of a non-marketable body type (he was scarred, ugly, had primitive prison tattoos, and his masculinity was negated by the micro-penis he put on display); extreme self-mutilation, typically with the microphone or beer bottle at hand rather than any props brought on stage; sexual aggression directed at both women and men in the audience; taunting the public with the most taboo of bodily substances (see Figure 3.1). Don't worry, there's more on shit below.

By the close of the eighties, Allin also began declaring he would kill himself on stage in fanzines and at spoken word events. For example, in a 1987 interview in the punk fanzine *Maximum RocknRoll* he was asked if he was a masochist. His response was: "Pain is fucking life. It's great. I will kill myself on stage. Nothing fucking hurts when I'm doing it. I fuckin' bleed. I cut myself with broken glass. I beat myself black and blue. I eat my shit. I'm a total masochistic, self-destructive motherfucker." (*Maximum RocknRoll*, 1987). The last few years of his life consisted of ill-fated tours interspersed with visits to the hospital (he was usually the one with the worst injuries) and stints in jail on charges of indecency and assault. After a more extended stay in prison following a sexual assault charge, filed by a woman that accompanied Allin's band to an after party in Michigan, he skipped probation to organize another tour at the suggestion of the young filmmaker Todd Phillips (then a student at NYU).

Phillips' documentary *Hated* about the final tour of the Murder Junkies is one of the only accounts to provide any nuance about Allin's role in punk subculture (Phillips, 1993). Phillips' extra footage also shows Allin's last performance on

June 27, 1993 at a small underground show in New York. The venue cut the electricity a couple of songs into the set and Allin ran out into the street naked and sullied, briefly provoking a street riot. The few dozen showgoers followed him into the streets and with the help of friends he eluded cops as sirens blared in the background. The next morning he was found dead of a heroin overdose that occurred at an after party.[2] At the time of his death, he was not in any obvious way a 'loner' hiding in a hole of isolated misanthropy. He was a guy with a past marriage, past jobs (he once drove a laundry truck), a band, a documentary filmmaker following him around, a current girlfriend (Liz Mankowski), and a small host of friends and admirers that hated everything right alongside him.

GG Allin's distinct lack of mainstreaming has not condemned him to total obscurity. One can check out the hundreds of thousands of hits on Youtube videos, peruse occasional rock journalism pieces that joke about him in passing, or contemplate how he still figures in the dark imagination of contemporary punksters.[3] Yet, he clearly has never come close to "canonization" in rock-n-roll history and he has never been taken seriously within the more "serious" accounts of punk subculture, supposedly that last bastion of an explicitly subversive rock-n-roll (cf. Azerrad, 2003; McNeil and McCain, 2006; Marcus, 1989; Savage, 2002).

My question is this: Do GG Allin's extreme performances point toward a participatory and collective space filled with a hate indiscriminate enough to indicate this more universalistic problem of species-hate? Basically, yes. I think his public actively participated in constructing his extremity, viscerally engaging in it, not as a freakish spectacle but as a euphoric embrace of this pathetic, humiliating, and hateable human self. While still delimited by other social vectors—race, class, gender, and so on—punk has also always represented a participatory practice and anarchically inclusive space: in artistic terms (do it DIY everybody); in expressive terms (hey, everybody, say whatever the fuck you want); and in performative terms (the musical simplicity, like the stage dives, are a refusal of the divide between performer and public). As we'll see, Allin's particular practice of punk extremism allows us all to expose the shit we hate about ourselves.

Part II: Making Nothing out of Nothing

In 2013, the small punk merchandiser Aggronautix, better known for selling punk bobblehead figurines, published a book titled *My Prison Walls*. It represents

a posthumous compilation of the "collected works" of GG Allin: short rants about masturbation, rock-n-roll, alcohol withdrawal, desires to die, and wishes to kill; disturbed self-portraits done in blood, shit, and pen; and correspondence with jailed serial killers like John Wayne Gacy. It's not exactly high culture.

Margarita Shalina (2013) published a review of the book in *The Brooklyn Rail*. In some respects it's a serious commentary, asking open-endedly: What *does* Allin's art represent? "Yes, art," she insists, right after the first use of the word. This clarifies she is struggling to consider it as such because she knows the rest of the world does not and will not: hence, the need to insist.

She positions Allin as an irreplaceable icon of a gritty New York City, one that is now impossible to imagine thanks to the Giuliani "clean-up" period and all the gentrification that followed. She even pauses to consider Allin's self-comparison to Van Gogh on the grounds that, like Van Gogh's paintings, his punk performances are just misunderstood by the narrow-minded masses. Maybe he was a performer ahead of his time is the implicit message. Yet, to make it so, she is forced to cite from one of the prison letters in the book—this one to his brother Merle—in which the prose makes it clear he can barely construct sentences. Reading the rest of his prison diary, one realizes he can't even spell the words that should matter to him most, "masterbation" and "enimies."

For my purposes, the first line of the review is really the crucial one. "I never attended a GG Allin show because I'm not into poo," she writes, later clarifying that she once declined when an old boyfriend invited her to do so. But why such explicit coyness with this term 'poo' when it is GG Allin's shit that we must contend with? Her linguistic distancing mimics her stated aversion to stepping into Allin's performative arena. Poo is playful. Shit, like Allin, is just fucking gross. Poo sounds babyish and it operates as a euphemism. Allin was intent literalness. His play with shit, however performative, was as viscerally disgusting as possible. Not only did he shit in front of his audience completely naked; he often came down from the stage and did it on the floor right in front of them. He also ate it and wanted to feed it to others. He not only smeared it all over himself but threw it into people's faces.

The real problem in Shalina's review is that it follows the impulse to translate Allin's performances into the established explanations of "transgressive" or "shock" art, which often presume that certain artistic practices are "controversial" for their given moment but can be retrospectively explained as the work of an individual genius mastering the fine art of breaking taboo. Thus, she explains GG Allin by comparing his performances with other controversial artworks of

the eighties period, most notably Piss Christ by Andres Serrano (the photograph of a crucifix submerged in the artist's piss that raised the ire of conservative Congressmen and the religious right). Were the point to compare Allin to other artists, she might have foregone the emphasis on historical period and been more loyal to this central symbolic-cum-bodily substance. Back in the early sixties, Piero Manzoni placed calculated amounts of a substance, which he declared was his actual shit, into "tinned" cans and valued them in terms of their weight in gold. The critics said it was an ironic statement about human production (and its excessive byproducts) or, more confrontationally, a comment about the absurdity involved in producing artistic value. The work is still linked to a controversy about whether the contents are "real" or "symbolic" shit, since, in perfect ironic twist, the cans cannot be opened lest their "actual" artistic value be destroyed (Glancey, 2007).[4]

Of course, Serrano had National Endowment for the Arts funding and sought formal platforms of artistic recognition (e.g. Piss Christ first appeared in an art competition), hence all the political blowback from conservative state officials. Manzoni had a "Count" in his name by birth, exhibited in Italian castles, and his work went on to be acquired by modern art museums the world over. Just three decades after Manzoni produced Artist's Shit, Sotheby's was selling his little tins of shit for the hefty sum of $67,000. As Miller (2007) notes, the work had outstripped its gold value by more than 70 times, even adjusting for the rise in gold's value. This was something Manzoni likely expected to happen; in fact, it was basic to his conceptual point that shit might actually prove more valuable than than gold in formal art circles.

Another way to explain Allin's extremism might be to consider him as just another "shock" music performer, an established tradition within certain popular music genres (e.g. rock, pop, rap). That sliding scale of consumable musical and performative transgression runs from Alice Cooper to Slayer to Madonna to 2 Live Crew to Marilyn Manson to Iggy Azalea.

Yet, to align Allin with other conceptual art overlooks the part where his performances were explicitly anti-conceptual, intended to be so literal as to go beyond the "performative." To see him merely as another shock rocker overlooks the part where he was either completely un-strategic or just clueless about how to "market" his destruction of taboo, his approach so disgusting that it is still beyond the bounds of consumable transgression. In the wake of Allin's penurious death, brother Merle has been reduced to selling T-shirts, posters, and used clothing for a few bucks to the small cult following that remembers Allin's

outrageousness. In short, GG Allin was neither a Van Gogh of the eighties nor did he convert into an icon of rock rebelliousness. He was just one guy who invited others to take punk's nihilist self-hatred to its literal extreme.

In Phillip's documentary *Hated*, there's an interview where Allin is sitting on a bed in a trashy dive hotel, wearing a black hoodie, and talking about how all his possessions fit into the non-descript grocery bag on the windowsill beside him:

> You know the whole thing with society today is, you know, go to school, get a job, and get married, and have kids, and take out loans, and dig a fuckin' hole that you can never get out of. And to me that's just the way of the government chaining you down so that you can never get out of their grip. But somebody like me who can do whatever they want, I never have to pay taxes. I can fuck who ever I want. I can go here. I can go there. You know if somebody calls me I can go tomorrow. I don't have to think about, well, I gotta take care of this. It's like, I can just . . . go. And that's the only way to fuckin' live.

Not long after the interview, Allin dug a heroin hole he couldn't get out of and failed to carry out his public suicide, never reaching this purported performative climax. Brother Merle got to keep the contents of his paper bag. To the extent that Allin had a conceptual critique of the "whole thing with society" it was expressed through the most banal and transparent of lyrics, like for example in the song Abuse Me (I want to Die):

> I wanna die, die, die, I wanna die
> Kill me, motherfucker
> I never died before
> Bury me under the floor
> Stick me in the heart, I ain't got one anyway
> Stick me in the ass, that's the best part of me
> Because I don't care if I live or die
> It just don't matter, kill me anyway.

References to his own ass are never incidental. Of all his queer stage antics, and all the excessive aggression and exhibitionism he displayed, it was always Allin's shit play that became his trademark. Eating his own shit, or smearing it all over his grotesque body, was one thing. Really it was running around with it, and throwing it at people, that clarified this punk space was not an individual spectacle of self-hate. Instead it was a collective moment of the human's negative effervescence, a visceral eruption of not Allin's individual anal obscenity but of

everyone's. It was something only a reader of Bataille could come to understand, "For it is not self-evident that the noble parts of a human being (his dignity, the nobility that characterizes his face), instead of allowing only a sublime and measured flow of profound and tumultuous impulses, brusquely cease to set up the least barrier against a sudden, bursting eruption, as provocative and as dissolute as the one that inflates the anal protuberance of an ape" (Bataille, 1985:78).

Let's take note of the fact that the small size of his shows (usually there were only a few dozen people in attendance) heightened the immediacy, intimacy, and indiscriminateness of his scatological performances. This effectively required participation. Allin's artistic space had no time, nor the necessary distance, for those infinite horizons of conceptual artistic mediation. Rather than display his piss in a photograph he would just spray you with his piss. Rather than be coy about whether his shit is actually in the can he would just pick it up and throw it in your face.

As is apparent from video footage, one could not go to a GG Allin show and safely place oneself in a position to 'watch' rather than engage. The stages were minimal or non-existent in the small clubs he played. His movements were chaotic and hard to fully anticipate. Although one assumed violence, nakedness, and bodily substance would be in play, no one could fully predict who exactly was the target since he tended to assault women and men all the same. He would be singing into the mic and bashing his own head with it one minute, only to spring into the crowd and smash someone in the face with it. He would be on the floor smearing shit all over himself one minute and then dart into the crowd, try to tongue kiss a random guy, or drag a random woman on stage.

In Phillips' extra film footage there is ample coverage of Allin's last show. In it, there's this astonishing figure of a guy from the audience who appears covered in plastic bags from the neck down. Despite this statement about protecting himself from shit, he runs around behind Allin constantly trying to insert his gloved fingers into his ass. It's the most poignant portrait of punk desires to collapse rather than maintain the boundaries of filth and purity, conflate rather than separate desire and disgust. It's so beautiful in its bodily grotesqueness.

Rather than exhibit too much abstract then, this misanthropological approach looks to the punks that actually did attend Allin shows. It takes account of those that were clearly into his shit and a lot worse. It surfs the web to see what people say about the cheap GG fetishes brother Merle is trying to sell on Facebook. Ultimately, GG Allin's shit represents the fact that he hates himself and everybody

around him, and those that helped construct his performative space reciprocate in kind.

Take, for instance, a punk nicknamed Unk. He was one of a handful of punks that appear in *Hated* to offer commentary on what GG Allin is doing, why they like to hang out with him, and why they consider him just a regular guy instead of some sort of rock-n-roll icon or artistic celebrity:

> Myself, I don't look at GG as a leader. I do believe GG hates everybody. And I think a lot of people pick up on that because a lot of people, especially like me, are filled with a lot of shit. That maybe even if I don't ever get it out myself, he's gettin' it out for me. I can do it vicariously through him.

Unk, also like GG, doesn't make good sentences, given his move to start one with a reflexive pronoun. But he knows some things regardless. Despite the ridiculous rock-n-roll messiah stuff that periodically emerged from GG's brain, he really wasn't anybody's leader. The point is that he was everybody's loser. A loser just like them. A loser like "a lot of people." In misanthropological terms, this means a loser like all of us. The symbolic equation, enacted through visceral practice, of getting out one's shit in order to expulse one's self-hate seems clear enough.

At this juncture in the account, I'll confess I follow brother Merle's activities via his administration of the GG Allin Facebook page pretty steadily. Amid the daily postings—announcement of a Murder Junkies reunion tour this day, GG Allin thong panties for sale that day—no post has peaked my interest more than one from February 10, 2016. It was posted at 12:06pm from Long Beach, CA and read thusly in all capital letters:

> GG ALLIN SHORTS WORN BY HIM ON THE 1993 TOUR. THESE ARE AVAILABLE TO PURCHASE. MESSAGE ME WITH A SERIOUS OFFER TO MY INBOX. OH I MUST NEED MORE MONEY FOR DRUGS.

Pictures accompany the post. One is of some dingy jean cut-offs. Another is this lackluster image of GG Allin wearing them, his pallid belly pooching out over the waist, German army motorcycle helmet on his head, guitar case in hand, some non-descript power lines in the background. Amid the dozens of responses, some in Spanish, almost all make reference to the presence of bodily substances that would presumably authenticate the shorts. This was the most "liked" response: "I like GG and all but do you really want his cum/shit/vomit soaked short shorts?"

The rhetorical tone of the question is a bit like a textual version of that extraordinary image of the guy at Allin's last show, the one running around trying to stick his finger up Allin's ass while decked out in plastic to "protect" himself from GG's actual shit. Clearly, if you "like GG Allin and all," you are fundamentally interested in pondering your own relation to "cum/shit/vomit" and all it represents.

GG Allin's shared performative space, this shit-smeared arena of the worst aspect of our collective human selves, is not a tale of caution. It's not a narrative of alarm. It's not an analysis of individual artistic spectacle. The whole point is that it's a shit all the way down story. Bah, the humanity: incapable, pathetic, hateful, and hate worthy. Full of shit.

Says the misanthropologist, "What if we just stop trying to make something out of it?"

Conclusion

Myself, I think that line I wrote a second ago sums it up. And (yes, Katie) this is directed at every "smarmy do-gooder" that ever existed.

Notes

1 I also won't have space to substantiate any of this here (and who knows, maybe I'll write a book of general ethnological import someday). I suspect what I am calling misanthropology is not specific to Western modernity, even though much analysis in philosophy, literature, and art about "misanthropy" might implicitly or explicitly think of it as a result of the individualization, alienation, and general bad vibes that modernity tends to generate. Having done extensive fieldwork in Amazonia, and read a thing or two about acephalous societies across the planet, I am pretty sure the exotic romanticisms that position so-called "pre-modern" societies as an implicit critique of Western modernity's individualized alienation are operating on, well, romantic exoticisms. My "cross-cultural" assumption, or working ethnological hypothesis, is that you can find people hating on themselves in one way or another almost anywhere you go, no doubt manifesting according to cultural particularities. For example, blood feuds and witchcraft accusations, which manifest in diverse societies across the globe, have these internal logics of collective self-destruction. Contrary to some theories that they balance social/familial/material debts, they

often demonstrate a tendency to illogically perpetuate aggressive human intentions in a total spiral downward.
2. As one might expect, particularly given punk's complex concern about authenticity as opposed to the presumed superficiality that accompanies the mainstream, this death by heroin instead of public suicide gave rise to heated debates about whether GG Allin was just another predictably self-destructive rock star wannabe rather than the radical "real thing" he purported to be. I have no opinion on the matter, since heroin overdose seems sufficiently self-destructive to me.
3. Francis Bean Cobain (daughter of Kurt Cobain and Courtney Love) opened her first L.A. art show in 2010 with the title Scumfuck, a reference to GG Allin's arm tattoo that read simply "Life sucks scumfuck." The exhibition consisted of Bean's drawings of freakish and androgynous bodily figures and included a rendition of a classic GG Allin portrait (Hartog, 2010). Another example is a 2015 collection of underground punk fiction published in honor of GG Allin (Johnson and Richard, 2015). The writers imagine Allin in more fantastical scenarios, e.g. having a disgusting three-way with George and Barbara Bush, doing weird things with onion rings and John Wayne Gacy, battling mutants from outer space, etc. But they still basically speak to his actual performative repertoire.
4. For that matter one can go back further to Duchamp and works like The Fountain, but surely alluding to bodily excess and actually handling it is a different matter.

References

Allin, GG. (2013), *My Prison Walls*, Phoenixville, PA: Aggronautix.
Azerrad, Michael (2003), *Our Band Could Be Your Life*, New York: Little, Brown.
Bataille, George (1985), *Visions of Excess, 1927–1939*, Manchester: Manchester University Press.
Clover, Joshua and Juliana Spahr (2014), *#Misanthropocene 24 Theses*, Oakland, CA: Commune Editions.
Farman, Abou. "Misanthropology?" Platypus, The Castac Blog. Available online: http://blog.castac.org/2014/12/misanthropology/ (accessed August 30, 2016).
Glancey, Jonathan (2007), "Merde d'artiste: not exactly what it says," The Guardian, June 13. Available online: http://www.theguardian.com/artanddesign/2007/jun/13/art (accessed February 24, 2016).
Hartog, Kelly (2010), "Smells Like Teen Spirit: Francis Bean Cobain puts on her first art show (and it's creepy)," *Daily Mail*. July 15. Available online: http://www.dailymail.co.uk/tvshowbiz/article-1294730/Kurt-Cobains-daughter-Frances-Bean-puts-art-creepy.html (accessed February 24, 2016).

Johnson, M. P. and Sam Richard, eds. (2015), *Blood for You: A Literary Tribute to GG Allin*, Minneapolis: Weirdpunk Books.

Marcus, Greil (1989), *Lipstick traces: a secret history of the twentieth century,* Cambridge, Mass.: Harvard University Press.

Maximum RocknRoll (1987), "Interview with GG Allin." *Maximum Rock-n-Roll*. #45.

McNeil, Legs and Gillian McCain (2006), *Please Kill Me: The Uncensored Oral History of Punk*, New York: Grove Press.

Miller, John. (2007), "Excremental Value" *Tate Etc.* 10 (summer). Electronic Document: Available online: http://www.tate.org.uk/context-comment/articles/excremental-value (accessed February 24, 2016).

Phillips, Todd (1993), *Hated* [Documentary Film]. Skinny Nervous Guy Productions.

Savage, Jon (2002), *England's Dreaming*, New York: St. Martin's.

Shalina, Margarita (2013), "GG Allin Gets Trapped in America, Sends Word to the Empire," *Brooklyn Rail*, November 5. Available online: http://www.brooklynrail.org/2013/11/music/gg-allin-gets-trapped-in-america-sends-word-to-the-empire (accessed February 24, 2016).

Notes Toward Critical Ethnographic Scores: Anthropology and Improvisation Training in a Breached World

Joe Dumit

Improvisation Games with Ethnography

This chapter experiments with a series of games—syllabi games, classroom games, and ethnographic ones—involving anthropology and improvisation. It began with the challenge of taking the texts of cultural anthropology and the handbooks of theater and dance improv, and read them as doppelgängers, as uncanny doubles of each other. One way of reading cultural anthropology is in a basic Bourdieuian sense: that being part of a culture means that we don't follow rules, but we constantly improvise in such a way that from the outside it looks like rules are being followed.

A seeming opposite form of improvisation emerges in performance studies: in theater and dance and music are those who call themselves 'professional improvisers'. Sometimes they make up half of my classes. These practitioners start from the premise or insight that it is hard to improvise. Take improv handbooks (for theater, comedy, and dance improv), which are full of such games, and read them as theories of culture and practices to employ in the classroom and in fieldwork. And in turn, read ethnographies as secret manuals of improvisation, with their own games and scores.

This project was extremely provocative in generating conversations and practices around ethnographic training. At the same time, when read alongside work in black studies and critical improvisation studies, this very productivity is seen as privileged, limited in application, and in need of radical revision. This chapter is a provocation for trying to stay with this trouble.

What is a Game or a Score Here?

I started by discussing games—using "game" in the way that theater and comedy training talks about "theater games"—a set of light rules within which people "play", and in doing so, learn to improvise better. One of the first games taught is called: "Yes and" Step into a scene and, no matter what your partner says, say Yes, and then continue to talk. In choreography there is a similar concept of 'scores', taken from the practice of musical scores: a set of instructions that then require interpretation. Burrows describes a soft score that "acts as a source for what might happen or what might emerge, but whose shapes may be different from the final realization." A movement score might be: "Walk in such a way that someone else is always on your right, and occasionally change speed." (Try this with 10 people). These notions of games and scores instigate action, act as sources of inspiration, and usually generate surprise.

Throughout this chapter, I address one and you. I'm describing a process of addressing myself as a continuing student, learning from the texts I cite and trying to practice them, which is to also think with them. I know that they do not refer to everyone, but I also have learned that others have learned from them, such that trying to name those who these lessons are not for is as presumptuous as naming a universal. So I am trying anyway.

If ideology has to do with the ways in which we maintain habits of speech and action, improvisation points to how we make selves and worlds, moment by moment. Like Zizek's account of different ideological analyses as a series of positions that each deconstruct the previous one, till they come full circle, I have found that improvisation theories pick out different parts of the world, and the point is not to settle on one, but to be able to use all of them. So I offer the following series of scores as means of experimenting with this terrain.

Ask: "What is Improvisation Here?"

Answer the question "What is improvisation?" by using any book you have at hand. At the core of any text is a theory of improvisation (in the very general sense that agency, habits, ideology, human nature, etc. are explicit or implied, and within those coordinates is a proposal about how something other happens nonetheless).

Read any text, including texts about improvisation, anthropology, critical improvisation studies and training manuals, in order to practice precision in understanding how improvisation is defined and identified and, by extension, how the capacities and kinds of humans are being assumed. Through these conversations across texts we become attuned to what Sylvia Wynter calls "the genres of the human" that are at stake in every theory and every description.

By way of illustration and to offer another series of scores, each of the following is (1) a theory of improvisation derived from one or more readings, some explicit but most implicit, and (2) a new score of reading for improvisation, one that can be applied to any text. None of these theories are exclusive, but they do each have a different sense and conjure different worlds and politics. I found that learning to rigorously identify these worlds, and the genres of human invoked, can be incredibly powerful in understanding how politics, play, power, and differences are distributed in texts.

Improvisation is Ordinary
Improvisation is not a Choice, but Survival
Improvisation is Innocent and Good
Improvisation is Worldmaking

Improvisation is Ordinary

Improvisation is the one term/practice that grounds the cultural anthropologist's attention to how lives are made, traditionally or modernly. Improvisation is how humans do culture. This is the way that Hallam and Ingold begin their book on anthropology and improvisation: "There is no script for social and cultural life."

This sense of cultural actors as constantly creative and improvisational is incredibly generative as a research premise and a form of observational listening: to the extent that you as an observer see a script, instead learn to see an ongoing improvisation. Thus one way of reading cultural anthropology is as the art of finding improvisation in the everyday, all the time. The very being and becoming of culture is everyday or ordinary improvisation, it is the foundation of social action, something we all do.

Reading for this means seeing everything that people do as improvisational: as inventing a means of responding to an essentially new situation, no matter how repetitive it seems. Ethnographically, it means seeing each person as improvising in a way that responds to the situation yet maintains the doer as a particular type of person (as a typical person for their culture/society, even if that typicalness demands a performance of "individuality" or "creativity"). In this manner, everything that is done is revealing of living culture and how that culture is maintained. In turn, it has the effect of dividing up the world into different cultures, each with their own improvised regularities.

Improvisation is not a Choice, but Survival

Another definition of improvisation can be read in work within black studies. Choreographer and theorist Mayfield Brooks writes in *Improvising While Black*, "As a gesture towards survival, blackness improvises upon itself in order to consciously submerge itself; while at the same time emerging again to express a warped rendition of its previous self ... and something new can arise." Reading for survival reveals that the previous forms of attention assume a correspondence between person and the social world, that people are together in a shared world. In this shared world, improvisation appears as a choice. Brooks and also James Baldwin argue that "difference is an exercise of choice" only for those with the power of agency.

Reading for survival attends instead to a fundamental antagonism between peoples, and between some people and "a" social world that is organized or structured in big and small ways against them. These antagonisms reveal themselves in the way that the world offers different affordances to people depending on who they are (as disability studies teaches). The world is seen for how it works against, attacks, or rejects some persons who therefore have no choice but to improvise in order to survive.

Anthropologist Signithia Fordham's work on young black women in high school used improvisation precisely to describe describe the "tortuous relationship" they had between individual and group, how "they had no choice but to improvise a new definition of femaleness that would be a synthesis of the bicultural worlds they remembered and inherited ... Ad hocing or improvising one's life suggests constructing an identity that, on the one hand, does not violate one's sense of "Self," while, on the other hand, enhancing one's sense of fit within a given context." This form of reading sees how others are able to depend upon the world to support them and their habits. Others are forced into double binds. Improvisation is here a symptom of the unequal distribution of power.

Improvisation is Innocent and Good

A very different definition of antagonism emerges in many theater improvisation manuals and work that draws on them. Keith Johnstone details the repression of culture and education resulting in "normal life [where] the personality conceals or checks impulses." Theater games and mask techniques become a form of survival for a human seen as a more authentic self. Thus we can read Viola Spolin who argues: "Through spontaneity we are re-formed into ourselves. It creates an explosion that for the moment frees us from handed-down frames of reference ... Spontaneity is the moment of personal freedom when we are faced with a reality and see it, explore it and act accordingly." This form of analysis divides life into childhood creative innocence versus adult training non-creative conformity. Offers potential practices to free oneself (to free one's innate creativity) from this conformity through improvisation practice.

The reading practice is to see the everyday as that which has no improvisation, as a diminishment into automata of a prior and basic human form of improvisational creativity. Culture is seen as negative training—removing capacities that can be restored through the arts. Here the notion of improvisation as survival is gentrified, reading mainstream society as restricting an inherent human freedom, but one that does not see differences in kinds of humans. Compared to the previous reading in which many humans' survival were at stake, here all humans survive but at the cost of their improvisational capability which must be rescued.

Improvisation is Worldmaking

A final (for here) definition of improvisation situates it at the level of the world history rather than the person, where Fishlin, Heble, and Lipsitz state that "it can be one of the activities whereby people break the chains of the past and learn to become fit to found society anew." This approach to improvisation divides up history into a deadly world that prevents itself from changing through denial, and the improvisation that starts from this recognition and not only allows survival but has the capacity to change society as well.

Muyumba shows how Albert Murray's classic analysis of jazz and blues culture provides a starting point: "[S]winging the blues is generated, as anyone familiar with Negro dance halls knows, not by obscuring or denying the existence of the ugly dimensions of human nature, circumstance, and conduct, but rather through the full, sharp, and inescapable awareness of them." Similarly, Brooks challenges assumptions about equality, about everyone being equal, in improvisational training, a contact improvisation jam or elsewhere, asking: "How are the political stakes of analysis and aesthetics raised and altered if we theorize the structural relationship between blacks and humanity as an antagonism rather than as a reconcilable conflict?"

Improvisation here is thus the opposite of a retreat from society; it is rather the very means, perhaps the only means, for confronting the denial of history and humanity. Muyumba points out that "the major impediment to achieving the ideals of American democracy had always been American society's legal and murderous resistance to black humanity." Improvisation's promise and power is here inseparable from an ongoing analysis of oppression and from a practice of political change; worldmaking, as Weheliye describes it, means making another world in this world, in the fierce urgency of the now.

Classroom Scores: Hidden Theories

A hallmark of close reading expanded is that every text can be examined as containing a hidden theory of X (of language, development, human nature, bodies, etc.). When teaching a class with graduate students from multiple disciplines, each student is asked to survey their discipline for the key texts about X and create a syllabus of readings for which they are accountable.

For example, bodies/embodiment: each week a question is chosen for the following week at random. How does a body remember? How does a body end? How does a body act? Students read their own syllabus books and articles and then come to class prepared to discuss how their readings answered that question. Most of the time the question will not be explicitly addressed in the texts but must be sought out between the lines. This also has the interesting side-effect that the students know that almost no one else shared their readings, they cannot assume or depend upon a shared understanding. They instead must engage the shared question through articulating what their reading implicitly brings to the shared question and conversation.

Speak only until Interrupted

In one graduate class, our meta-game was to read manuals of improvisation and put them into variation in the classroom. I proposed that we adopt the following score for discussing weekly reading:

When you are speaking, you must stop immediately when someone else interrupts. That person then speaks and stops when interrupted by anyone other than you.

You speak until someone interrupts you and then you absolutely have to stop. That next person then speaks until interrupted by a third person.

While I thought of it as a game of interruption, each group immediately found it absolutely delightful to not interrupt, and by the rules of the game, the result was that the person speaking had to keep speaking, far beyond what they had wanted to say. Yet, because it was a game, they were game, and continued talking, surprising themselves by what came out of their mouths, often interesting and important to them.

Through repeated practice in these games, players report a capacity to stay in the moment for extended periods of time. They become recognizable to other 'pros' as having been trained. The point of the improvisations are to change the doers. Improvisation in this sense is always in a middle voice, pulling the embodied subject into being at stake (to use the terms of Myers and Dumit). Here, through the seemingly simple medium of light but explicit rules.

Say Yes for 90 seconds

In this score, when you are called upon, you take up the point the last person was making and continue for exactly 90 seconds and then point to someone else who had to take up the conversation at that point. This opposes the tendency to use the time others are talking to think about what you might say next. What one learns, through throwing oneself into such an extremely simple game, is that it requires what participants call "active presence and listening". This is in contrast to the redundancies of everyday conversation, as described by Deborah Tannen, in which you can barely pay attention yet still get along just fine.

"Yes and …" could be one score for ethnography. The participation part of participant observation. Say yes to whatever your situation offers you and follow along. This is some version of the rapport score. I have slowly begun wandering the field to find the games and scores that are implicitly at play in the ways in which we conduct fieldwork. And to explore how theater and dance games might make us better ethnographers.

Practicing improvisation games puts you on the spot: Gere describes how "decisions must be made now. This moment … without creative block or procrastination. There is not time for delay in improvisational performance. There is simply no time." Through magnifying the effect of tensions, hesitations, self-indulgence and non-listening—they provide hooks for staying in the situation. These effects and successes are clearly visible to participants and observers and mentors. In improv training, it is based on a notion that one can get better at improvising, at staying with the trouble and surprising oneself, precisely because one doesn't know what one is going to say or do next.

Reflecting on what worked afterwards provides a deconstruction of attentional practices and embodied choice-making. This intense temporal form of choice is altogether different from the image of rational choice.

Dis-ordering Class

In *The Undercommons*, Fred Moten proposed a score for the classroom in the university: "What's totally interesting me is to just not call the class to order."

"How hard it would be, on a consistent basis, not to issue the call to order—but also to recognize how important it would be, how interesting it might be, what new kinds of things might emerge out of the capacity to refuse to issue the call to order. In recognizing all kinds of other shit that could happen, see what happens when you refuse at that moment to become an instrument of governance, seeing how a certain kind of discomfort will occur."

Attentional Scores: Learning How You Don't See

A final offering of scores/exercises/games comes from my work with performers in choreography and theater. They have showed me how scores can help train attention so that the practitioner can come to notice more in what they are seeing, doing, and attending to than they did before.

This has my informed my research into how scientists come to train in being curious, in their capacity to be surprised. In my work with Natasha Myers, we traced the way in which scientists were taught to look and look some more. To learn to see more. One training score for biologists was to look again, at an egg through a microscope, for half an hour, and then for a whole day. "You just start noticing more things," one scientist reported. Alfred North Whitehead, as translated by Isabelle Stengers, wrote that knowledge requires this, in science as well as anthropology. A scientist's, an ethnographer's, an actor's, a dancer's sensorium can be trained to be more excitable in precise ways. Training a sensorium, as in training in seeing and listening more deeply, has an odd relation to habit. Sometimes one trains in order to develop habits, but sometimes one trains in order to free oneself of habits, even to become expert in not being habitual.

We often joke about anthropology as having no methods class, that one learns in this empirical manner through deep hanging out. Nevertheless, we might explore the notion of ethnographic scores/games as a type of training. Here are a few of these inspired by reading ethnographies and theories.

Getting an Object

This score can be used in large groups. They are broken up into smaller groups of 3 to 5 people and given the instruction to take a walk somewhere, find an object and bring it back. They are given 10 minutes to return. Upon returning they are each told to take a sheet of paper or their laptop and in five minutes write down everything they noticed on their journey. Then they can compare notes to see what they were able to recall. In our experience, even seasoned anthropologists are surprised, and even embarrassed, at how little they noticed, especially because they spent most of the journey talking to each other.

If there is time, they can go back as groups to return the object and this time come back with what they noticed (anthropologists of sound are particularly chagrinned). Variations can involve writing down what they noticed about other participants, about a previous room they were all in, about breakfast, etc. Comparing these lists reveals a lot about what senses are active, how people categorize things, and so on. The training here is to become more attentive to when and how you stop attending to (or start ignoring) certain things. And everyone stops somewhere, at what might be explored as habit, culture, the limit of description, and exhaustion. At the same time, repeating this score regularly increases one's ability to attend and recall.

Secret name for this score: Waking up to not noticing.

Worlding Oneself

A different score involves attending to one's own attention as an index of culture, as a habit of composing worlds. Katie Stewart's "things that shine" offers an example of an ethnographic score: attend to qualities, textures, tracks, and rhythms by looking at them through one life that is related to yours. She looks at these qualities and tracks through the life of her mother. For Stewart, culture is the process by which habits are formed, slowing it down, noticing. Habits emerge, as worlds a special type of imitation ray: "Our New Hampshire was a compositional habit we'd learned from our mother not by copying her, or mirroring what she did, but by moving in the manner of her. In our literal passages between self and world we were becoming sentient."

Stewart suggests that we can learn to attend to how worlds emerge by looking at a life as a "series of worldings that have laid down tracks of reaction, etched habits and composition onto identities, desires, objects, scenes, and ways of living." The written method for her here is "slow description and questions of how worlds emerge." And the interplay between seeing and writing becomes ways of living and ways of looking: attuning to the little things. In this sense she points out that, for the ethnographer, by looking you see more, through unseeing your starting point—"prefabricated knowledge"—and find the "live density of social life".

This way of practicing seeing understands each moment as singular, as the ongoing production of trained attention. When engaging with another person, this becomes the practice of noticing what another notices and how they notice: what is the world for this person? How is it composed? What does it not contain? It requires constant slow description, it requires practicing writing.

Hesitations

Play the theater game: "Yes and ..." Step into a scene and no matter what your partner says, say Yes to it, and then continue to talk. Most participants find it quite challenging at first, often freezing, inhibited. But persist. A key result of these games and scores are types of surprise at oneself. The pressure of saying Yes first and then continuing talk brings forth a variety of surprising responses. Johnstone says that a good rule is to say the first thing that comes to mind.

Now he points out that when first doing this, it often means cultural debris (clichés) and cultural repression (stereotypes and potty mouth) come out. One viscerally experiences words starting to emerge and then one's own habitual cultural hesitations. Repeatedly playing this game and letting these be said eventually enables a new presence of speech to emerge afterwards.

Culture for Johnstone is that which resists improvisation and is close to cliché in the sense Deleuze developed it in his *Cinema* books, in which we "are precisely not without sensory-motor schemata for recognizing such things [like factories as prisons], for putting up with and approving them. We have schemata for turning away when it is too unpleasant, for prompting resignation when it is terrible, and for assimilating when it is too beautiful."

Witnessing One's Avoidances

Schemata (structures of feeling *pace* Berlant) have a political function here, enabling us to see and talk and feel about the world without challenging it, and they even provide us with habits of thought when we are at a loss for words and action. Deleuze offers a similar warning: "It should be pointed out here that even metaphors are sensory-motor evasions, and furnish us with something to say when we no longer know what to do."

A follow-up score is to notice, when you turn away, what you ignore. Where do you see poverty, homelessness, prisons, social and environmental injustice, and turn away when it is too unpleasant, or feel resignation when it is too terrible? If you have a critique of society, then many times during the day you reinforce the thing you critique. But this score is NOT a practice in further resignation or self-hatred or anything else that repeats disengagement (those too are sensory-motor schemata). DiAngelo's powerful handbook essay on "White Fragility" details the ways in which whites turn away from social injustice through strategies (clichés) of guilt, fear, panic, shame, etc.

Witnessing One's Creative Avoidance

Instead of noticing turning away as repetition of a cliché, a different score is to see the improvisation within it, the adaptation of clichés to ever-changing situations. Johnstone notes that when theater game players "block"—become unable to come up with something to say—or a student doesn't know the answer to a question, they can be seen to do so in creative ways, hemming and hawing, scrunching one's face, looking at the text intensely.

"People may seem uncreative, but they'll be extremely ingenious at rationalizing the things they do." In other words, he recognizes a type of improvising that is deeply conservative: "people maintain prejudices quite effortlessly." Johnstone offers an important score here: notice the creativity in how you turn away. Attending to turning away as improvisation gets at a deep type of pleasure in avoiding, precisely because it is creative work, and it maintains one's world, one's privilege, or some part of the world.

This can be seen as part of what Wilderson calls the libidinal economy that actively resists uncomfortableness, tension, and disorientation, and contributes to the intractability and ignorability of racism, as with the "creativity" of police that Martinot and Sexton describe. An excellent ethnographic example of this type of reading is Arun Saldanha's study of the "the creativity of whiteness [among hippies in Goa] to show to what extent it can reinvent and reinforce itself … [even as it attempted] to transcend the constraints of white society."

Theater Games as Political Training

Almost any game or score can be used to train in improvisation in order to be more politically ready. In my teaching and workshops, I have found that improvisation games, even the classroom ones described above, involve a potent "training in disorientation" (Albright's phrase), and what Gere calls "learning to replace an impacted and deep-seated fear of the unknown with a new sense of joy in the moment of discovery, and a basic trust in the mental and physical processes [that enabled the improvisation]." In many settings in the university, however, this form of emphasis upon joy can seem opposed to politics, where political discussion makes it "not a game" (akin to what Sara Ahmed calls a feminist "killjoy"). Hennessey (in workshops), Schaffman, and others have made a similar observation about many contact improvisation spaces where mostly white participants find questions of identity or politics an imposition, and seek improvisational freedom as an escape from political engagement or trauma. Danielle Goldman suggests that we see this response as an erasure of the always existing political forces in the framing of improvisation within an individualist and white tradition—while still noting the powerful effects of both of these in training people in being "ready for a range of possible situations."

Goldman has outlined the history of improvisational training within African American communities as explicitly about training in responsiveness, in non-violent civil rights resistance, in how to survive: "literally giving shape to oneself by deciding how to move in relation to an unsteady landscape." Drawing on the work of Bill T. Jones and other artists, she notes that, "if anything, it is the sped-up, imaginative, expressive negotiation with constraint that defines improvisation. To imagine it any other way is not only to deny the real conditions in which we find ourselves but also to deny improvisation its keenest political power as a vital technology of the self."

Framing training games this way positions improvisation not as pre-cultural but post-civilizational and futurist. It does not disrupt individual habits (and therefore reinforce the individual subjects of those habits and their social order), but works directly to disrupt the social order habits of the contemporary human genre. Required reading: the improvisational practices of La Pocha Nostra offer potent pedagogies; Gómez-Peña and Sifuentes work directly with participants (students, community members) on their identities and political aspirations within the frame of theater.

Post-social Anthropology: Studying Antagonism

Learn to see another world in this one. For a long time I've been working with Deleuze's notion of immanence: a believing in the world as it is, and therefore to make worlds. "[W]hat we most lack is a belief in the world, we've quite lost the world, it's been taken from us … If you believe in the world you precipitate events, however inconspicuous, that elude control, you engender new space-times, however small their surface or volume. Our ability to resist control, or our submission to it, has to be assessed at the level of our every move." But Moten takes this notion of belief into action in academia: "Like Deleuze. I believe in the world and want to be in it. I want to be in it all the way to the end of it because I believe in another world in the world and I want to be in that."

In an important Q&A in a lecture on "The Touring Machine," Moten elaborates a specifically anthropological score about improvisation. When asked if there is a way to help white people understand black people better, he responds: "If I understand Fanon: to put oneself in the position trying to alter how someone sees you in this racial economy is already defeat. You need to change the economy. The more urgent and productive task it is to disrupt the system through which these evaluations actually take place. But I think there is this other thing going on that Fanon was less interested in but I'm totally interested in.

"It is about a whole bunch of rich complex modes of alternative social life that black people, and others, created, which if they are paid attention to and if they are studied, give us some models of how we might actually make the world a more sustainable place—that is what I am interested in. People build something, create new modes of sociality that we need to study. Because if we copy those we might be able to do something."

The often anthropological definition of studying the everyday as improvisation that makes the ordinary is here turned inside out to become the study of the extraordinary improvisation of those inventing modes of living within an antagonistic social order as they try to change it. This score starts with a recognition of the antagonistic structure of this world.

References

Ahmed, Sara (2017), *Living a Feminist Life*, Durham: Duke University Press.

Albright, Ann Cooper (n.d.), "Dwelling in Possibility." In *Taken by Surprise: A Dance Improvisation Reader*, edited by Ann Cooper Albright and David Gere, 257–66. Middletown CT: Wesleyan University Press.

Albright, Ann Cooper and David Gere, eds. (2003), *Taken by Surprise: A Dance Improvisation Reader*, Middletown, CT: Wesleyan University Press.

Berlant, Lauren (2015), "Structures of unfeeling: mysterious skin," *International Journal of Politics, Culture, and Society*, 28 (3):191–213.

Brooks, Mayfield (2016), "IWB = Improvising While Black: Writings, Interventions, Interruptions, Questions (with Interview by Karen Nelson, for CQ)," *Contact Quarterly Journal*, Winter/Spring, 33–39.

Burrows, Burrows, Jonathan (2010), *Choreographer's Handbook*, New York: Routledge.

Deleuze, Gilles (1995), *Cinema 2: The Time-Image*, Minneapolis: Minnesota.

DiAngelo, Robin (2015), "White Fragility: Why It's So Hard to Talk to White People About Racism," *The Good Men Project*, April 9.

Dumit, Joseph (2014), "Writing the Implosion: Teaching the World One Thing at a Time," *Cultural Anthropology*, 29 (2):344–62.

Fischlin, Daniel, Ajay Heble, and George Lipsitz (2013), *The Fierce Urgency of Now: Improvisation, Rights, and the Ethics of Cocreation*, Durham: Duke University Press Books.

Fordham, Signithia (1993), "'Those Loud Black girls':(Black) Women, Silence, and Gender 'passing' in the Academy." *Anthropology & Education Quarterly*, 24 (1):3–32.

Gere, David (n.d.), "Introduction." In *Taken by Surprise: A Dance Improvisation Reader*, edited by Ann Cooper Albright and David Gere, xii–xx. Middletown CT: Wesleyan University Press.

Goldman, Danielle (2010), *I Want to Be Ready: Improvised Dance as a Practice of Freedom*, Ann Arbor: University of Michigan Press.

Hallam, Elizabeth and Tim Ingold, eds. (2007), *Creativity and Cultural Improvisation*, London: Bloomsbury Academic.

Harney, Stefano and Fred Moten (2013), *The Undercommons: Fugitive Planning & Black Study*, Autonomedia.

Johnstone, Keith (1987), *Impro: Improvisation and the Theatre*, New York: Routledge

Lipsitz, George (2015), "Improvised Listening: Opening Statements Listening to the Lambs," In *Improvisation Studies Reader: Spontaneous Acts*, edited by Rebecca Caines and Ajay Heble, New York: Routledge.

Martinot, Steve and Jared Sexton (2003), "The Avant-Garde of White Supremacy," *Social Identities*, 9 (2):169–81.

Myers, Natasha and Joseph Dumit (2011), "Haptic Creativity and the Mid-Embodiments of Experimental Life," *A Companion to the Anthropology of the Body and Embodiment*, 239–61.

Peña, Guillermo Gómez and Roberto Sifuentes (2011), *Exercises for Rebel Artists: Radical Performance Pedagogy*, New York: Routledge.

Saldanha, Arun (2007), *Psychedelic white: Goa trance and the viscosity of race*, Minneapolis: University of Minnesota Press.

Schaffman, Karen (2001), *From the Margins to the Mainstream: Contact Improvisation and the Commodification of Touch,* [PhD Thesis], University of California Riverside.

Spolin, Viola (1983), *Improvisation for the Theater: A Handbook of Teaching and Directing Techniques*, Northwestern University Press.

Stark Smith, Nancy (n.d.), "Life Scores," In *Taken by Surprise: A Dance Improvisation Reader*, edited by Ann Cooper Albright and David Gere, 245–55. Middletown CT: Wesleyan University Press.

Stewart, Katie, "Things that Shine." This volume.

Tannen, Deborah (2007), *Talking Voices: Repetition, Dialogue, and Imagery in Conversational Discourse*, Cambridge; New York: Cambridge University Press.

Walton M. (2009), *The Shadow and the Act: Black Intellectual Practice, Jazz Improvisation, and Philosophical Pragmatism*, Chicago: University Of Chicago Press.

Weheliye, Alexander G. (2014), *Habeas Viscus: Racializing Assemblages, Biopolitics, and Black Feminist Theories of the Human*, Durham: Duke University Press Books.

Wilderson III, Frank (2003), "Gramsci's Black Marx: Whither the Slave in Civil Society?" *Social Identities*, 9 (2):225–40.

Wilf, Eitan (2013), "Toward an Anthropology of Computer-Mediated, Algorithmic Forms of Sociality," *Current Anthropology*, 54 (6):716–39.

Wynter, Sylvia and David Scott (2000), "The Re-Enchantment of Humanism: An Interview with Sylvia Wynter," *Small Axe*, 8 (Sep):119–207.

Becoming Sensor in Sentient Worlds: A More-than-natural History of a Black Oak Savannah

Natasha Myers

I live just down the street from High Park, a 400-acre urban parkland I've wandered through since I was a child growing up in Toronto's West End. It's a place that has watched me grow, and a place whose deep time, daily rhythms, and seasonal transformations I have come to feel in my bones.

If I could take you with me on a walk, we would start here on the park's Eastern edge. This stone and metal gate at Parkside Drive and High Park Boulevard marks one of three entrances to the roadways that wind through the park. Just past here is another gateway. It is a living architecture forged by trees that have been holding forth for quite some time. This gate marks the edge of an ancient remnant of a black oak savannah.

Oak savannahs are remarkable *happenings* that ingather many kinds of beings, becomings, and comings undone. They are composed of widely spaced oak trees, tall prairie grasses, and wildflowers that love to take root in sandy soils. And yet the composition of these lands is not only dependent on "natural" forces. Oak savannahs depend on the disruptive force of fire to keep the grasslands thriving and to promote the regeneration of oaks. And for that reason, they depend on people with knowledge of fire and the skills to use this force to care for the lands. Oak savannahs are in this sense *naturalcultural* formations par excellence. The one extending north from here is at least 10,000 years in-the-making.

The "here" that we experience now was a different "here" when these trees were young. They've been moving slower and growing more imperceptibly than the city has around them. I am told that some of these oaks could be as old as 250 years, grown up from acorns activated in the smoldering flames of a huge fire

Figure 5.1 High Park, Parkside Drive Gate. Photograph by Natasha Myers.

that swept through the region in the 1750s. Back then this land belonged to the Mississauga First Nation. That was before the lands were stolen for a meagre sum in a land deal that founded Toronto's predecessor, the Town of York.

What do the trees know? If we learned how to listen, what stories could they tell?

Incredulous readers will insist: You can't be serious. Trees can't know things. They certainly don't speak, let alone tell stories. And if they did, how could we ever hope to understand them? Aren't you just anthropomorphizing?

This chapter attempts to interrupt this line of questioning, and invites readers to unlearn the self-evidence of these seemingly rational protests. It asks whether these questions aren't themselves too mired in colonial imaginations of nature and culture to do the serious work of addressing what matters to these oak savannah lands. Consider that these questions are themselves expressions of colonial logics that have for centuries constrained how we think about lands and bodies, and their relations. This essay offers a glimpse of the ways that the disavowal of nonhuman sentiences is intimately bound up in colonial projects that have taken shape under the guise of the ecological sciences. It also invites readers to consider that ongoing protests against the very conception of nonhuman

sentiences risk re-colonizing the past, reviving a colonial present, and ensuring that colonial rule over settled lands and bodies endures well into the future.

This chapter seeks to unsettle assumptions about the innocence of the ecological sciences. Indeed, ecology is founded in settler colonial logics. Ecologists invented and developed their tools and theories at the frontiers of colonial expansion and capitalism's violent incursions on Indigenous lands.[1] The stories ecologists are schooled to tell are those that monetize lands and bodies; made over into natural resources, bits of nature come to circulate as commodities in tightly regulated energetic and moral economies bent on minimizing expenditures and maximizing efficiency. Ecological thinking has been shaped by functionalist, neo-Darwinian logics that story nature in militarized, mechanized, heteronormative, and deterministic terms. These foundations have produced an ecological science whose data forms and modes of inquiry tacitly and explicitly assume the only metrics of a life are an organism's capacity to survive and reproduce its genome.[2] There is no room for sentience in these accounts of bodies and lands.

And so, perhaps conventional ecology is not a great ally in efforts to tune in to what matters to this oak savannah. To become better allies here we might need to forget everything we thought we knew about nonhuman lives and worlds. This chapter invites us to forget what we thought "nature" was; to forget how we thought life "worked"; and to forget, too, the naturalizing tropes that made us believe that living beings "work" like machines, or that forests perform "ecosystems services," or that "reproduction" and "fitness" were the only valuable and recordable measures of a life.[3]

Perhaps, rather than picking up the ecologists' well-worn tools and theories, it is time that we find ways to reach toward the unknowable, the imperceptible, the ineffable, and the numinous. Not with the desire to *capture* some truth, or attempt to render the world legible to the constraints of our colonized imaginations, but rather to learn how to step into *not knowing* as an ethic and a practice.[4] *Not knowing* ahead of time that the trees have nothing to say. *Not knowing* what matters to a life or to this land. Not knowing is not about cultivating ignorance or indifference. Rather it is a capacious and humbling space that offers some refuge from the hubris of knowledge systems—like ecology—that are bound so tightly to colonial conquests and their enduring discursive regimes, cultural norms, and moral economies that have too long dictated what is good, valuable, and true. Asking "what do the trees know?", and "what matters to this land?" is thus to insist on pushing past assumptions about what counts as proper forms of knowing and the proper objects of knowledge in both anthropology and ecology.

Becoming Sensor

So, forget your best training and consider that anthropomorphism is more and other than what we have long thought it was.[5] Consider, perhaps, that the stories we tell ourselves about nonhumans do not always involve a one-way imposition of human characteristics on nonhuman others. Indeed, what I have found over and over again working as an anthropologist among life scientists is that practitioners become so intimately entrained to the beings and doings of the organisms they study that they find themselves expanding their all-too-human sensorium (often through technological prostheses) to tune their bodies and imaginations in to meet the richly sensory worlds of the nonhumans they study.[6] The molecular biologists and plant scientists I've worked with give themselves over to their inquiry in such a way that they continually *become with and alongside* the living beings they study. Such "involutionary" encounters have a *meta-morphic* effect, one that changes not only what practitioners come to feel and know, but the very meanings of the concepts and metaphors they set in motion to story nonhuman worlds.[7] What I have learned working with and alongside plant scientists, in particular, is that deep inquiry into plants' remarkable lives has the effect of *vegetalizing* the sensorium of anyone who gets caught in their *whorls*.[8] Indeed, caught in the affective entanglements of inquiry, it becomes unclear who is animating what and what is animating whom.[9] Are the plants getting *humanized* or the humans *vegetalized*? What we have long called anthropomorphism doesn't appear to work in one direction. These near-shamanic, shape-shifting, and intimate dimensions of scientific practice can be hard to perceive, especially when broader publics expect scientists to deliver mechanized, disenchanted accounts of a living world.

What follows is an experiment in suspending our all-too-well cultivated *disbelief* in the sentience of other things and beings. For the past twenty years I've been working between the arts and the life sciences, and more recently in anthropology, to experiment with modes of attention that might allow plant sensitivities and sensibilities to transform my sensorium.[10] I begin from the assumption that attunements to other sentiences require cultivating subtler sensitivities. I for one have learned that my sensorium is as expandable (and constraining) as my imagination.[11] I've been in training to tune my sensorium to the plants, to learn how to sense alongside them, with the aim of *becoming sensor*, sensitized to this sensing and already sentient world. I begin with the assumption that we are surrounded by forms of sentience that we have for the most part been

trained to tune out and ignore; that we inhabit a more-than-human world that is always already sentient; that this world full of beings, becomings, and processes of coming undone is pullulating with sensing and sensitive forms of life and death that are attending and attuning, caught up in dances with and athwart one another, composing and decomposing in responsive, repulsive, and propulsive relation.

To be sure, these sentiences may not be *for us* to know: there is a world of affectively charged chatter in the loquacious ecologies all around us, taking shape among creatures we may never see, or know, and who have nothing whatsoever to say to us.[12] And at the same time, there are some sentiences among us who perhaps deserve a little more attention. I am thinking of the plants. Plants, after all, are the substance, substrate, scaffolding, symbol, sign, and sustenance of political economies the world over.[13] They hold the sky up and the earth down. What might happen if we reach toward them with methods better attuned to their remarkable beings and doings, and with the openness of an ethic of *not knowing*? Perhaps they could teach us how to ask better questions and invent better methods and modes of inquiry.

Unsettling the Colonial Ecological Imagination

More than an attunement to plant sensing, *becoming sensor* on these lands in High Park demands sensitizing oneself to the power moves of a settler colonialism that has rendered more-than-human sentiences so illegible, and so impossible to perceive. *Becoming sensor* requires unsettling and make strange the ways conventional ecology continues to be deployed not only to colonize land, but also to colonize our imaginations; how it continues to evacuate all other ways of knowing the living world, most especially those local and Indigenous knowledges that are attuned to the sentience of lands and bodies.

Decolonizing the ecological sensorium is especially pressing today as High Park, now named as a site of scientific and natural interest, becomes a site of intensive ecological restoration, where naturalists, ecologists, volunteers, and the city's Urban Forestry team attempt to "bring back" the ancient oak savannahs that used to stretch out across these lands.[14] Their restoration efforts tend to build on conventional ecological ideas; they uphold the view that plants and trees perform ecosystem services; and they make extensive use of chemical pesticides in attempts to eradicate vilified invasive species, as if they could erase the effects of colonial

incursions on the land. Conventional approaches like this tend to hail an imagined past that assumes there was a time when this land was in some state of *nature*; some *natural* state. And yet, this is quite explicitly no site of pure nature. The very existence of oak savannahs here is evidence of enduring Indigenous land care practices over millennia. Indigenous peoples shaped these lands extensively before the land was stolen, sold off as acreage and then, later, cordoned off as municipal parkland. And thus restoration efforts to save the oak savannah's "nature," with no attention to the rich cultural histories shaping this land, have the effect of erasing the very people that give this land its contours and significance. Here ecological restoration efforts participate in an ongoing colonial project that has enforced the dispossession of Indigenous peoples from their lands.

Is it possible to decolonize ecology?[15] To *do ecology otherwise*? How might becoming sensor on these lands teach us how to do ecology as if it were allied to the *resurgence* of Indigenous peoples, not their continued oppression?[16] It is becoming clear that the first step requires disrupting assumptions about the innocence of ecology, that science which is supposed to right the wrongs of capitalism's excess. It is time to wake us up to the colonizing forces of the ecological sciences that are founded on the assumption of nature as exploitable resource; to disrupt the conventional ecological sensorium in order to cultivate new modes of embodiment, attention, and imagination, and new ways of telling stories about lands and bodies. Decolonizing one's ecological imagination takes serious work; de-tuning a well-trained sensorium demands upending everything we thought we knew. Returning again and again to this work of de-tuning my sensorium has inspired the invention an *ungrid-able ecology* for a *more-than-natural history* up to the task of documenting this *naturalcultural* happening 10,000 years in-the-making.

A More-Than-Natural History of High Park's Inhabited Lands

If you could come with me on a walk, we'd start here at the gate. Veering away from the road, just a few steps from here, there's an inviting pathway for recruitable wanderers, those who are not compelled (willingly, unwittingly, or forced) to follow the paved road. This 400-acre park's circuitous roadways carry a steady stream of cars, racing bikes, and joggers, dog-walkers and stroller-pushers, and people with mobility devices seeking hard, flat, and sure surfaces. The woodland paths I stick to are accessible only to some.

Figure 5.2 Compositions and Decompositions. Photographs by Ayelen Liberona, with Natasha Myers.

The oaks that stand here at the entrance have sensed so much. Their heavy limbs reaching and curving above are characteristic of so many of the oaks that live here. The ones with long, vertical furrows in their bark are red oaks. Trees with chiseled and broken lines in their bark are black oaks. White oaks thrive here too, with their ragged, ghostly grey bark. Some oaks have limbs with smooth and steady arc lines; some have limbs that meander waywardly. Still others' limbs are cut short by chainsaw or broken off in shards from the force of high winds or falling branches. After over one hundred years of *mattering*—pulling matter out of thin air through the cosmically attuned alchemical processes of photosynthesis—one of the trees right here at the entrance finally let go and began its long fall. Disintegrating, dematerializing, it will still be falling for another hundred years.

The trees in this park are not to be mistaken as mere vegetation: that mute and passive undergrowth that so readily serves as the aestheticized backdrop to human pursuits. The plants and trees here are active *participant-observers*: their growing limbs and fissured barks have recorded each moment of the wider landscape's transformation over time. Each node of growth, each bud, meristem and root tip, is a *center of indetermination*, improvising, experimenting, and conducting moment to moment inquiry into the play of light, gravity, and

vibration.[17] Worldly conjurers, these photosynthesizers both make and are made by the surrounding airs and soils; and they both shape and respond to worldly rhythms and shifting climates.

Sticking it out, through thick and through thin, all these years, the trees here have been paying very close attention to this changing world. What matters to these trees? Lots matter to them. The abundance of water and light and heat and cold matter for sure. But they also care about the other plants and trees around them; they care about the squirrels and caterpillars and ants and fungi. It matters especially who is feeding from their widely distributed bodies, who is nourishing them, and who are the agents of their undoing. These trees care about the different people who have over the years been weaving their way in between them. These days the asphalt, salt, heavy metals, and the exhaust from cars matter significantly. But these phenomena haven't always been their immediate concerns.

One of my favorite spots in the park is just past this gate. Others love it too. In summer it fills in with leaves and green and becomes a secret grove, bounded on either side by mounds heaving with life and rot. It's a tangled bank of lurching and fallen trees covered in frilled fungi and neon green mosses, a thickening underbrush of European buckthorn, young oaks, tick-trefoil and milkweed, and the searching tips of wild grape vines. One young, spindly birch gave up and its leaves turned brown well before fall last year. A flattened cardboard box was perhaps someone's bed one night. I think that's an old sweatshirt bundled up and decomposing under that log. A pair of men's shoes, one here, one there.

Figure 5.3 Still Falling. Photograph by Natasha Myers.

Pungent wafts of marijuana smoke billow from here some sunny afternoons. Sometimes it's the neighborhood kids. Sometimes I'm sure it's their parents. In the winter, the thickened foliage dies back, stalks wither, blacken and collapse. Those seeking refuge lose their cover. You can see clear to the road and into the homes across the street.

This little section of the park spans no more than two acres. You have to pass this space if you are walking into the park from the Parkside Drive gate. I never used to come here. Maybe it never looked inviting. Maybe I could sense that it was already inhabited by others; wanderers, wayfarers, and gallivanters, their beer bottles, cigarette butts, tarps, used condoms, bongs, and trash scattered here and there.

This was a blank space on my internal map of the park, which I claimed to know like the back of my hand. From a safe distance it seemed crumbling, derelict, uncared for. Massive limbs of fallen trees lay scattered as if they were bodies left unburied in a graveyard. Or maybe it felt too exposed here, not only to the roadway with its groaning engines and that unending expanse of city to the east, but also to the sky. The trees are tall here and the spaces between them are wide. This stretch of land up here doesn't let you forget for a moment that you're in a city.

And maybe that's why I'm so drawn to this place now. I still haven't gotten over the fact that a space like this can and does exist, right here, even at the cusp of such intense urbanization; that a place like this is still unpaved, still churning life into death and death into life.[18] Trees that fell a hundred years ago are *still falling*. And for thousands of years, this has been a place where people, animals, birds, and insects have been weaving their way between the worlds made by these trees and grasses and wildflowers.

High Park has the feel of other major metropolitan parks, like Central Park in New York City. But there is at least one important difference: Central Park was built on land that Frederick Law Olmsted razed and terraformed to sculpt into aestheticized woodland formations.[19] As much as High Park grounds have been sculpted by roads, stormwater catchment ponds, athletics infrastructure, commercial enterprise, lawn mowers and ornamental gardens, a good proportion of these lands retain their ancient forms. Oak savannahs are old lands.[20]

These days, when I'm leading multisensory tours through the savannah for friends, artists, and other plant lovers, I take them to places where you can sense the deep time of this landscape. There are glimmers of its ancient formation throughout the park, but here's one very special place just north of the gate here,

right on the edge of the park overlooking Parkside Drive. This mound has a magnetic draw that pulls me right up its steep slopes every time. From the top of this mound you can see the undulating topography of the land rolling out to the south, west, and north, and you can look over the city streets and homes that line the park to the east.

Here you can feel the lift and lilt of the tall, arcing, black and red oaks dancing with one another in winds that catch the upper canopy. They are not just played by the wind; you can see the trees playing it, throwing the wind, tossing it back and forth between branches high up in the canopy. The towering white pines and younger red pines dance differently in the winds. Over the course of the summer, waves of tall grasses, low-lying sedges, and brilliantly colored wildflowers bloom across these sloping hillsides: yellow goldenrods, black-eyed Susans, and woodland sunflowers; purple tick-trefoils, harebells, hoary vervain, wild bergamot, and late-blooming asters; the wispy white of wild carrot; the paper white of pearly everlasting; and the flaming orange of butterfly weed. European buckthorn, raspberry, and wild grape thicken the under-brush here and there. Some plants thin themselves out over the slopes and in the gullies; others nestle close together in the swerves and turns of the land, tucking into its troughs and groves.

Figure 5.4 Coming Undone. Photograph by Natasha Myers.

When I kick my boot into the dirt here it becomes clear that this mound is made of very fine sand and silt. The rolling hills that contour this site are sand dunes. When you start looking closer, everywhere you look, there is sand. These lands used to be the bed of an ancient lake. Ten thousand years ago this was all under water. Lake Ontario, Lake Erie, Lake Huron, Lake Superior, Lake Michigan, the St. Lawrence River: the lakes and rivers that we know today used to have different contours. They used to be much bigger. And at times, they were much smaller. This was a landscape of "shifting, drowned, and emerging shores, worked and reworked by water and wind."[21] Lakes rose and fell while lands rebounded, released from the weight of retreating glaciers; some of what is submerged today in Lake Ontario used to be above water.

Water, in its myriad liquid, frozen, and gaseous states, is just one of the elements that has sculpted this landscape. Another significant elemental force shaping these lands over millennia has been fire. Oak savannahs thrive in the sandy dunes of ancient lakebeds. But the widely spaced trees, open canopies, and prairie grasses that make up savannah ecosystems are ephemeral. They are transitional ecologies, always on their way to becoming forest. Oak savannahs need fire to keep the shade-loving forest from encroaching, to stimulate the germination of oak seedlings, nourish the soils, and to keep the seeds of prairie wildflowers and grasses awake and active in the seedbed. The rhythms of composition and decomposition in these landscapes are bound to the combustive and disruptive rhythms of fire.[22]

But fire is not just a natural force; fire is integral to culture and practice. People around the world use fire to sculpt their lands.[23] Where plaques and monuments throughout the park celebrate colonial histories, it becomes clear that the stories that don't get told about High Park are precisely the stories of the deep cultural history of this land. According to the archeologists, there were people living in this region before the ice arrived, as early as fourteen thousand years ago. The stories told by the descendants of these peoples attest that they have been here since the beginning of creation.[24] One of the many devastating legacies of settler colonialism in this region was the suppression of fire. It wasn't just that settlers suppressed the natural rhythm of fires set by lightning strikes, they also suppressed the fires set by Indigenous peoples who had long used fires to care for this landscape. Colonizers worked hard to suppress the very knowledge of these practices.

The oak savannahs in High Park have endured for millennia only because they were cared for by Indigenous people who deliberately and consistently used fire to keep them open and thriving. Fire allowed the many who lived in this

region to cultivate acorns, walnuts, butternuts, chestnuts, beechnuts, hickory nuts, and hazel nuts.[25] These nourishing trees and the open canopies of the savannah lands attracted white-tailed deer, turkey, raccoon, squirrels, and passenger pigeons, and bears, making these spaces good sites for hunting. The fires also opened up spaces for people to build homes and villages, and to grow corn, beans, and squash, sunflowers for oil, and tobacco for ceremony.[26]

The Wendat, Haudenosaunee and Anishnaabe Nations lived here. Many other Indigenous peoples moved through this region, which was an active center of trade. High Park is close to the Humber River, whose winding route forged a path for the Toronto Carrying Place Trail, a major traveling and trade route that tracked along the Humber River Valley watershed between Lake Ontario and what is now known as Lake Simcoe to the north.[27]

The removal of Indigenous peoples from their lands and the attempted destruction of their cultures through residential school systems and forced assimilation has had, and continues to have, devastating effects on individuals and communities across Canada.[28] High Park's oak savannah provokes another line of inquiry into this history: What does a land lose when it is dispossessed of its people? Decolonizing ecology demands grappling with the inextricability of Land/body relations, in such a way that dispossession can also be seen as a violence done to the land. Restoration ecology would take on a different meaning in a decolonial context, where "restoration" would invoke the return of stolen lands to Indigenous peoples.

You can't take people out of an oak savannah: it will cease to be an oak savannah. The canopy will thicken, blocking out the sunlight that the prairie grasses and wildflowers have come to thrive on. Maples will move in. The pines will encroach, changing the soils with their pungent chemistries.[29] The widely spaced oaks with their far-reaching limbs will be starved for light. Nourishing acorns and nut trees will become scarce. Hunting will be harder. In the deadly wake of first contact with Europeans there were regions where "hardly an acre" was "broken for corn or cleared for farming for a century and a half."[30] Many of the ancient savannahs that lost their people filled in so thickly that when European settlers returned in the late 1700s they encountered woods that looked like their fantasies of primeval forest: they appeared to be untouched by human inhabitation. It is this de-peopled landscape that has become the conservation ideal for forest restoration.

By the early 1800s the lands that now make up High Park were fully colonized. Farmers put sheep out on the grassy meadows, which appeared to be so perfectly prepared for them. The sheep seemed at first to do just as a good job as the fire

for keeping the canopy open. But then again, they ate everything, including the young oak seedlings. The old oaks kept growing, but no new oaks grew alongside them. This was not a problem for the farmers. But it dramatically altered the land. Over time, grazing sheep transformed the composition of grasses. This suppressed the wildflowers who cleverly secreted their seeds deep in the seedbed, waiting and waiting for the fires to come. There are seeds still in the soil that remember a different world. The 250-year-old trees that are still thriving and dying here today remember remember the fires. Do they remember their people?

Doing Ecology Otherwise: Protocols for an Ungrid-able Ecology

Toronto's Urban Forestry team has put up signs throughout the park to mark Monitoring Plots where they have done ecological restoration work. These are sites park workers return to every few years to take photographs and record changes, storing the images in an archive at city hall. I take these designated plots as a provocation. What is it to monitor an environment? What would it take to really pay attention to what is happening here? And what modes of attention might be required for a decolonized account of this land?

For the past two years I've been visiting the park almost daily and working alongside Ayelen Liberona, a dancer, filmmaker, and long-time friend, as we cultivate modes of attention that might help us tune in to the deep time of these lands and the *naturalcultural* happenings shaping its present. We've been experimenting with techniques drawn from the arts, anthropology, and ecology. In addition to working with images, sounds, and movement, Ayelen and I have been leading multisensory tours through this stretch of savannah each season. Since our first Spring Walk in April 2016, we have brought over 50 people to the land, in small, intimate groups. We take them on silent walks, lead them through guided visualizations and meditations, and offer them a range of sensory techniques for deep listening and close observation. Our aim is to give them the space and time to tune into the compositions and decompositions of these remarkable lands. Our participants to date have mostly been artists, educators, and practitioners in a range of healing arts. Their accounts—taking shape in stories, songs, drawings, poems, and dances—are forming an archive for an "ungrid-able ecology" of this oak savannah. *Interested* and *involved*, we are collectively learning to expand and extend our all-too-human sensoria so that we might find ways to pay attention to what matters here.[31]

Kinesthetic Attunements

We take seriously the idea that these monitoring plots are sites where we need to pay very close attention. What, we ask, would we have to do to really tune in? *Becoming sensor* in this already sentient world, we are experimenting with modes of attention to learn how to pay attention to this land that has been paying very close attention to all the transformations taking shape around it for so many years.[32] Plants and trees are themselves remarkable sensors. How can our sensing practices do justice to documenting the beings and doings of an oak tree, let alone the vast numbers of trees taking root together across this wide swath of ancient land? Becoming sensor in the savannah demands subtle attunements of our always already *synesthetic* sensoria. As long-time dancers our attunements to these lands are always already kinesthetically attuned and profoundly attentive to rhythm, temporality, momentum, and more-than-human movements of all kinds. Two years in, our first attunements are just beginning to sensitize us to what this land is *mattering*, and what *matters* to this land. I see our work as an effort to invent protocols for an "ungrid-able ecology" up to the task of documenting the beings and doings of these bodies and lands.

It is important to note that these protocols are not intended to re-colonize these lands with yet more settler colonial stories. Rather, these techniques offer an example of some ways to break the consensus of a colonial ecology that is indebted to mechanistic, neo-Darwinian logics. These protocols demonstrate how one might begin to refuse the colonial norms and logics of conventional ecology and open up to sensing other sentiences. These protocols explicitly push up against the forces of a scientific rationalism that disavows nonhuman sentience and commodifies nature as resource. In so doing, they aim to expand the discursive field in which stories about bodies and lands can be told. Consider these attunements as one way that settlers can ally themselves with the remarkable work of Indigenous activists and scholars in the name of decolonization.[33]

You too can *do ecology otherwise*. Try your hand at inventing techniques that disrupt the colonial ecological sensorium. Remember though, that an "ungrid-able ecology" is not bound to the moral economies of mechanism or energetic efficiency. And as you experiment with techniques, modes of attention, and inquiry, and get interested and involved in the *naturalcultural* happenings around you, be sure to remember to resist the compulsion for legibility, quantification, and grid-like mappings.

Kinesthetic Imaging

Technique: Hack into your camera to slow down the shutter speed so you can record the energetics of your encounters with the moving bodies of the creatures you are drawing into view. This will allow you to tune in the affectively charged relations taking shape among lands and bodies.

Figure 5.5 Dances with Light. Photographs by Ayelen Liberona, with Natasha Myers.

Considerations: If traditional nature photography captures living bodies and turns them into objects of aesthetic and scientific interest, these kinesthetic images gesture to a different kind of account of the living world. These images

are attunements. They are generated in the act of *moving with and being moved by* the beings and doings around you. As relational images they document the push and pull between bodies. Rather than a means to capture events or objects, these images make it clear that it is the photographer who is caught: captivated, they are the ones who hitch a ride on what is *becoming* and *coming undone*. The rotting logs, frilled mushrooms, crumbling leaves, ancient sands, and greening grasses are not discrete things, they are *happenings* taking shape through deep time and in the ephemeral moments of now, and now, and now. It is the photographer who must learn how to keep pace with these rhythms through their body.

Kinesthetic Listening

Technique: Bring a digital audio recorder with a directional microphone with you into the savannah. Rather than standing still, stay in movement while you are recording. Lean into the sounds to amplify their intensities, speeds, slownesses, and their affective charge. Turn and twist your body to feel through the multiple sources of sounds. This dancing with sound is a mode of *kinesthetic listening*. Back at home, use sound editing software to speed up and slow down the sounds. What do you hear?

Considerations: Sound palpates space and pulls at time. It is a remarkable tool for documenting ecological relations. Documenting the land's sonic ecology helps to tune in to its vibratory milieu, and conjure a sense of deep time, its seasonal cycles, its daily rhythms, its improvised encounters, fleeting moments, and disruptive events.

Note from April 2016: The sounds of cars and trucks and planes are never fully muted here in the oak savannah. They just propagate differently. Muffled and modulated by trees and shrubs, birds and squirrels and insects, ravines and slopes, city sounds resonate in a distinct vibratory milieu. *Sounding out the savannah* reveals that there are no boundaries between the rhythms of city life and the lives of the creatures who take root and take flight here. Speeding up and slowing down the recordings reveals otherwise unimaginable worlds and opens up new ways of telling stories. Stomping feet become falling trees, shaking the earth in ways that recall the geological forces that formed this land. Slowing down bird calls reveals other songs, other creatures and voices haunting the space. Gulls become coyotes.

Figure 5.6 Vibratory Milieu. Photographs by Ayelen Liberona, with Natasha Myers.

Traffic becomes rushing, rhythmic waves. Life churns to other rhythms. There is no silence here. To listen in on our kinesthetic experiments with sound the Becoming Sensor website (http://becomingsensor.com)

Kinesthetic Smelling

Premise: If you want to become a nose capable of sniffing out plants' alchemical utterances in an affective ecology of volatile chemistries you must begin from the assumption that plants are creative and expressive synthetic chemists, mattering and modulating the chemical composition of the atmosphere. Plants are alchemists who craft volatile concoctions to excite other plants, as well as animals and insects and people. The aim of developing a kinesthetic sniffing practice is to

tune in to the significances and sentiments that plants articulate through their volatile chemistries.[34] Mapping these smells is a way to map *involutions* among plants, among plants and insects, and among plants and people.

Technique: To do this work consider becoming a *transducer* of the alchemical utterances shaping this affective ecology. Let these scents excite your tissues in order to document your situated knowledge of this alchemical ecology. Learn to transduce chemical excitations through your tissues and record these as energy diagrams.

Step 1: Sniffing out the Savannah

1. Select individual flowers or clumps of flowers.
2. Lean right in to the flower, to take in its full bouquet. Pull away. Lean back in for a second sniff, and then a third. Let the range of smells move through your tissues. Feel how the scent has form, speed, height, depth, and weight.
3. Transduce each sniff as an energy diagram, letting the pencil in your hand loosely track the energies of this encounter.
4. Note plant species, the time of day, the date and time of the last rain, the location, and describe the composition of neighboring plants.
5. Repeat at different times of day and in different points in the season.

Step 2: Develop an ambulatory mapping of this smellscape over time.

Considerations

a. Pay attention to atmospherics and temporalities: it seems as though evenings are a time when the scents linger, when they are no longer getting burned off by the sun or evaporated in the heat. When the sun's rays lengthen and the scented air cools, the smells seem to drop down and gather in the troughs of the savannah's undulating landscape. Note where the smells mingle, and where the contours of the land shape the ways the smells gather.
b. Be careful: the flowers are potent. Do not work with more than one species at a time. (Note from August 1, 2015: I got totally high after working with sweet clover, wild bergamot, Queen Anne's lace, and goldenrod in one session.)

Figure 5.7 Energy Diagram of Queen Anne's Lace. Drawing by Natasha Myers.

Coda

I return again and again to this oak savannah in High Park because I sense that it can teach me important lessons about the shape of people's relations with plants in a time of unprecedented ecological transformation. It is also a place where it might be possible to reimagine forms of *land care* that do not hinge on the removal of people; where saving a lands' *nature* does not hinge on the displacement of its *cultures*. It is a place where I am learning it is possible to practice a decolonial queer, feminist ecology that is not bound to economizing, militarized, heteronormative, and colonial logics. It is a place where ecological restoration might yet be disarticulated from incentivized management schemes that aim to maximize a land's ecosystems services. I have hopes that this is a place where moralizing discourses about invasive and native species might start to loose their traction; a place where the reproductive imperatives and productivist tropes of neo-Darwinian survival stories might become less salient.

However, the oak savannah is *becoming other*. The oaks have been coming down, and fast. Seven enormous oaks have fallen since I started coming here daily last year. The next generation, which have grown up in thickets on sites that

have been burned according to urban forestry protocol, are just over fifteen years old. In spite of all the well-meaning efforts of the city's Urban Forestry team, and the volunteer stewards, there is no saving the oak savannah. Intensive, ongoing efforts to restore the oak savannah through burns, chemical treatments, plantings, weeding, and seed collection, remind me again that you cannot take people out of a savannah. New *naturecultures* are actively in-the-making. So it is necessary to keep posing the questions: What matters to this land? Whose cultures, whose natures, and whose stories will get to flourish into the future?

Acknowledgements

In addition to the remarkable feedback from our workshop participants, I want to thank Max Liboiron, Jon Johnson and Charis Boke for their close readings of earlier versions of this paper

Notes

1 See for example Kingsland (2008).
2 See Hustak and Myers (2012).
3 See Hustak and Myers (2012).
4 On not knowing, see also de la Cadena (2015).
5 See Myers (2014, 2015a, 2015b).
6 See Myers (2015b)
7 See Hustak and Myers (2012).
8 Ibid.
9 See Stacey and Suchman (2012) and Myers (2015b).
10 See for example Myers (2001, 2005, 2014, 2015a).
11 See Myers (2014). See also Myers (2015b) for an account of the expansive kinesthetic imaginations alive in the practice of science.
12 Ibid.
13 On *photosynthetic mattering*, see Myers (2016).
14 See Varga (1989).
15 Thinking with Eve Tuck and K. Wayne Yang (2012), and exploring ways to work as a white-settler ally to Indigenous resurgence projects, I am not employing decolonization as a metaphor: decolonizing ecology in my view does require repatriation of lands to Indigenous peoples. See also Makoons Geniusz (2009) for an

Indigenous scholar's approach to decolonizing botanical knowledge. See Mastnak et al. (2014) for ways of decolonizing understandings of "native" and "invasive" species.
16 On resurgence, see Simpson (2011) and Simpson (2013).
17 On "centers of indetermination," see Deleuze (1986) and Myers (2015a).
18 See Myers (n.d.).
19 See Gandy (2003) and Smithson (1996).
20 See Riley (2013) and Remiz (2012).
21 Riley (2013): 6.
22 On disruptive ecologies, see Tsing (2015). On soils and decomposition, see Puig de la Bellacasa (2015).
23 On fire in disturbed landscapes, see for example Dey and Guyette (2000), Pyne (2011), Verran (2002), and Sandilands (2014, 2016).
24 See L. Simpson (2011).
25 Riley (2013): 14. See also Kimmerer (2015).
26 Riley (2013): 14–17.
27 See Johnson (2015).
28 See for example Simpson (2008), Simpson and Ladner (2010), Simpson (2011, 2014), Maracle (2015), and Coultard (2014).
29 See Tsing (2015) on pine forests.
30 Riley (2013): xvii.
31 See Liberona and Myers (2016), "Becoming Sensor in a Black Oak Savannah: Cultivating the Arts of Attention in a 10,000 year-old Happening." Available online: http://becomingsensor.com; on "interest" see Latour (2004); on "involvement" see Hustak and Myers (2012).
32 Note that I am deliberately blurring the distinctions here between human and nonhuman modes of attention. There are crucial differences and incommensurabilities among human and nonhuman sensoria, to be sure. But perhaps there are also sites of possible resonances that we have not yet fully grasped.
33 See for example Todd (2016), L. Simpson (2008, 2011, 2014), A. Simpson (2007), Tallbear (2013), Liboiron (2016).
34 Hustak and Myers (2012).

References

Coultard, G. (2014), *Red Skin, White Masks: Rejecting the Colonial Politics of Recognition*, Minneapolis: University of Minnesota Press.

De la Cadena, M. (2015), *Earth beings: Ecologies of practice across Andean worlds*, Durham: Duke University Press.

Deleuze, G. (1986), *Cinema 1: The Movement Image*, Minneapolis: University of Minnesota Press.

Deleuze, G. and Guattari, F. (1980), *A Thousand Plateaus: Capitalism and Schizophrenia*, Minneapolis: University of Minnesota Press.

Dey, D. C. and Guyette, R. P. (2000), "Anthropogenic fire history and red oak forests in south-central Ontario," *The Forestry Chronicle*, 76 (2):339–347.

Gandy, M. (2003), *Concrete and clay: reworking nature in New York City*, Cambridge, MA: MIT Press.

Geniusz, W. D. (2009), *Our knowledge is not primitive: Decolonizing botanical Anishinaabe teachings*, Syracuse, NY: Syracuse University Press.

Hustak, C. and Myers, N. (2012), "Involutionary Momentum: Affective Ecologies and the Sciences of Plant/Insect Encounters," *differences*, 23 (3):74–118.

Johnson, J. (2015), *Pathways to the Eighth Fire: Indigenous Knowledge and Storytelling in Toronto*, Doctoral Dissertation, Graduate Program in Communication and Culture, York University, Toronto, Ontario.

Kimmerer, R. W. (2015), *Braiding Sweetgrass: Indigenous Wisdom, Scientific Knowledge and the Teachings of Plants*, Minneapolis: Milkweed Editions.

Kingsland, S. E. (2008), *The Evolution of American Ecology, 1890–2000*, Baltimore: John Hopkins University Press.

Kohn, E. (2013), *How Forests Think Toward an Anthropology Beyond the Human*, Berkeley: University of California Press.

Latour, B. (2004), "How to Talk about the Body? The Normative Dimensions of Science Studies," *Body and Society*, 10 (2–3):205–29.

Liberona, Ayelen and Natasha Myers (2016), "Becoming Sensor in an Oak Savannah: Cultivating the Arts of Attention in a 10,000 Year-Old Happening." Available online: https://becomingsensor.com/

Liboiron, M. (2016), "Care and Solidarity Are Conditions for Interventionist Research," *Engaging Science, Technology, and Society*, 2:67–72.

Maracle, L. (2015), *Memory Serves and Other Essays by Lee Maracle*, Edmonton: NeWest Press.

Mastnak, T., Elyachar, J. and Boellstorff, T. (2014), "Botanical decolonization: rethinking native plants," *Environment and Planning D*, 32 (2):363–380.

Merleau-Ponty, M. (1968), *The Visible and the Invisible*, Evanston, Ill.: Northwestern University Press.

Myers, N. (2001), *Bodyfullness in Biology: Feminist Environmentalism Meets Merleau-Ponty's Philosophy*, Major Research Paper, Masters in Environmental Studies, York University, Toronto, Ontario.

Myers, N. (2005), "Visions for Embodiment in Technoscience." In *Teaching as Activism: Equity Meets Environmentalism*, edited by P. Tripp and L. Muzzin, Montreal: McGill-Queen's University Press. 255–67.

Myers, N. (2014), "Sensing Botanical Sensoria: A Kriya for Cultivating Your Inner Plant," *Centre for Imaginative Ethnography*, Imaginings Series: Affect. Available online: http://imaginativeethnography.org/imaginings/affect/sensing-botanical-sensoria/

Myers, N. (2015a), "Conversations on Plant Sensing: Notes from the Field," *NatureCulture*, 3:35–66.

Myers, N. (2015b), *Rendering Life Molecular: Models, Modelers, and Excitable Matter*, Durham: Duke University Press.

Myers, N. (2016), "Photosynthesis." In "Lexicon for an Anthropocene Yet Unseen," eds. Cymene Howe and Anand Pandian, Theorizing the Contemporary, *Cultural Anthropology* Website, January 21, 2016. Available online: http://culanth.org/fieldsights/790-photosynthesis

Myers, N. (n.d.), "Life is death is life is death is . . ." in *What is Life: An Exquisite Cadaver*, edited by Helmreich, Myers, Rossi, and Roosth. Unpublished manuscript.

Puig de la Bellacasa, M. (2015), "Making time for soil: Technoscientific futurity and the pace of care," *Social Studies of Science*, 45 (5):691–716.

Pyne, S. J. (2011), *Fire: A Brief History*, University of Washington Press.

Remiz, F. (2012), "Toronto's Geology: Including History, Biota, and High Park," High Park Nature. Available online: http://highparknature.org/wiki/wiki.php?n=History.Geology

Riley, J. L. (2013), *The Once and Future Great Lakes Country: An Ecological History*, Montreal: McGill-Queen's Press.

Sandilands, C. (2014), "Queer Life? Ecocriticism after the Fire." In *The Oxford Handbook of Ecocriticism*, (1st ed.) edited by G. Garrard, Oxford University Press. 305–19.

Sandilands, C. (2016), "Combustion," *The Goose*, 15 (1):1–9.

Simpson, A. (2007), "On ethnographic refusal: Indigeneity, 'voice' and colonial citizenship," *Junctures: The Journal for Thematic Dialogue*, (9).

Simpson, L. (ed.) (2008), *Lighting the Eighth Fire: The Liberation, Resurgence, and Protection of Indigenous Nations*, Winnipeg: Arbeiter Ring Publishing.

Simpson, L. (2011), *Dancing on Our Turtle's Back: Stories of Nishnaabeg Re-Creation, Resurgence, and a New Emergence*, Winnipeg: Arbeiter Ring Pub.

Simpson, L. (2013), *Islands of Decolonial Love: Stories & Songs*, Winnipeg: Arbeiter Ring Publishing.

Simpson, L. (2014), "Land as Pedagogy: Nishnaabeg intelligence and Rebellious Transformations," *Decolonization: Indigeneity, Education & Society*, 3: 1–25.

Simpson, L. and Ladner, K. (Eds.) (2010), *This is an Honour Song: Twenty Years Since the Blockades*, Winnipeg: Arbeiter Ring Publishing.

Smithson, R. (1996), "Frederick Law Olmsted and the Dialectical Landscape (1973)," in *Robert Smithson, the Collected Writings*, edited by J. D. Flam, University of California Press: pp.157–71.

Stacey, J. and Suchman, L. (2012), "Animation and Automation: The Liveliness and Labours of Bodies and Machines," *Body & Society*, 18 (1):1–46.

TallBear, K. (2013), *Native American DNA: tribal belonging and the false promise of genetic science*, University of Minnesota Press.

Todd, Z. (2016), "An Indigenous feminist's take on the ontological turn: 'Ontology' is just another word for colonialism," *Journal of Historical Sociology*, 29 (1):4–22.

Tsing, A. L. (2015), *The Mushroom at the End of the World: On the Possibility of Life in Capitalist Ruins*, Princeton: Princeton University Press.

Tuck, E. and Yang, K. W. (2012), "Decolonization is not a metaphor," *Decolonization: Indigeneity, Education & Society*, 1 (1):1–40.

Varga, S. (1989), *A Botanical Inventory and Evaluation of the High Park Oak Woodlands: Area of Natural and Scientific Interest*, Ontario Ministry of Natural Resources Parks and Recreational Areas Section, Central Region, Richmond Hill.

Verran, H. (2002), "A Postcolonial Moment in Science Studies: Alternative Firing Regimes of Environmental Scientists and Aboriginal Landowners," *Social Studies of Science*, 32 (5/6):729–762.

Art, Design, and Ethical Forms of Ethnographic Intervention

Keith M. Murphy

1. Introduction

In this chapter I want to reimagine the task of ethnography as a process of aesthetic production. More specifically, I want to explore the possibilities for reinventing the figure of the ethnographer by means of two others—the artist and the designer—and consider how doing so might transform how the ethics of ethnographic intervention are traditionally conceived in anthropology. When I say intervention, I'm talking about a very small scale of interaction: little pushes that go against an anxiously dormant impulse for "objectivity" in the everyday intimacies of fieldwork, when ethnographers move together co-presently with their interlocutors. The main concern I want to address is the vexing notion that ethnographic interventions—at least those that seem most to interfere with the "reality" of what we're observing—can, or maybe always do, cause harm, both to the people we study and the integrity of our work.

I'm choosing these two domains—art, specifically the kind that falls under the "relational aesthetics" rubric (Bourriaud, 2002), and design—because some of their practices are adjacent to ethnography, yet their respective inclinations toward intervention are different from, and useful for considering, the work that ethnographers do. Of course I'm not the first to find common ground between these fields. In recent years both anthropologists and artists have been trekking the muddy terrain between ethnography and art in ways that all but cover over older incarnations of "the anthropology of art" (e.g. Desai, 2002; Foster, 1996; Sansi, 2015; Schneider and Wright, 2010; see also contributions to this volume). Meanwhile design, in some of its most basic practices and pedagogies, has been

taken up by anthropologists as both a source for productive partnerships (Clarke, 2010; Gunn and Donovan, 2012) and a resource for augmenting the conventions of ethnographic fieldwork (Murphy and Marcus, 2013; Rabinow et al., 2008). When ethnography is aligned with aesthetic fields in these ways, it's often easy to identify a range of overlapping qualities between them, for instance methods, practices, and subject matter (Sansi 2015).

2. Ethics

I'm not particularly concerned here with the philosophical foundations of research ethics[1] so much as in querying how anthropologists conceive of fieldwork itself, and the ethics implied in the methodological armature of that conception. I think this issue of ethics manifests at two different scales.

When viewed from the widest angle, anthropology is ethics-obsessed. One ascendant species of contemporary anthropological research is what Sherry Ortner (2016) calls "dark anthropology." Influenced by Marx, Foucault, and other theorists who foreground a critique of power, anthropologists have worked since at least the 1980s to reformulate the broad ethical norms of the discipline in ways that find explicit solidarity with what Joel Robbins (2013) calls "the suffering subject." No longer content to downplay or ignore the effects of colonialism, imperialism, and inequality, this politically-charged realignment of a "militant" anthropology (Scheper-Hughes, 1995; see also Kulick, 2006) expects that through their work ethnographers should centrally address, or even strive to counteract, injurious conditions that their interlocutors experience.

From a slightly tighter angle, ethics also sit at the center of ethnographic methods—the specific ways in which we interact with other humans to carry out our research—especially in relation to a more expansive framework for studying humans that's dominated by the contingencies of biomedical science. At a basic level, the intricacies of all anthropological work implicate complex ethical issues at different scales and in different modes (Castaneda, 2006), and, as I'll explore below, the discipline has invested tremendous effort in developing and refining ethics codes that specifically match the realities of ethnographic research. But within the regulatory system that has historically exercised significant power in shaping these codes, there is no real conception of how ethnography works in practice (Cassell, 1980). Many anthropologists have thus argued against current

models of anthropological research ethics, either because they derive from circumstances largely irrelevant to ethnographic inquiry (Murphy and Dingwall, 2007; Wax, 1977), or they don't adequately cover certain kinds of fieldwork, like dangerous or illegal situations (Hodge, 2013). Even some of the most stalwart components of these models, like informed consent, have been called into question (Bell, 2014; Shannon, 2007; Wax, 1995; cf. Fluehr-Lobban 1994), not due to a backlash against ethical research, of course, but to a sense that legally required protocols often create and amplify ethical dilemmas in the actual practice of ethnographic fieldwork.

As a way to escape this thorny ethics predicament, Rena Lederman (2007:317) has called for an "improved mapping" of the terrain that typically covers how human research itself is understood, a redrawn cartography that from the start eschews the biomedical perspective and looks elsewhere for motivation. One starting point, then, could be replacing the ethnographer's longstanding analog in the context of research ethics—the biomedical researcher, or even the doctor (Murphy and Dingwall, 2007)—with someone new.

3. Form

Before I continue, I want to make a stipulation about ethnography, and that stipulation is that ethnography is, at its core, a method for understanding social formations and forms of life—or perhaps more accurately, forms of living. The word "form" here is not meant in its vaguest sense, as a proxy for "stuff that more or less goes together," but in its more technical sense of discernible configurations and arrangements of elements that, even if not obvious, are still recoverable with some effort. When Wittgenstein (2009) introduced the notion of "forms of life" into his philosophy, the form part was not merely an abstraction, but a way to meaningfully account for patterns that organize relations between people, how they're distributed and organized in space, and how people make sense of and follow the rules binding them to specific activities and to each other. In other words, human life is lived as a continuous enactment of interrelated and repeated socially conditioned forms—of action, of thought, of speech, of power, and so on. One central task of ethnography is to identify, plumb, and illuminate those forms and how they operate in, and give meaning to, specific cultural contexts. Following George Marcus (2010:266), then, I am delineating ethnographic fieldwork as "a matter of aesthetics rather than methods as traditionally

conceived," as a provocation aimed at fostering "a different modality of purpose and result for ethnography" (Marcus, 2010:274).

4. Relational Aesthetics

Relational aesthetics is a term coined by French curator Nicolas Bourriaud (2002) to gloss what he saw as a new kind of art emergent in the 1990s, one positioned against a traditional artworld focus on relatively coherent objects created by artists for a viewing audience.[2] Dubbed "dialogic art" by Grant Kester (2013), this style eschews the typical materials and methods of artistic creation—painting, sculpture, collage, photography, and so on—in favor of fostering specific human interactions and "forms of conviviality" (Bourriaud, 2002:16) as the very stuff of the artwork itself. Such works are not conventionally material, though materials are often involved, but rather they are enacted cooperatively and experienced through multiple senses. They are often highly localized and impermanent, involving only a small number of participants—or interlocutors, or interactants, or collaborators, all terms that more accurately describe what would otherwise be considered an artwork's audience or viewers. For example, Egyptian artist Amal Kenawy's 2010 piece *Silence of the Lambs* involved fifteen mostly non-professional performers crawling across a busy Cairo intersection on their hands and knees (this at the start of the Arab Spring), inciting a range of emotional responses from both passersby and state authorities. And in 2003 Katerina Šedá's *There Is Nothing There* coordinated the routines of a small Czech village called Ponetovice on a single day, encouraging all residents to shop at the same time, perform household chores at the same time, and go to bed at the same time, among other mundane activities (see Thompson, 2012, for more on these and other works).

I want to highlight two features of relational aesthetics that sit at the center of projects like these. First, in this framework the notion of artistic form is radically re-imagined. Orthodox formalism based in physical objects and their constitutive elements is replaced by a more ecumenical model that includes "all shapes and configurations, all ordering principles, all patterns of repetition and difference" (Levine, 2015:3). Crucially, this means socially ordered forms of human action and interaction, patterns of bodily motion, and arrangements of people in space are all rendered eligible for artistic manipulation, or, as Bourriaud (2002:28) phrases it, "all manner of encounter and relational invention thus represent, today, aesthetic

objects likely to be looked at as such." This is not, strictly speaking, an anti-formalist refutation, but rather a provocation challenging how a work of art is even constituted and presented, shifting the evaluative emphasis away from visible forms toward the "character" (Kester, 2013:10) of the interpersonal interaction produced.

Second, work that draws on relational aesthetics is almost uniformly political in both tone and topic. This is obviously so in projects explicitly concerned with recognized social issues like, for instance, refugees, prostitution, state violence, or climate change. But even in terms of their basic mechanics, many of these projects attempt to instantiate what Bourriaud (2002:31) calls "everyday micro-utopias" in which "the artist is able to catalyze emancipatory insights *through* dialogue" (Kester, 2013:69, original emphasis). Assembling people to talk, work, and simply be together in formations that likely would not spontaneously occur—that is, orchestrating encounters and interventions in people's everyday lives—is figured as in itself an artistic undertaking. The results of such arrangements may not be predetermined or even predictable, but that rarely matters. Instead, by prioritizing the "criterion of co-existence" (Bourriaud, 2002:82) in relational aesthetics the artist is continuing the work of all great art by critically revealing an otherwise unexamined and misrecognized social reality through aesthetic experience.

Relational aesthetics has certainly received a fair amount opprobrium from an art critical perspective, in particular with regard to these two features, form and politics. Claire Bishop (2004, 2012), for instance, argues that by disregarding longstanding criteria for formal evaluation there is no way to determine whether a relational work of art is good or bad, and no way to compare the relative quality of different pieces. Another even more basic critique voiced by Bishop (2012) and others (e.g. Downey, 2007) is that because such projects often look and feel indistinguishable from, say, social justice activism, community gatherings, focus groups, teach-ins, and so on, then the only thing that really "makes" them works of art is the say-so of the artists who principally create them, and that, perhaps, is too thin a reed to rely on.

Relational aesthetics and its critical context provide a useful lens through which to analyze the ethical and political implications of ethnographic encounter because a number of significant (if not precise) resonances rebound between the two domains. Both relational aesthetics and ethnography treat humans and their meaningful interactions as fundamentally constitutive of social form. Both the artist and the ethnographer play pivotal roles in observing and pushing on those social forms in direct pursuit of their professional work. And in both cases meaningful interventions are explicitly introduced in ways that disrupt or alter

what would otherwise be happening had the artist or ethnographer not amplified attention to this segment of the social world.

5. Ethnography

Really: making explicit pushes to shape encounters is a central component of many basic ethnographic techniques. Interviews assign roles of question-askers and question-answerers, typically requiring our interlocutors to contemplate aspects of their lives that usually remain unarticulated. Participant observation installs a newcomer with an ambiguous or ill-defined identity into already-running situations, where, for instance, following along on our interlocutors' daily routines adds an additional body in need of management. We ask people to fill out different kinds of paperwork, like taking surveys or drawing maps, and we introduce surveillance devices—recorders of various kinds, including notebooks—into the rhythms of the everyday lives they live. Each of these moves is, of course, small, almost insignificant in terms of reshaping the overall worlds we study, but that doesn't mean these encounters aren't shaped and formed by the ethnographer's interests. This is not dialogic art, but dialogic—relational—research, entirely predicated on a series of continuous tiny interventions.

Except in comparatively rare instances, nobody asks for an anthropologist to show up to observe what's going on, which means an ethnographer's very presence is almost always an intervention in an otherwise ongoing lifeworld. And that's OK, because from a certain point of view, all interactions between humans are interventionist. Humans are, by their very nature, intervening in each other's lives, constantly pushing and pulling each other, making demands and requests, feeling obligations and fulfilling (or breaking) promises, reproducing and reshaping the social forms that constitute life as it's lived. None of this is neutral, of course. In fact, all of it is always charged in one way or another, and in some respects the presence of an ethnographer is, as with many relational aesthetics projects, more a *version* of a kind of experience than something radically different in its basic constitution.

Which leads to a question: what would happen if we admit, rather than ignore, that our presence is inherently interventionist—and then play with that form to make the intervention more productive; for our interlocutors, for our research, and for knowledge-building more generally? Following the move made in relational aesthetics, fieldwork moments like conducting an interview or

accompanying our interlocutors as they work might be figured as "microutopias" with demure goals, convivial arrangements produced not for art, but for research, in which the "good" of the action stems simply from the capacity of this new social form to illuminate the world from which it emerges.

Of course, such a position raises at least two obvious, and familiar, objections. First, won't that change what we're observing and distort the conclusions we can draw? The answer to that is almost certainly yes; but probably not any more than our simply being there already distorts our field sites. The difference is that our current ideology of "reflexivity," a necessary aspect of what we do, is too blunt and agonistic—and non-methodological—to allow a sufficiently complex analysis of the actual impact ethnographers have on the things they study. The simple act of mindfully re-casting ethnographic encounters as productive convivial arrangements converts the unavoidable presence of the ethnographer from a source of anxiety into a manageable methodological advantage.

The second objection—can't these orchestrated social forms cause harm to our interlocutors?—is one that has, in one form or another, stalked anthropology since the discipline's earliest days, and has received much more specific administrative attention.

6. Codes

The American Anthropological Association (AAA) adopted its first code of ethics, "The Principles of Professional Responsibility," in 1971, and since that time ethics has become big bureaucratic business for the organization. There is a standing Committee on Ethics that reports directly to the Executive Board, several smaller ancillary committees on ethics, and resources for members seeking to include material on ethics in their anthropology courses. The original ethics code has been officially revised a number of times since 1971, and after decades of being written in formal, quasi-legalistic language the most recent version assumes a more readable and inviting tone.

There were two central factors that resulted in drafting the original AAA ethics code (see Jorgensen, 1971). The first was Project Camelot, a 1964 program planned and funded (but never enacted) by the US Army, designed to use social scientific research to study and manipulate counterinsurgency efforts in Latin America. The second was the Vietnam War. In both cases anthropologists and their data were called upon by the American political-military apparatus to

participate in ways that could—and most likely would—directly harm their informants. One immediate goal in creating the ethics code, then, was to bring forth a real and tangible "thing," a clear list of non-negotiable tenets that anthropologists could use as a sort of prophylaxis against governmental requests for collusion. With such a code in hand, to refuse to collaborate with power would not be viewed as a personal choice, but instead as a professional responsibility.

This was a major step in formally establishing a doctrine of professional independence based on ethical concerns toward anthropological subjects. Since the discipline's inception anthropology has, of course, worked in the shadow, if not always the service, of some powerful institutional benefactors, including churches, colonial governments, private corporations, and yes, militaries. For many decades this arrangement was not only viewed as unproblematic, but in some instances as precisely the morally correct way to do things: in as much as these institutions in the early days represented the best that "civilization" had to offer, anthropologists were the brokers who would help bring this civilization to the "natives" (see Pels, 1999, and citations therein, for more on this). Of course not all, or even most anthropologists working in the first half of the twentieth century saw themselves in this light, but neither did they spend much time worrying about the implications of their presence in the field. However in the wake of decolonization, two global wars and countless other local ones, alongside the growing institutionalization of anthropology as a discipline, the nature of the relationships between anthropologists and the state, and anthropologists and their informants, began to shift quite rapidly in the 1960s. By the end of the decade the crisis in ethics was unavoidable, and confronting it seemed a necessity.

What resulted from this, in that original 1971 code, was a list of six "responsibilities," including (in order) those to the public, the discipline, students, sponsors, and governments (both home and host). The first and "paramount" responsibility, above those five, was to anthropologists' informants themselves, a responsibility that urged researchers to "do everything in their power to protect the physical, social, and psychological welfare and to honor the dignity and privacy of those studied." This was one of the first official public admissions that anthropological research, because of its sensitive and intimate nature, holds a high potential for harm in the lives of the very people who sit at the center of the field.[3]

The 2012 code[4] is more explicitly hortative than previous versions (see Barnes, 1999), instructing anthropologists in plain language how to behave in ethical

ways. Rather than presented as a list of quasi-legalistic responsibilities, this code is formatted as seven "rules of thumb," and the explicit specter of harm, for so long avoided or obfuscated, is placed front and center in the very first item:

1. Do No Harm
2. Be Open and Honest Regarding Your Work
3. Obtain Informed Consent and Necessary Permissions
4. Weigh Competing Ethical Obligations Due Collaborators and Affected Parties
5. Make Your Results Accessible
6. Protect and Preserve Your Records
7. Maintain Respectful and Ethical Professional Relationships.

Moreover, that first premise, Do No Harm, is considered so important, so central to anthropological comportment, that it can override all of the others, up to and including stopping the research project entirely: "When it conflicts with other responsibilities, this primary obligation can supersede the goal of seeking new knowledge and can lead to decisions to not undertake or to discontinue a project."

Thus the prospect of intentionally or unintentionally causing harm is the loose thread that, if pulled, threatens to unravel the entire fabric of anthropological inquiry.

7. But...

Harm. It's such a tricky concept. It's quite difficult to devise a universal, context-independent idea of what counts as "harm," especially given the extreme variation that characterizes anthropological sites, questions, commitments, and in some cases, methods.

The decades of debate leading to anthropology's ethics code and its subsequent revisions have importantly brought the discipline to a point in which *doing no harm* has become an established, taken-for-granted aspect of how we conduct our research. But because that category is so non-specific, and can apply to so many different sorts of situations, the default position that much of the discipline has come to take *methodologically* is to avoid almost any kind of activity that might, in some way, constitute harm in the field. One consequence of this is a generalized resistance to methodological innovation, especially in the domain of explicit intervention. On the one hand there is a fear that certain kinds, or degrees, of

intervention in the field might cause some damage to our informants. But on the other anthropologists often feel that too strong an intervention might somehow be "creating data" that we otherwise wouldn't find were we inconspicuously dropped into the field to observe goings-on like flies on a wall. And if we're *making data happen* by intervening in the field, we're necessarily misrepresenting the people we're studying, which is its own particular sort of harm. The ideal goal is to blend in while in the field, and simply have conversations, to be professional friends or colleagues with our informants. To push too much, whatever that push might look like, is always a potential point for causing harm.

It's no wonder then that the most basic tools in every anthropologist's tool kit—pens, pencils, and notebooks—are 19th-century technologies valued more for their inconspicuous, non-interventionist profile than for their severely limited data-collecting capabilities. The discipline is changing, of course, and many anthropologists are doing more in the field with more tools and methods. But the pace of change is glacial, and the reasons for that pace misguided. Digital video and even photography, for instance, two well-worn and not terribly invasive methods, are not considered required mainstays of anthropological fieldwork, only optional (or even worse, strictly the purview of visual anthropologists). Of course, many field sites involve significant sensitivities around capturing personal images, including situations in which having one's image linked to a foreigner—or even simply talking to an anthropologist—can be outright dangerous, and indeed, privacy and confidentiality will always matter. Ethnographers must always take all precautions to protect their interlocutors, up to and including not using video or photography, if this sort of protection is called for. But not all, or even most, contemporary field situations fit this description. Nonetheless, as more anthropologists work alongside elites—for example, bureaucrats, physicians, video gamers, and engineers—most of whom don't require the special protections afforded to powerless populations, we still operate from a default perspective that intervening too much, even taking pictures and video, is an ethically compromised methodology that is best avoided in fieldwork.

8. Art

In contrast to anthropologists, artists are not so institutionally troubled by the ethics of their interventions. Of course there are longstanding debates about the ethics of artistic production, and philosopher Arnold Berleant (1977) has attempted

to simplify them by articulating three overlapping layers of moral responsibility that apply to practicing artists: the moral obligations faced by all humans, those relevant to artists specifically as professionals (which often apply to other professionals, as well), and those that apply only to artists due to the nature of their work. This third layer—the specific ethics of making art—is the most challenging because art itself is such a complex social form, and what artists do in society is treated as quite distinctive. As Berleant (1977:198) puts it, making art "is intensely serious, offering others not only opportunities for heightened sensibility, expression, communication or imaginative representation, but unique occasions for exposure, discovery and an intensified awareness of the world for human beings"—a description which, not coincidentally, might also apply to anthropologists.

But unlike anthropology, there is no substantive code of ethics for artists. While the College Art Association (CAA), the main professional organization representing artists, critics, and art historians in the U.S., does contain a section called "Artist Code of Ethics" in the group's Standards and Guidelines, the text actually pushes back against the idea of doing no harm, if the integrity of the artwork is at stake:

> Key elements in the professional codes for many disciplines include honesty, integrity in business dealings, civility, obeying laws and regulations, disclosure of conflicts of interest, truth in labeling, individual accountability for professional acts ("do no harm"), and the articulation and communication of personal and professional judgments. While applicable in many contexts, these elements potentially limit legitimate artistic expression and therefore should not be enshrined in a universally applicable, CAA-sanctioned Artist Code of Ethics.

In other words, in contrast with the anthropological framing of harm, it seems that making art can, if push comes to shove, supersede the avoidance of doing harm.

Even relational aesthetics projects, which use human interactions as material and form, are not typically evaluated within an ethical framework based in causing harm. Rather than deconstructing the ethical implications of arranging social encounters for the sake of producing art, most criticism has instead challenged the very concept of ethics underpinning the relational aesthetics framework itself, what one critic described as "a naive mimesis or aestheticisation of novel forms of capitalist exploitation" (Martin, 2007:371). Bishop (2004:77) has argued that by disregarding longstanding formalist traditions in modernist art in favor of working with social forms, "political, moral, and ethical judgments have come to fill the vacuum of aesthetic judgment" in relational works of art.

That is to say, judging whether a relational work is "good" or "bad" is not a matter of evaluating its formal qualities, but rather assessing the callow ethical tone of the overall staged encounter, which is typically colored in explicitly "utopian" hues. Thus for relational aesthetics it seems that there is no worry of doing harm because the enterprise is fundamentally predicated on a sense of doing good.

9. Design

If anthropology excessively frets over the ethics of intervention, and relational aesthetics assumes them away, design tends to exploit intervention as a rationale for its very existence. When Herbert Simon (1996:111) famously and influentially described design as "changing existing situations into preferred ones," he breezily ignored the fact that a "preference for change" is always politically situated, charged with contingency, and suffused with all sorts of power. That attitude—that designers know best, that they know what needs changing and the right way to do it—reveals just how interventionist design really can be. Indeed, most design disciplines are inherently interventionist, but typically finds no reason to treat that status as particularly problematic.

This benign unawareness was something I first noticed when I studied a group of architects in Los Angeles in the early 2000s. These were all good people and good architects. They were designing a complex scientific building for a university campus. None of the decisions they would make were matters of life or death, at least not directly. But the decisions they made —the seemingly trivial details that collectively form "a design" but in isolation seem so insignificant—were often bursting with ethical implications. Take for instance the following short interaction I recorded between two of the architects, Mark and George, concerning how to control access to the building's loading dock (see Murphy, 2011).

> M: There could also be like a- a **bell** out here.
> If somebody's got a delivery and they're closed during the day,
> they can—just like, a security system for an apartment building (.)
> they can ring it and—
> (0.5)
> I don't know who would respond in the building. (1.0)
> G: Yeah, I don't think they're gonna be getting daily deliveries in this building.
> M: Well they've got a building manager
> G: Right. (0.5) He's got an office.

Mark's proposal to add a bell solves the immediate problem faced by the architects: how to design a way for people who are *outside* the loading dock area to get *inside* the loading dock area. For the purpose at hand, the bell is an ideal solution: it's simple, low-cost, and easy to implement. However in the wider world, the world in which the actual building will actually house actual people, the presence of this bell intervenes in the lives of the building's users in a way that will require the creation of particular social forms, which goes mostly unrecognized by the architects. How loud is this bell? Who will hear it? How often will it ring? Will people in the labs above the loading dock have to suffer from constant bell-ringing? Will the bell sound pleasant or harsh? Who will answer the bell? Does the manager mentioned by Mark really want to be answering bells all day? And what if he's sick? Who will serve as the Second-in-Command bell answerer?

Again, from one angle these sorts of factors are relatively trivial: unanticipated consequences, especially small ones like these, are just the cost of doing business when designing a very large and complicated thing, like a laboratory building. But I do think that they also represent a fundamental quality of almost all design work (or at least that which gets released into a world of users): that design is always, even in its smallest details, interventionist in ways that constitute the very discipline itself. And this is a condition whose implications most design disciplines, and most designers, don't spend much time worrying about; because intervening is just what they do.

10. More Codes

Of course this doesn't mean such concerns are entirely unaccounted for. Like the AAA and the CAA, most professional design organizations have established their own professional codes of ethics, or codes of conduct, to help members figure out how to go about doing their business. Different design fields intervene in the world in different ways and through different channels, and the ethical challenges they face in doing so are not necessarily the same, which means that their codes will be somewhat differently organized.

The American Institute of Architects (AIA) code[5] places some vague, general concern for "cultural heritage" and "human rights" in the code's first section (or "Canon"), and does rank "Obligations to the Public" high, even above "Obligations to the Client"—however those obligations to the public amount to an exhortation and requirement for architects not to break the law.[6] In the entire document

specifying the ethical standards of the professional organization whose members create the spaces that most humans spend most of their lives in, there is little to no explicit recognition that their work can—indeed, does—cause, or at least exacerbate, harm to users.

11. First Things First

In 1964 British graphic designer Ken Garland and twenty or so others in the graphic design field published a short manifesto called "First Things First," in which the signatories forcefully urged a new direction for graphic design. Arguing for a shift away from advertising, which only helped hock cheap junk to consumers who didn't need it, the manifesto attempted to push graphic design toward less pernicious and more socially responsible kinds of projects, including "signs for streets and buildings...instructional manuals...industrial publications and all the other media though which we promote our trade, our education, our culture and our greater awareness of the world." At the core of this critique was a recognition that graphic designers, through the work of crafting what Vance Packard (1957) called "hidden persuaders," are conjuring objects with potentially deleterious effects on the people who interact with them, *nudging* them (in a more contemporary phrasing) to buy and accumulate more and more goods, like "cat food, stomach powders, detergent...[and] striped toothpaste." The manifesto was updated in 1999, and then again in 2014, but instead of presenting a struggle against traditional durable consumer goods, as the two previous versions had done, *First Things First 2014* rails against "trivial, undifferentiated apps; disposable social networks; fantastical gadgets obtainable only by the affluent; products that use emotion as a front for the sale of customer data; products that reinforce broken or dishonest forms of commerce." The signatories continue:

> There are pursuits more worthy of our dedication. Our abilities can benefit areas such as education, medicine, privacy and digital security, public awareness and social campaigns, journalism, information design, and humanitarian aid. They can transform our current systems of finance and commerce, and reinforce human rights and civil liberties.

The authors and signatories of these manifestos, unlike the ethics codes of most design organizations all proceed directly from the premise that their work is inherently interventionist, is always wrapped up in affecting the world in one way

or another. Importantly, the ethical stance these signatories assume is not that intervening is itself problematic, but that the *ways* in which you intervene—what you make, how you make it, who you work for, what purposes your work is put to—along with the general commitments you hold must be carefully considered from the very start of the process. This isn't an argument that the work that graphic designers do simply shouldn't support "bad" things, like a hyper-inflated consumer culture, but that it should be used to help generate "good" things in the world, to push society in more positive directions. It's a recognition that neutrality is a myth, and that once that myth is dismissed and abandoned, steering that lack of neutrality in principled directions is itself a worthwhile goal.

12. Form-giving Social Forms

Earlier I stipulated, following Marcus (2010), that ethnographic fieldwork is an aesthetic process predominantly geared toward studying social forms. I've placed ethnography alongside two other professional domains, relational aesthetics and design, both of which in their own ways are also preoccupied with querying the social forms of lived reality. All of these fields are sustained by practices that feature as their essential material humans and their interactions—with each other and with the stuff of the world—and as such they are all subject to specific kinds of ethical considerations. Working through the framework of ethical norms and ethics codes, the central question I've posed has been, how might modeling the figure of the ethnographer on the artist or the designer help update and reformulate the basic research practices of ethnographic fieldwork?

I've focused on the ethics of intervention for two reasons. First, a focus on intervention provides a new gloss on the default norms of anthropological methods. Framing ethnography as an aesthetic process that's centrally concerned with creating and studying social forms helps shift perceptions of the profession of anthropology in ways that promote thoughtful, considered, ethical intervention as an explicit and significant knowledge-building aspect of ethnographic research. The biomedical model of research ethics assumes that the only things produced in human-centered research encounters, aside from knowledge, are either harm or benefit. Reframing ethnographic encounters in aesthetic terms, as sites for orchestrating social forms that, in their emergence, can reveal otherwise obscured aspects of the social worlds we study, expands the imaginary of possible outcomes produced by ethnography. Second, by viewing ethnography through

the practices and values of adjacent disciplines that both treat intervention differently than anthropology does, we can heed Lederman's (2007) call for reimagining anthropological research by other means. For instance, embracing non-neutrality in ways that resonate with relational aesthetics and design—that is, recognizing and accepting that everything we do in the field has interventionist qualities—will free us to think more clearly about how intervention can be shaped and configured to be used strategically as an ethical method of inquiry and medium of knowledge-production. This can then allow us to break free of the biomedical framework that haunts the development of research ethics in anthropology, which in turn could generate a new kind of critical empiricism in ethnographic practice that resolves ethical problems in its own terms, rather than the terms of others.

Acknowledgments

Different iterations of this essay were presented at the following venues: the Research Network for Design Anthropology's "Interventionist Speculation" workshop, Copenhagen, Denmark, August 14, 2014; the Working Title workshop at UC Irvine, May 21, 2015; and the Matter and Method Workshop in Banff, Alberta, Canada, March 31, 2016. I'd like to thank all of the participants of these events for reading and commenting on earlier drafts, especially Gretchen Bakke, Tom Boellstorff, Craig Campbell, Susan Coutin, Carl diSalvo, Jamer Hunt, Tim Ingold, Sean Mallin, George Marcus, and Ton Otto.

Notes

1 There are a number of important books and articles on anthropology and ethics, see especially Armbruster and Laerke (2008), Fluehr-Lobban (2002), and Price (2011). For work on ethics as an object of anthropological inquiry, see Faubion (2011), Keane (2016), Laidlaw (2014), and Lambek (2010).
2 A number of anthropologists have engaged explicitly with relational aesthetics as both practice (Flynn, 2016; Reichert, 2016; Sansi, 2015) and theory (Kreps, 2015; Win, 2014; Zito, 2014).
3 The entire text of the 1971 code is posted to the AAA website (http://www.aaanet.org/cmtes/ethics/AAA-Statements-on-Ethics.cfm), as is the text for all previous and current iterations.

4 The full Statement can be found here: http://ethics.aaanet.org/category/statement/
5 The AIA code can be found here: http://www.aia.org/aiaucmp/groups/aia/documents/pdf/aiap074122.pdf
6 The sixth and final Canon does concern an Obligation to the Environment.
7 Found here: http://firstthingsfirst2014.org/

References

Armbruster, H. and Lærke, A. (2008), *Taking Sides: Ethics, Politics and Fieldwork in Anthropology*, New York: Berghan.

Barnes, J. A. (1999), "Commentary on Pels 1999," *Current Anthropology*, 40 (2):116.

Bell, K. (2014), "Resisting Commensurability: Against Informed Consent as an Anthropological Virtue," *American Anthropologist*, 116 (3):511–22.

Berleant, A. (1977), "Artists and Morality: Toward an Ethics of Art," *Leonardo*, 10(3):195–202.

Bishop, C. (2004), "Antagonism and Relational Aesthetics," October, 110 (110):51–79.

Bishop, C. (2012), *Artificial Hells: Participatory Art and the Politics of Spectatorship*, New York: Verso.

Bourriaud, N. (2002), *Relational Aesthetics*, Dijon, France: Les Presses du réel.

Cassell, J. (1980), "Ethical Principles for Conducting Fieldwork," *American Anthropologist*, 82 (1):28–41.

Castañeda, Q. E. (2006), "Ethnography in the Forest: An Analysis of Ethics in the Morals of Anthropology," *Cultural Anthropology*, 21 (1):121–45.

Clarke, A. J. (2010), *Design Anthropology: Object Culture in the 21st Century*, New York: Springer.

Desai, D. (2002), "The Ethnographic Move in Contemporary Art: What Does It Mean for Art Education?" *Studies in Art Education*, 43 (4):307–23.

Downey, A. (2007). "Towards a Politics of (Relational) Aesthetics," *Third Text*, 21 (3):267–75.

Faubion, J. D. (2011), *An Anthropology of Ethics*, Cambridge: Cambridge University Press.

Fluehr-Lobban, C. (1994), "Informed Consent in Anthropological Research: We Are Not Exempt," *Human Organization*, 53 (1):1–10.

Fluehr-Lobban, C. (Ed.). (2002), *Ethics and the Profession of Anthropology: Dialogue for a New Era* (2nd ed.), Philadelphia: Temple University Press.

Flynn, A. (2016), "Subjectivity and the Obliteration of Meaning: Contemporary Art, Activism, Social Movement Politics," *Cadernos de Arte E Antropologia*, 5 (1):59–77.

Foster, H. (1996), "The Artist as Ethnographer." In *The Return of the Real: The Avant-Garde at the End of the Century*, 171–204. Cambridge, MA: MIT Press.

Gunn, W. and Donovan, J. (Eds.). (2012), *Design and Anthropology*, London: Ashgate.

Hodge, G. D. (2013), "The Problem with Ethics," *PoLAR: Political & Legal Anthropology Review*, 36 (2):286–97.

Jorgensen, J. G. (1971), "On Ethics and Anthropology," *Current Anthropology*, 12 (3):321–334.

Keane, W. (2016), *Ethical Life: Its Natural and Social Histories*, Princeton: Princeton University Press.

Kester, G. (2013), *Conversation Pieces: Community and Communication in Modern Art*, Berkeley: University of California Press.

Kreps, C. (2015), "University Museums as Laboratories for Experiential Learning and Engaged Practice," *Museum Anthropology*, 38 (2):96–111.

Kulick, D. (2006), "Theory in Furs: Masochist Anthropology," *Current Anthropology*, 47 (6):933–52.

Laidlaw, J. (2014), *The Subject of Virtue: An Anthropology of Ethics and Freedom*, Cambridge: Cambridge University Press.

Lambek, M. (Ed.) (2010), *Ordinary Ethics: Anthropology, Language, and Action*, New York: Fordham University Press.

Lederman, R. (2007), "Comparative 'Research': A Modest Proposal Concerning the Object of Ethics Regulation." *PoLAR: Political and Legal Anthropology Review*, 30 (2):305–27.

Levine, C. (2015), *Forms: Wholes, Rhythm, Hierarchy, Network*, Princeton: Princeton University Press.

Marcus, G. E. (2010), "Contemporary Fieldwork Aesthetics in Art and Anthropology: Experiments in Collaboration and Intervention," *Visual Anthropology*, 23 (4):263–77.

Martin, S. (2007), "Critique of Relational Aesthetics," *Third Text*, 21 (4):369–86.

Murphy, E. and Dingwall, R. (2007), "Informed Consent, Anticipatory Regulation and Ethnographic Practice," *Social Science and Medicine*, 65 (11):2223–34.

Murphy, K. M. (2011), "Stories: The Embodied Narration of What Might Come to Pass." In J. Streeck, C. Goodwin, and C. D. LeBaron (Eds.), *Embodied Interaction: Language and Body in the Material World*, 243–53. Cambridge: Cambridge University Press.

Murphy, K. M. and G. Marcus (2013), "Ethnography and Design, Ethnography in Design…Ethnography by Design." In W. Gunn, T. Otto, and R. C. Smith (Eds.), *Design Anthropology: Theory and Practice*, 252–268 London: Bloomsbury.

Ortner, S. B. (2016), "Dark Anthropology and Its Others: Theory Since the Eighties," *HAU: Journal of Ethnographic Theory*, 6 (1):47–73.

Packard, V. (1957), *The Hidden Persuaders*, New York: Pocket Books.

Pels, P. (1999), "Professions of Duplexity: A Prehistory of Ethical Codes in Anthropology," *Current Anthropology*, 40 (2):101–36.

Price, D. A. (2011), *Weaponizing Anthropology: Social Science in Service of the Militarized State*, Petrolia, CA and Oakland, CA: CounterPunch and AK Press.

Rabinow, P. and Marcus, G. E. (2008), *Designs for an Anthropology of the Contemporary*, Durham: Duke University Press.

Reichert, A.-S. (2016), "How to Begin, Again: Relational Embodiment in Time Arts and Anthropology," *Cadernos de Arte E Antropologia*, 5 (1):9–95.

Robbins, J. (2013), "Beyond the Suffering Subject: Toward an Anthropology of the Good," *Journal of the Royal Anthropological Institute*, 19:447–62.

Sansi, R. (2015), *Art, Anthropology, and the Gift*, London: Bloomsbury.

Scheper-Hughes, N. (1995), "The Primacy of the Ethical: Propositions for a Militant Anthropology," *Current Anthropology*, 36 (3):409–40.

Schneider, A. and Wright, C. (Eds.) (2010), *Between Art and Anthropology*, Oxford: Berg.

Shannon, J. (2007), "Informed Consent: Documenting the Intersection of Bureaucratic Regulation and Ethnographic Practice," *PoLAR: Political & Legal Anthropology Review*, 30 (2):229–48.

Simon, H. A. (1996), *Sciences of the Artificial* (3rd ed.), Cambridge, MA: MIT Press.

Thompson, N. (Ed.). (2012), *Living as Form: Socially Engaged Art from 1991–2011*, New York and Cambridge, MA: Creative Time Books and MIT Press.

Wax, M. (1977), "On Fieldworkers and Those Exposed to Fieldwork: Federal Regulations and Moral Issues," *Human Organization*, 36 (3):321–28.

Wax, M. (1995), "Informed Consent in Applied Research: A Comment," *Human Organization*, 54(3):330–331.

Win, T. S. (2014), "Marketing the Entrepreneurial Artist in the Innovation Age: Aesthetic Labor, Artistic Subjectivity, and the Creative Industries," *Anthropology of Work Review*, 35 (1):2–13.

Wittgenstein, L. (2009), *Philosophical Investigations*, Oxford: Blackwell.

Zito, A. (2014), "Writing in Water, or, Evanescence, Enchantment and Ethnography in a Chinese Urban Park," *Visual Anthropology Review*, 30 (1):11–22.

The Recursivity of the Gift in Art and Anthropology

Roger Sansi

So much has been written about the gift in anthropology; it is indeed one of its key concepts, one of the hallmarks of ethnographic theory. It is hard to imagine what else could be said, what could be added. On the other hand, the "gift" is not only central to anthropology, but also in other worlds of thought, like art, if perhaps in less explicit ways. Can the concept of the gift in art effectively say something more, something else, to what anthropology has already proposed?

To answer this question, I will start by addressing some recent examples of relational and participative art. In spite of the intense debates on these practices, the understanding of the gift as voluntary exchange between equal peers is rarely questioned in the field of art. On the opposite, the anthropological literature since Mauss has developed a very different theory of the gift. Anthropologists have described gifts time and again as compulsory and hierarchical, not voluntary and egalitarian. This anthropological perspective can offer a clear counterpoint to art, showing how apparently very different positions within this field of share some basic assumptions, for example, the presupposition of equality between subjects in gift exchanges and participative practices.

One could stop here, simply by showing what can anthropology teach art about the gift. But there are still other possible readings on the question. For example, Georges Bataille and the situationists went beyond the dichotomy which I have just formulated. The situationists were interested in the gift in terms of expenditure and transgression, not just as an alternative to commodity exchange but as a weapon to overcome this very exchange.

In fact, perhaps all these definitions and approaches are not contradictory, but they add upon each other: the gift is a recursive concept, a concept that is constantly feeding back upon itself. Each enactment and use of the gift is at the

same time redefining its previous uses and opening new possibilities. In these terms what the gift actually is, or has been, is perhaps less interesting than what it can be, what it gives. This could help us address, for example, the key role of the gift in the utopian vision of situationism. Ultimately, it can also be a path to unfold the relational ontology that the concept of the gift puts forward.

Relational Art and the Free Gift

The question of the gift in art came first to me as a surprise, in the late nineties, when I encountered a number of art practices explicitly based on gift giving. Felix González-Torres' more emblematic works were piles of candy in geometrical shapes, rectangular carpets or pyramids leaning against a wall, all "Untitled". They were left in process: the aim of González-Torres was for the audience to take the candy, and then the pile has to be filled up again by the gallery. They are constantly being deconstructed and reconstructed in an endless act of gift-giving.

Rirkrit Tiravanija's work gave rise to similar questions. Tiravanija's first shows basically consisted in cooking meals for the people who visited the gallery. The aim was to bring people together, participating in a meal. For Tiravanija, "It is not what you see that is important but what takes place between people."[1]

More than what they represent, what is interesting about González-Torres and Tiravanija's work is what they make happen: a situation of encounter, a social relation. Both Tiravanija and González-Torres were central to Nicolas Bourriaud's arguments in *Relational Aesthetics* (Bourriaud, 2002). Bourriaud described the "relational art" of these artists as "taking as its theoretical horizon the whole of human interactions and its social context, rather than the assertion of an independent and private symbolic space" (Bourriaud, 2002:14). The real object of González-Torres's or Tiravanija's work was to invite people to eat and talk to each other, to construct a social relation, to participate. For Bourriaud, art is a situation of encounter (Bourriaud, 2002:18) "All works of art produce a model of sociability, which transposes reality or might be conveyed by it." (Bourriaud, 2002:18). The form of the artwork is in the relations it establishes: to produce a form is to create the conditions for an exchange. In other terms, the form of the artwork is in the exchange with the audience. Hence the artist becomes a mediator, a person that fosters and provides situations of exchange, rather than a creator of objects. For Bourriaud, relational art practices establish particular social relations for particular people; the artist tries to keep a personal

contact with the public that participates in the exchange, fostering what he calls a "friendship culture" (Bourriaud, 2002:32), in contraposition to the impersonal mass production of the culture industries.

Relational artworks as gifts would be free, spontaneous, personal, and disinterested events, in opposition to commodification and mass consumption. Yet we could say that the vision of the gift in relational art is not radically new, but it is deeply anchored in classical Kantian aesthetics, based on the notion of the judgment of taste as free of interest and finality. This reading of the gift as free, spontaneous, and disinterested appears in the eighteenth century in radical opposition to commodities, which on the opposite, are bounded to interest. James Carrier, in his historical account of discourses about the gift in the modern Western world, points out the emergence of the notion of the "true" gift in the eighteenth century. The perfect present should be given freely, as an expression of personality. The "spontaneous" gift would be the absolute opposite of interest, and therefore, of the world of commodities. Carrier traces the withdrawal of the "gift" to the realm of personal relations and disinterest and its separation from the "commodity" and the realm of private interest. Paradoxically, it is the very emergence of an impersonal market that allows for a notion of the "personal" and "free" gift to emerge in opposition to it (Carrier, 1994:163).

The emergence of the notion of the personal and free gift in the eighteenth century is not just contemporaneous with modern aesthetics, but it is intimately connected with it: both express the possibility of thinking a domain of practice, a form of relation of people and things "free of need and finality," as Kant would say. A form of relation in radical opposition to the emerging, dominant regime of modernity: the impersonal market. In the end, aesthetics is also based on subjectivity, like economics, but the subject of aesthetics is constituted precisely in opposition to economics: instead of the calculating, maximizing individual who thinks in terms of need and utility, Schiller described the aesthetic education as the promise of a society where free citizens would think beyond their immediate interests, but for the common good. In these terms, the gift emerges as the natural embodiment of aesthetics as a form of relation based on freedom and play, as opposed to the commodity as a form of relation based on need and utility.

This aesthetic utopia of the free gift is still at the center of many of the participative art practices of today. The presupposition of equality among participants is its fundamental tenet, as Jacques Rancière has shown (Rancière, 2004). Moreover, arguments on the free gift are still very present, not just in contemporary art, but in a larger sphere of debates on "free culture" and the

cultural commons that have re-emerged in the last decades with new digital media and the free software movement (see Hyde, 2009). The paradox of this utopia is that since its origin, it has been constituted in direct opposition to the economic model of bourgeois utilitarianism, and precisely because of that, it shares many things with it: it is based upon an egalitarian, liberal, and individualist cosmology that is the key of bourgeois modernity.

Anthropology and the Hierarchical Gift

This understanding of the gift is very different from what many anthropologist have said since Mauss: in opposition to the ideology of freedom, improvisation, and egalitarianism of the gift in modern art and aesthetics, anthropologists, in their ethnographies and theories, have often described gifts in terms of obligation, ritualization, and hierarchy. Mauss' first paragraph in the gift concludes with the statement: "In theory these [gifts] are voluntary, in reality they are given and reciprocated obligatorily." (Mauss, 1990:3). Many decades later, Strathern described gifts that "convey no special connotations of intimacy. Nor of altruism as a source of benign feeling" (Strathern, 1991:295).

Does this distinction between theory and reality also apply to the gift in modern art? Are gifts in art voluntary and egalitarian in theory, but obligatory and hierarchical in truth? For Bourdieu (Bourdieu, 1996), this "false consciousness" or "misrecognition" would be at the basis of the rules of art, and of all social life as a matter of fact. The criticism to many of the different forms of relational and participatory art that have emerged in the last decades also have been built, directly or indirectly, on arguments of false consciousness. Claire Bishop has described how community arts been embraced as a sort of "soft social engineering" (Bishop, 2012:5) in the UK, promoting "participation" in the arts as a form of preventing social exclusion. For Bishop, "social inclusion" policies in the UK were deeply rooted on a neoliberal agenda, seeking to "enable all members of society to be self-administering, fully functioning consumers who do not rely on the welfare state and who can cope with a deregulated, privatised world." (Bishop, 2012:12). Notions of "creativity" as innate talent of the socially excluded, an energy that could be transformed from a destructive to a constructive impulse, are also quite common in these cultural policies. Participatory and community art could become, in this context, devices of neoliberal governmentality (Miessen, 2011).

Distributed Personhood

Yet there is something more to the question of the gift than false consciousness. Mauss did not just describe the gift as a misrecognized form of symbolic capital, he also presented it in direct relation to the notion of the person: how a gift is an extension of the person who gives, hence blurring the very distinction between people and things (Mauss, 1990). Mauss opened the door to imagine other ontological possibilities to Western individualism, where this division is clearly established from the onset. The relation between gift and personhood was a central question for Melanesian anthropology all along, but in particular in the 1980s and 1990s in the work of Weiner (1992), Munn (1986), Strathern (1990), and Gell (1998). Gell famously extended the discussion of the "distributed person" to a general theory of art in *Art and Agency* (1998). In that book Gell proposed to look at works of art as indexes of agency. Indexes of agency are the result of intentions: "Whenever an event is believed to happen because of an "intention" lodged in the person or thing which initiates the causal sequence, that is an instance of "agency" (Gell, 1998:17). To have intentions means to have a mind. The "life" we attribute to things, and works of art in particular, would be the result of a process of abduction or indirect inference of a "mind" in a thing.

Relations

Still, there are limits to Gell's approach. For Gell, agency is always originally human, and often seems to give primacy to the (first) agent, namely the artist, even if other agencies are "entrapped" in the process. Artworks have power; but for Gell this power is always bestowed upon them by people with "minds", whose intentions are distributed in art objects. But the notion of distributed or partible person may be much wider. For Strathern, partible persons may not start or generate from a single human person, but they may assemble collectives of humans and non-humans in multiple ways. In these terms, tracing back the origin of agency is less important than describing the particular relation, where relations take precedence over entities: "it is at the point of interaction that a singular identity is established" (Gell, 1988:128). This shift of the question from agency to relations is important for understanding one central issue in modern and contemporary art, what Grant Kester has called the "disavowal of agency" (Kester, 2011:4): allowing chance to guide the process of production of art,

modern and contemporary art have proposed to open up the space of possibilities of the artistic process by explicitly withdrawing the agency of the artist, and describing these process as an assemblage of heterogeneous elements, human and non-human, without a pre-established order of agency.

Shifting the discussion towards an ontology of relations also brings further the contradictions of the concept of the gift as an object of exchange. We owe to Jacques Derrida the explicit formulation of the ontological antinomy of the gift: taken to its logical conclusion, a pure "gift" cannot be reciprocated; because if a return is expected, the gift always implies its opposite—interest, benefit, utility, accountancy, commodification. "The gift, like the event, as event, must remain unforeseeable ... It must let itself be structured by the aleatory; it must appear chancy or in any case lived as such." (Derrida, 1992:122). The gift is not in the thing given, but the event of giving; an event that gives itself, and that has to be forgotten as such. In part, this understanding of the gift as an event goes back to the notion of the spontaneous, free gift that we have described before as key to modern art and aesthetics, but bringing it to a deeper phenomenological level. Derrida's understanding of event and gift are explicitly indebted to Heidegger's discussion of "the thing" as a gift (Heidegger, 1971), as the establishment of a relation, of giving itself as an event. The gift happens as an event before there is a division between subject and object, before there is being as substance (Derrida, 1992:24). To put it in Strathern's terms, the gift as a relation takes precedence over the entities it constitutes. The gift is not a given: it is not there before it happens; it cannot easily be naturalized or reduced to a sociological model (like "exchange").

Recursivity

At this point I should stop spinning around the concept of the gift. But that is precisely the point I wanted to make: we have a number of definitions of the gift as a concept and practice, from the "free" gift of art and aesthetics, to the hierarchical gift of Mauss and the anthropological and sociological tradition, to the "distributed person" that has been more recently reclaimed, and to the gift as an event. Some seem contradictory, some seem to come from radically different places—eighteenth-century Europe, ethnographic Melanesia. Yet I would argue that these definitions are not contradictory or in dialectical opposition, but they add upon each other: the gift is a recursive concept. It was Strathern who drew

attention to this when she described the antinomies of the gift in terms of a recursive sequence of revelation, in which the gift is a relation that is constantly redefining the partners in the exchange, the objects of exchange, and the very concept of exchange.

The concept of recursion is complex and multifaceted (recursive itself, of course!), so it may be worth giving some visual examples. A Russian doll is a good example of recursion, since it constantly draws upon itself; the concept of the gift, like the Russian doll, would always contain yet another version of itself within. A mirror confronting a mirror would be another example; it may be helpful in particular terms to show how recursivity can appear as a different way of understanding how concepts are formed, differently from theories of representation. One of the classical images of representation would be the "mirror", as a reflection of a culture. In these terms, a classical image of the incommensurability of cultures would be the opposing mirrors. For example, in the case of the gift, we have two radically opposed concepts, or images: the Western image of the free gift, and the anthropological image of the hierarchical gift, which is a representation constructed upon the "other cultures" that anthropology studies. Both concepts stand in direct contraposition to each other, backwards, reflecting the culture that produced them (Western culture on the one hand, "other cultures" on the other hand). But what happens if we turn the mirrors toward each other, looking into each other? The problem is reversed. The mirrors no longer reflect opposing worlds, but they create a world within themselves, a world that is infinitely recursive. They become a machine, a dispositive of creating worlds, not simply of reflecting them.

One of the main ethnographic examples of recursion is computer programming. Computer programs are often recursive—they call upon themselves—and that is what gives them the capacity to change, to reprogram and redesign themselves, and (as some computer scientists say) also to redesign their designers. In his work on the "free software movement" Chris Kelty (Kelty, 2008) has come to define the "free software" community as a "recursive public". For Kelty, this would differ from other publics because of their focus on the radical technological modifiability of their own terms of existence (Kelty, 2008:3):

> Recursive publics are publics concerned with the ability to build, control, modify, and maintain the infrastructure that allows them to come into being in the first place and which, in turn, constitutes their everyday practical commitments and the identities of the participants as creative and autonomous individuals.
>
> <div style="text-align: right;">Kelty, 2008:7</div>

Yet there is an implicit contradiction in this "public." It defines itself as a collective of autonomous individuals claiming their essence as individuals to take precedence over the infrastructure, responding to an individualist and naturalist ontology not that far from the aesthetic regime. But in fact, recursive infrastructures may not be only tools in the hands of autonomous individuals, but they could also be seen as the very device that brings into being these very individuals.

Finally, we could think of the recursivity of "concepts." For Martin Holbraad, a concept is recursive when "it changes every time it is used to express something" (Holbraad, 2012:76), and this change is built upon the previous uses. In this sense it is also important to understand that what Holbraad (and others, such as Henare, 2007) is proposing in fact is a radical criticism of the model of representation, that we change our very understanding of what a "concept" is—a concept may not be just a representation separated from the thing it represents, it may be an outcome of the thing itself, or we could say, the event itself. The gift is the core anthropological example of recursion both as event and concept, as it is constantly changing and adding up to its previous instances. The concept of the free gift is presupposed and contained upon the concept of the hierarchical gift, which in turn is contained in the concept of the distributed person, which is recursively integrated in the very notion of the gift as a model of recursion. What the gift is, as the representation of a given truth, in art and elsewhere, is perhaps less interesting that what it can be, what it gives.

Gift and Theft

If we approach the gift as a recursive concept rather than as a social fact, we can shift the focus toward its potential to become. This could help us address, for example, the key role of the gift in the utopian vision of situationism, to come back to the field of art. Situationists in the 1950s and 1960s explicitly engaged with theories of the gift, in particular Bataille's reading of the "potlatch" in his theory of an economy of expenditure and excess (Bataille, 1993). Bataille envisioned a human condition that was not determined by need and utility, but empowered by pleasure and play. But still Bataille's notions of free play didn't have much to do with the democratic and libertarian utopias of contemporary art, like Bourriaud's relational aesthetics: on the contrary, his images of the gift as expense are transgressive and destructive.

After Bataille, for the situationists, the gift, the potlatch, and the economy of excess prefigured a form of exchange radically different to commodity exchange. In *The Revolution of Everyday Life* (2009 [1967]), Raoul Vaneigem made a sharp distinction between two different kinds of gift—one that would imply hierarchy, another that would be the gateway to revolution. The first he defined as the "feudal gift"; the gift of what Mauss or Bataille would call "archaic societies," before capitalism. For Vaneigem, the feudal mind seemed to conceive the gift as a sort of haughty refusal to exchange—a will to deny exchangeability; hence its competitive, agonistic character, where one has to be the last to give, to keep their reputation, rank, and hierarchy (Vaneigem, 2009:57). Vaneigem's vision was not to return to the feudal gift, but the opposite: moving forward to the "pure gift" (ibidem, p.59). The pure gift would be the *don sans contrepartie*, the gift without return, that would characterize the future society, in opposition both to bourgeois society, based on the market, and the previous aristocratic society based on the agonistic gift that didn't play for benefit, but for fame and rank. In this sense, the situationists dismissed the hierarchical aspects of the potlatch that were central to Mauss, Bataille, and most of the anthropological and sociological tradition. In the "pure gift," instead, the "young generations" would play for the pleasure of playing itself. The gift for the situationist has the subversive potential of questioning commodification and the property relations in themselves, of decommodifying the commodity (Martin, 2012). Following Bataille, the transgressive, excessive character of the gift is put forward, very far away from the measured, liberal humanism of the aesthetic utopia. And yet, this transgression for the situationists doesn't have the aristocratic tone of cosmic tragedy of Bataille's sacrifice, but on the contrary, it is a utopian hope. "A new reality can only be based on the principle of the gift" (Bataille, 2009: 31). It is interesting to note how Vainegem had a very clear understanding of the "ontological aporia" of the gift, as we have formulated it before: the impossibility of thinking the "pure gift" if not in opposition to the commodity. In these very terms, situationism describes this "pure gift" as a revolutionary, utopian project of subversion of the existing social relations, which appears not just in contradiction, but in direct confrontation, to overcome commodity exchange. It is also interesting to note that the main example of Vaneigem's pure gift is nothing but . . . theft. In his own terms:

> The insufficiency of the feudal gift means that new human relationships must be built on the principle of pure giving. We must rediscover the pleasure of giving: giving because you have so much. What beautiful and priceless potlatches the affluent society will see—whether it likes it or not!—when the exuberance of

> the younger generation discovers the pure gift. The growing passion for stealing books, clothes, food, weapons, or jewelry simply for the pleasure of giving them away gives us a glimpse of what the will to live has in store for consumer society.
>
> <div align="right">Vaneigem, 2009 [1967]:59</div>

Can theft be a gift? Vaneigem clearly elaborated on the connection between the two notions by emphasizing the idea that the "young generations" steal objects out of a desire to give them away, not to hoard them. Perhaps this connection is a bit far-fetched, but still, any anthropologist can recognize that giving is always the counterpart of taking; often the anthropological literature has made reference to poaching, freeloading, the aggressive soliciting of gifts by people who feel entitled to have them, or even the simple act of taking the gifts without permission, if they are not given. This poaching may take place in confrontation to commodity exchange, for example in colonial situations or during fieldwork, when the colonists or the anthropologist are asked to share what they define as their "private property" (e.g. Sahlins, 1993). In this sense, Vaneigem's understanding of the "pure" gift as theft did not just build a conceptual opposition between gift and commodity, like most anthropology has done, but explicitly proposed the gift as a practice of overcoming commodity exchange; the gift as theft is a "situation," a revolutionary act.

To finish this section I would add that, although many contemporary art practices (like relational art) are inspired by situationism, their transgressive potential is quite mitigated. The forms and notions of the gift that circulate in the world of cultural production today are not so much transgressive but constructive: there is a widespread discourse on the commons, care, participation, co-labor, etc, that provides narratives of the autonomous creation of a utopian alternative, based on the libertarian ideology of the free gift, rather that on the creative destruction of capitalism. Perhaps the sphere where the radical "pure gift" of the situationists thrives more openly is in digital media, not only through active hacking, but through the everyday practices of "piracy" and poaching of many of its users, operating in a gray area between "gift" and "theft," and forcing the culture industries to constantly re-invent their business model.

Conclusions

This journey through the "gift" has taken us much beyond the debates about the relationship between art and anthropology. But by introducing the gift as a third

term my objective was precisely this: the very notion of the gift implies the constitution of an exchange that goes beyond a mere give and take. My intention was precisely to show that the "relation" of art and anthropology is not simply a give and take, where anthropology can provide ethnographic methods in exchange for visual methods, or ethics in exchange of creativity. This relation is not a trade or barter, for what the gift and participation imply is more than an equivalent value. They imply a "getting involved with" and a "becoming part of something else". The gift transforms art and anthropology, they make them into something more, and something else, than what they were before. They "extend" their being, to follow Mauss (1990) and Strathern (1990), to something larger than themselves.

The question, at this point, would be what this something larger be? The situationist revolution or neoliberal "participative" governmentality? Paradoxically, they may have something in common. Many decades after situationism, there have been many different, contentious readings of the outcomes of this "revolution." Many think it never happened (by the early 1970s there was only one situationism left: Debord! Himself). And yet others think it did happen, but it went in the opposite direction to the aim of the situationists. The separation between art and life, and the alienation of labor, was indeed questioned by the new kind of society that emerged from the seventies. Yet this new society was still a new form of capitalism, with a "new spirit," as Boltanski and Chiapello have defined it (Boltanski and Chiapello, 2006). The new spirit of capitalism reappropriates the artistic critique, and proposes a new form of life in which the worker is creative, entrepreneurial, identifies with his work, doesn't really make a distinction between his life inside and outside of his work: his social relations are part of what he does for a living. This is the new model of "management," also a utopian model because it does not correspond to reality, of course, but is enfoced through performative mechanisms of bureaucratic enforcement that try to bend reality (everyday life!) to the model: mechanisms of accountability and auditing, which quantify "creativity," the value produced by everyday life as it becomes a commodity.

So in the new spirit of capitalism, the division of labor has been canceled in a particular way. The new model of management is the "participative society." In the participative society, the autonomy of different fields of practice has been abolished, to an extent, by the imposition of a model of life and work that is transversal: management. Management has become the overarching mechanism through which everything is "related." Nowadays, artists and anthropologists are also managers: they have to demonstrate they are able to raise money,

independently from the quality of their work in the autonomous terms of their practice *as* art or anthropology.

One particular reaction to this "new spirit" of capitalism, to this overarching system of relations, dominated by management, would be to claim back for autonomy, for "detachment" from these relations. This is a conservative reaction, and I don't mean it in a negative sense, but as a statement of fact: of preserving things as they were, or as they were meant to be; defending the autonomy of intellectual labor and art, and state the necessary autonomy of critical thinking. The division of labor in modern Western society also had a political sense, as a necessary complement of the division of powers in the public sphere. Intellectuals should be separated from the executive power, to be able to have a critical perspective. We could ask if this ever did actually happen, but there certainly is an argument to be made against the banalization of intellectual life. The ironical fact is that these arguments in defense of autonomy of art and the university are often accused of elitism from the ivory tower by the advocates of management: the situationist and Maoist arguments against elitism have become the arguments of the zealots of the managerial utopia (as in the "participative society").

There is indeed a case to be made for autonomy. Or, in other terms, there is a case to be made for detachment: not everything can be reduced to relations, participation, commonalities, interdisciplinarity or transdisciplinarity—there is always a moment of separation and cut (Candea et al., 2015). For example, in his work on the relations between anthropology and archeology, Yarrow found that it is precisely the disconnection and difference between the ways in which these disciplines produce knowledge that sets up the possibility for productive engagement (Garrow and Yarrow, 2010). There is no question that any relation produces a form of disengagement, just as any detachment is premised on a previosuly existing relation (Candea et al., 24:2015), as Strathern already pointed out in "Cutting the network" (Strathern, 1996).

Autonomist arguments are very valid, and yet they may be inevitably limited if we confront the extremely powerful and pervasive "relational" machinery of management that is ideologically inoculated against them. Another other possible reaction would more proactive. It would involve taking the bull by the horns and confronting the enemy on its own terms, not by detachment, but by multiplying the relations. The fact that the old forms of critique have been reappropriated does not mean that the potential for critical thought and action that has emanated from art and anthropology in the last century has been cancelled. The proposal that "everybody is an artist" may still have potential if we

see it in direct confrontation to the dominant "everybody is a manager." This confrontation may reveal, first of all, that both are based on utopia—they are not a description of reality but a political project. We can also say (why not?) that everybody is an anthropologist. That does not diminish the value of anthropology as an antonomous form of knowledge (beware!), but on the contrary, it proposes the necessity of making anthropology part of public life. What makes anthropology a part of public life, what makes it political, is radically opposite to the managerial utopia: it proposes opposed notions of the person, of the world, of the relation between people and things, etc. Hence it implies a certain politics, in contraposition to the politics of utility, impact, and added value. This politics entails working in collaboration with others, which could start from what we have in common, not from what makes us different; not from our expertise, but from a common political ground. Then, once we start working together, it is quite clear that the collective political process will make the different forms of knowledge and skill of all the actors involved, and certain forms of "detachment," and hierarchy, will emerge. But we still have to start from the common ground.

Note

1 http://www.artandculture.com/users/5-rirkrit-tiravanija. Last accessed 2/2/2013

References

Bataille, Georges (1993 [1949]), *The Accursed Share*, New York: Zone Books.
Bishop, Claire (2012), *Artificial Hells: Participatory Art and the Politics of Spectatorship*, London and New York: Verso.
Boltanski, L. and Chiapello, E. (2005), *The New Spirit of Capitalism*, London: Verso
Bourdieu, P. (1996), *The rules of art: genesis and structure of the literary field*, Cambridge: Polity Press.
Bourriaud, Nicolas (2002), *Relational aesthetics*, Dijon: Les Presses du reel.
Candea, M., C. Cook, C. Trundle, and T. Yarrow (eds.) (2015), *Detachments: essays on the limits of relational thinking*, Manchester: Manchester University Press.
Carrier, J. (1994), *Gifts and Commodities: Exchange and Western Capitalism Since 1700*, London, Routledge.
Derrida, J. (1992), *Given Time 1. Counterfeit Money*, Chicago: University of Chicago Press.

Garrow, D and Thomas Yarrow (2010), *Archaeology and Anthropology: understanding similarity, exploring difference*, Oxford: Oxbow.

Gell, A. (1998), *Art and Agency*, London: Clarendon Press.

Heidegger, M. (1971), "The Thing", in *Poetry, Language, Thought*, New York: Harper & Row, 163–86.

Henare, A., Holbraad, M., and Wastell, S. (Eds.) (2007), *Thinking Through Things: Theorising Artifacts Ethnographically*, London: Routledge.

Holbraad, M. (2012), *Truth in Motion*, Chicago: U of C. Press.

Hyde, L. (2009 [1983]), *The Gift. Creativity and the Artist in the Modern World*, New York: Vintage Books.

Kelty, C. (2008), *Two Bits: The Cultural Significance of Software*, Durham: Duke University Press.

Kester, Grant (2011), *The One and the Many: Contemporary Collaborative Art in a Global Context*, Durham: Duke University Press.

Martin, Kier, (2012), "The 'Potlatch of destruction': Gifting against the State," *Critique of Anthropology*, 32(2):125–142.

Mauss, M. (1990 [1925]), *The Gift. The form and reason for exchange in archaic societies*, London and New York: Routledge.

Miessen, M (2011), *The Nightmare of Participation*, London: Strindberg.

Munn, N. (1986), *The Fame of Gawa. A Symbolic Study of Value Transformation in a Massim Society*, Durham: Duke University Press.

Rancière, J. (2004), *The Politics of Aesthetics: The Distribution of the Sensible*, London and New York: Continuum.

Sahlins, M. (1993), "Cery Cery fuckabede," *American Ethnologist* 20 (4):848–67.

Strathern, Marilyn (1990), *The gender of the gift. Problems with women and problems with society in Melanesia*, Berkeley: University of California Press.

Strathern, Marilyn (1991), "Partners and Consumers: Making Relations Visible." *New Literary History*, Vol. 22, No. 3, Undermining Subjects (Summer, 1991):581–601

Strathern, Marilyn (1995), *The Relation: Issues in Complexity and Scale*, Cambridge: Prickly Pear.

Strathern, Marilyn (1996), "Cutting the Network," *The Journal of the Royal Anthropological Institute*, 2 (3):517–35.

Vaneigem, R. (2009 [1967]), *The Revolution of Everyday Life*, Retrieved on May 14, 2009 from the library.nothingness.org.

Weiner, A. (1992), *Inalienable Possessions: The paradox of keeping-while-giving*, Berkeley: University of California Press.

Another World in This World

Compostion

Spooks of the wheel
Turn and return

Bring us

Yesterday's papers, dead flowers, lost things, found things, blubbery things, deadalive things, fermenting things, in-between things

Childish things
Put aside
For safekeeping
Primitive survivals

Unme
Unthink
Unword
Unwrite
Unwhale
Unworld
Universe
Unprovise

What's happening?
A new production
Treading the ouija boards
To mulch a(c)claim

One world kipperflat
Emplaicement

Young angular mountains
A bloating muchness

Whalebellyburst
Of madrigals, masks, and membranes
Thisotherworldlythisworldlyworld

We make when we unmake we
Why Anthroplaylogy matters

 – Stuart McLean

My stomach is bloated. Once I was living on a little lake in Michigan called Grass Lake where everyone hung out on pontoon boats drifting around. One guy had sonic equipment that showed the fishing holes under water. He trolled the lake purposively every morning going along the edges so everyone had to see him or avert their senses.

I would drive to Ann Arbor past fields of cows and this is how bloat got me here. The image of the cow at A&M or someplace that had a window cut into its side so you could see its innards. The thought passes that a cow could explode like a whale and I don't know whether the window cut in her side would stop that possibility or start it.

Anyway, I would pull over and gaze back at these cows sometimes, usually on my way home having just avoided running over a lot of jumping rabbits. The human life around the lake was dull, a dull realism, but a weird realism exploded out of that dull realism. One of the neighbors killed somebody like his wife. When we walked around the lake we always found dismembered deer bodies. Packs of wild dogs ran. When we turned on the old furnace in the basement it started to smoke really bad so we finally called the fire department. A lot of firemen trooped in and said things. We heard scratching noises in the kitchen cabinets and no sign of mice and one night when I was propped up in the little bed of the one of the seven ramshackle bedrooms I felt something fly very close to my face, its wing wind stirring my cheek. I turned on the light. There was nothing. I turned off the light and sat there freaked out. After ten minutes a little paw-like thing tapped me on the shoulder. I had to unfreeze before I could get up and turn on the light again. Nothing. I could have become a sensitive then. Instead I invited someone to stay and she, without the benefit of my story, told me there were lots of animal spirits in the house. I became a nodding skeptic and never told her but I was glad for the company.

All of these registers would have been failings on their own, a flatness—the place, the pontoon boats, the firemen, the science cow, the crazy criminal acts erupting in the closed-up houses, the man with the sensory boat, even the rabbits just doing their thing at dusk. But this was a self-sensing world set off by a little bloat, some boats, a little memory drift. That lake moaned in early spring, deep, weird, loud, long moans, the occasional sharp crack of the ice, sudden and severe, not something to sneer at. We played games with it, getting out on the ice on snowshoes until a crack snapped too close and we could see the extent of the trouble and then we ran to shore as light-footed as we could, hardy sensitives, foolhardy realists.

– Kathleen Stewart

Scribbling / typing / thinking and un-thinking are happening. A huge cloud of dust just blew by and with it a slow growing *swooshhhhhhahh* (the kind that opens up at the end). An atmosphere lifted, stirred, whirled, and taken somewhere, over there. Like the tumbleweeds that wander through west Texas (starting one place, ending up in another, bloating along the way). There are no tumbleweeds here, but wind yes. Wandering as well.

Bloated words wander from our screens to printed pages to our mouths to the whiteboard, back to pages and screens. Do they get less bloated with all that wandering? Or are they haunted, like the tumbleweeds, by all the places they've been. I suspect they pick up more words along the way. Gangs of words jamming up against each other in a dust storm of uncongealed, uncooked thoughts. Haunted and windy wordscapes. Clicking keys, pauses, and sighs. Repeat. But don't keep repeating the same freaking words. Wander a bit. Like that dust. Or repeat, but differently. Un-think, un-learn. These few words. Pay attention to the birds, they just announced the calming of the wind.

Try not to write about shit. I didn't pick that word anyway. Why do people often write or talk about shit when asked to improvise? A Tourette-like reflex Keith, Joe, and I were discussing over lunch. Maybe I should've picked the word shit, to quirk myself out of old habits.

Stuart is quiet. He thinks. Or at least he looks very thoughtful. He stares at his screen but he doesn't type. He turns his head to face the sound of children outside. He returns to his screen and types like he is going somewhere. The wind sounds like a truck, or a river. Whatever it sounds like, it always sounds like something going somewhere.

– Lina Dib

clumps of still ailing microphones
sensing muchness of what?
ailing concepts clumping—wailing world
everything we find worth wondering about

bored anthropology?
of too much room?
what is listening?

what isn't listening?
what isn't worth listening to?

digital concepts of on and off
what isn't worth listening to again? bored?

suspended moments are not still,
still, a suspension, extended time,
what does an ailing microphone pick up?
a signal of itself,
a self sensing world
a self sensing world
when plants are singing (or wailing)
is ailing self sensing?
when singing in clumps –
still having to extend this
failing

noise?
the sound of wires, nerves, breathing,
when still
when wailing
are they sensing themselves?
a form of stillness?
what is sensed?

word clumps

theory as ailing word clumps

microphones sensing up small differences

in stillness, through boards,
de-clumping writing,
writing sensed clumps
whooshing of wind, not-soft carpet, keeping my feet up, broken chair sitting sideways, typing awkwardly, fighting the autocorrect which undisciplined my writing.

not epic

who will listen to the recordings our microphones have picked up? can we post them on youtube and pair them with spoken word events and Nailed It!

do squeaking chairs make those people move less, and does that change how they talk or write or think? do cold rooms or rooms with a vista or ailments change the character of workshops?

what would this writing have been if we hadn't had to speak it?

– Joe Dumit

What's happening? There's an itch that wants to be scratched. A sensation, an irritant—depending on how you attune yourself, you may find it's a pleasure. A provocation? Sit with it long enough and you'll move beyond its surface—to attune, to track, to respond to a subterranean, subcutaneous, sub-fascial itch.

It's a constellation of itches I seek. I am trying to attune, not to atone.

Must use all the matter in my head: bone, cartilage, fascia—tooth, nerve, tendon. Don't forget the inner ear—its bony, conductive labyrinth and its relation to the acoustic nerve, the fibrous bundle that keeps my body from succumbing to gravity's pull. Gotta stay upside downright.

To be a channel, a medium, one has to attune—but differently, variously.

Any stasis is ephemeral, but.
The ephemeral materiality of sound, snatched up by a change in air pressure, gains a second wind—a fleeting alterlife as verbal discourse.

Is the wind also a winding?
Natasha says the tree is spiral. The spiral is its tree-ness both in life and death. It is a slow and potentially generative death, a drinking and a dessication.
Funny how they go together—dehydration via the SOAK.

They had to throw water on the floor, just to make their measurements possible.
The humid and the try.
Now that's an interesting in-between-ness: the water in the stone—sinking, soaking.

COMPOST/ition. The compost heap: I've eaten cukes, squash, and tomatoes grown from plants that came up out of the pile.

How to make a think in the gaps, between the seeming objects?
Think with the glue. How does it bind? Or the fissure—what does it span?

Composition / Compost-heap—I'm pretending they're fused. That's where I want to make my think, but I don't have the words. A doing before or beyond words.

The simultaneous freedom and constraint of becoming the medium. R and A and A taught me to love the constraint, to inhabit it—to find a proliferating, microscopic world within the span of a fly's wings.

That's the odd thing about bodies, knowledge, sensing, and attunement. My scratch seeks the itch. It knows there are itches. They're not of the generalizable ilk, but the coordinates remain fuzzy. My proprioception's not yet fully attuned.

– Rachel Thompson

Another world in this world implies an origo, a center, a "this" that comfortably rests somewhere beyond the end of an extended index finger. Whose world is "this," though, and whose is another? I think of China Miéville's book *The City and the City*, in which two different cities exist—not so much next to one another, but more broadly *prepositionally*, which is to say about above after against along among around at before behind below beside between beyond by and down near each other. The residents of these two cities live their lives as a sort of anxious game governed by Breach, a mysterious institution that enforces rules about unseeing the other city and the people who live in it. Should one falter, which is to say, to see, they face harsh repercussions from Breach for doing so. Lines not so much visibly drawn or rendered in space between this world and another, but made palpably real through the force of law and the right for an authority to punish.

This prepositionality of relations, of being all mixed-up, or feeling like the relations take no certain form or all certain forms all at once, is a game of sorts, a terrible game that does one of the things that games do—it organizes the players and helps them figure out what to do and what to do next—but it utterly fails at the other thing games are for, the fun, the unwordable muchness that emerges (we hope, sometimes) from the action of the game.

This world and another world—the city and the city for Mieville, perhaps anthropology and art for us—how do they align, and where is the muchness—the fun—in their ordering? What sorts of punishments do we face from Breach for seeing these worlds in their full prepositionality, for seeing their otherwise unseen relations? Moreover, how do we do that seeing?

– Keith M. Murphy

Thinkathoughtthoughtathink
The indefinite becoming subject
Verb becoming object
Something's not quite right, some kind of nervousness, **the itch**
skin as sensor and the fact of subcutaneous touch
is proprioception recursive?
Or is it like wind? A difference in atmospheric pressure that moves
Worlding bodies that
I'm getting lost and hitting dead ends: I reached a wall
I'd rather wind around
Amble aimlessly
I'd rather stand still
And not try to say anything
But apparently something has to move, get moving, move along
We're all trying to "make-a-think"
I don't think I'm getting anywhere
I'm really not getting anywhere.

– Marina Peterson

Still. Follow me wondering, if you will, about milk vodka and a still as a reduction machine. Picture a hand carved wooden shuuruun on a pot with boiling water and cloth stuffed around it to concentrate the steam through a hollowed out trank, dripping into another vessel. All of this precariously balanced on the woodburning stove at the center of the *gir* (or yurt) with kids playing and adults milling about chatting. Eventually we'll have the hooch. Boiling down the mare's milk into *araga* which famously gets Russian presidents drunk. So getting drunk on the reduction and addicted to the still; is this dark side of ethnography. Beholden to the still, to the method and the enchantment of the drink. Getting drunk on the reduction and complicit with the still. To the stillness.

An other still is the still of stilling myself and chasing out myriad distractions. It is a focus, holding on to a fleeting idea. Clearing space to breathe and to think but also to fall and feel a chill but not to worry about other stuff. The clamour of other stuff is a curse and a boon. Finally still as an ongoingness as a still here. As an unfinishable project. And the project itself is a conjuring, a bringing into being. They conjured images long before the photograph was invented and it wasn't until the early nineteenth century that they figured out a way to put those images in suspension. The suspension is a stilling, too, and a killing but also a prolonging of one kind of life, anyway. As Trotsky said of Lenin: after "the October revolution photographers and cinema-operators took Lenin more than once. His voice is recorded on phonograph discs. His speeches were reported and printed. Thus all the elements of Vladimir Ilyich [Lenin] are in existence. But only the elements. The living personality consists in their inimitable and steadily dynamic combination." (see https://www.marxist.org/archive/trotsky/1925/lenin for a transcription of Trotsky's 1925 book about Lenin; accessed April 2017).

So wandering back to the first thing I conjured, the Tuvan still for distilling mare's milk into "vodka", I want to stay with the wondering. But not just the wondering of speculation and thought, the wondering of producing wonder worlds… the tinkering to make or reveal wonder, which is a weird/wyrd binding of the absolute particular of experience—the affective—to the sensuous particularity of history's eventness.

I chose suspension for the suspension of belief required to be a good reader and the suspension of disbelief required to be a sympathetic reader. We're caught shuttling between these places and I want to put my readers on this shuttle, too. I want them to have that give and take and the patience to the let the wonder world seep in, to weird their thinking as infinite futurity for being thinking in the world.

– Craig Campbell

What is happening is this: Things become swollen if in different ways.
Though I suppose that I mean these ways:
> swollen like a river in flood,
> swollen like the white space on a page,
> swollen like a man in a plastic bag,
> swollen like a belly in bloat.

Or I think distention in this case is really good, great even and it doesn't preclude dryness, or what I want to say is that there is something about the excessive bits, but that is the wrong word, about the gaseous bits that do the work, in many of these pieces, a swelling up of particles marking a distance from other particles that makes things seem difficult to stomach/seem simply true. Still Dead/Flowing. Poetry that is not poetry. That's a weird realism, that's a fattening of form, that's composure. No. A composure is something else. It's the time it takes for particles to move away from other particles to create a distention that can make things otherwise difficult to stomach simply simply easy. There is an easiness with which these words come together, these conversations, these works. I'd like to hold onto that, joy, play, serious distention, seriously weird realisms, seriously. Is what is happening, seriousness? No. No. Fermentation. More like that. Kim Chi is a weird realism of cabbage. How about doing things half way? This half a jerk is puffed up its form, is fattened by this other thing. Here acoustics. What is happening. I don't know. That is ok. I like pushing and not pushing, being pushed, and … listening. Composure. Is this an exercise? Can we fill halves of things with other things? Can we fatten form without loosing composure? This might in fact be my hope. No Boom. Though I didn't erase it. No surprise that one. I did see it go, with the tip of my index finger now green. How to make a think which is composted **and** distended. Which is poetry **and** not poetry. Is **and.** What I like? I liked Keith's this with that, belly with bloat, form with fattening, realism with weird, RK with acoustics. It matters a lot what stands between terms! This is the territory, the terrain that will matter. I think none of us are interested in against, not so much anyway? Fertility in bloat. No, no. It's not weird realism. It's not magical realism. Here is another thing I like a lot. I like the move away from productivity which is the enchaining (Enrectumating? Interventioning?) of doing toward purpose, here is not exactly unknown, but it is certainly unclear and I think it's not about creating a master dialog to throw (like a shit fight) at the others, let the anthropocene be, let the ontological turn be. Fermenting is not fomenting. What is happening is a thing finding its way, but it's not a thing. A burgeoning. An overwhelm. I didn't pick terms that allowed me to think about a paring down, a condensation which is not a composure, rendering we said but what from what? What pleases me about the bloat is that it defies easy deployment though it's very easy to create or just have happen.

– Gretchen Bakke

A report from the archives of the Monument to Eternal Return: Comgar

Craig Campbell

From The Introductory Statement Of "The First Comgar Work Plan":

Comgar is a modest détournement of monumental architecture in the service of food security. The future of Comgar is invested in the soil. We commit to the idea of the commons by redistributing labor and increasing the visibility of the toiling gardener through the spectacle of collective work. Comgar participates in food's recursion back into the spaces from whence it was expelled under nineteenth and twentieth century industrial development and urbanization. It is not any physical space but rather a revanche of the rural where food and labor dwell with greater proximity. Comgar presents another version of revolution: the slow revolution of location and labor. It is a common wealth that depends upon seasonal cycles, insisting upon and fostering multispecies encounters. Comgar is a Garden of Eternal Return, it is an urgent signal calling upon fellow travelers to get their hands dirty.[1]

An Introduction To The Monument

There is an urban garden located in a small city, not too far from Moscow. At the center of this garden is a raised bed planted with turnips, in the midst of the greens, the upper section of a gargantuan hand protrudes from promising loamy soil. The fingers are tight together; it is evidently the right hand of a giant whose body rests below. This finely carved statue of white stone rises nearly six feet above the tallest turnip greens and one can only guess how deeply it goes beneath the surface of the earth. Aside from its imposing proportions, the hand is unremarkable. More surprising: a human-like duck in sailor's shirt and cap has

wrapped a rope around the top of the sculpture and attempted to pull it out. He has pulled and pulled but has not been able to extract the hand, so he has called for help from his friend the mouse. The mouse (in trousers) has taken hold of the duck but together they cannot remove the hand. A third animal is summoned, and a fourth, and so on. A small crowd has gathered round the scene: some watching, some sitting and mocking (that lazy wolf with his cigarette!).

The hand belongs to Vladimir Ilyich Lenin, the Bolshevik revolutionary, author of *What is to be Done?*, first leader of the Soviet Union, and mummified corpse in the center of Europe's largest city. He was called Comrade Lenin by many, others gave him the honorific *Vozhd'* (the Leader),[2] after a sustained campaign of mythologizing children learned to refer to him affectionately as "Grandfather". Barely showing as much as the wrist, the hand is steadfastly gesturing like those old statues found across the USSR. But now, instead of pointing out the path to communist plenty, it is oriented toward the giving sun … as though instructing the field of turnips the way forward in their relentlessly progressive growth. The cartoon animals, icons for the children of the cold war, are attempting to unearth the hand. These characters, once pressed into service for work in the ideological battles between socialism and capitalism, are now free agents. Nearly human-sized, their hard-coated, candy-glossy colors stand out against the pale stone of the hand, the black dirt, and the green turnip leaves.

This monumental sculpture with neatly planted turnip rows is the centerpiece for another, much larger garden. The central plot of turnips is enclosed with a thick step of rich red porphyritic granite, polished smooth so it catches sparkle in the sun. It is the same stone that was used in the construction of Shchusev's mausoleum for Lenin, built in 1930. This stately polished stone wall rises nearly three feet above the ground. It offsets the mundane practicality of the outer plots. Beyond the granite border extends a large working community garden with walkways, lean-tos, sheds, and benches useful to its members. The outer garden is a patchwork of plots and paths. It is comprised of individual allotments each unique in its own way and modeled on Soviet-era dachas and war time "victory gardens." The community garden is itself bordered; not with granite this time, but with recovered concrete.

This nested memorial garden carved out of an entire city-block is called Comgar, an Anglicization of the Russian compound noun: *komsad*. This word is derived from the agglutination of *kommunalnyi sad*, which can be translated as communal garden. In part this memorial seeks to rescue the idea of communal

work from its semiotic denigration in the post-Socialist world. Communal apartments (*kommunalki*), Collective Farms (*kolkhozi*), and obligatory weekend labor parties (*subbotniki*) were forms of communal organization foisted upon diverse groups of people who found themselves living under Soviet rule. They are forms that are looked at by many with a deep sense of antipathy and resentment, though for others there is also some nostalgic valorization of these ideas.[3] While the violence, repression, and censorship of the Soviet era is under complicated tensions from feelings of nostalgia and national pride, it is understandably difficult for many people to approach anything with even the faintest whiff of communism without justifiably profound skepticism.[4]

Comgar reimagines the form of the monument as a space not merely for contemplation (or ritual performances of nationalist obligation) but of voluntary collective labor and the promise of eternal return.[5] The garden grows through the cracked cement of the great industrial age with the rooted and thriving force of a green future. There was no victor in the Cold War, an era that roughly maps on to the beginning of the Great Acceleration. Though if we trace the spoils we might catch a glimpse of its beneficiaries: the so-called advanced nations whose economic and political might was built on aggressive regimes of resource extraction, production, and consumption. More visible everyday are the inheritors of the Cold War's detritus: poisoned landscapes, increasingly disenfranchised citizens, and political chaos amid the abandonment of grand social imaginaries. The Cold War's *modus operandi* was founded on an accelerationist paradigm of industrial exploitation that arranged human populations according to geopolitical abstractions. The stakes today (as before) are no less than the recognition that "some modes of human sociality" (Povinelli, 2016:13) are more virulent and catastrophic than others. Of course it is not just the poisoned earth that threatens—that was always forgettable to mobile capital and world elite—global warming associated with the concentration of atmospheric carbon dioxide has expanded the threat to all humans. An expansive conviviality like the sort seen in Comgar rearranges human relations and debts. Through such work it deflates the overheated metabolic rifts (Wark, 2015b) caused by the indifferent peripatesis of industrialism. In the language of the Comgar project, it's about "getting right with Gaia." In accord with this hopeful challenge of fostering other modes of being with others, the Comgar monument presents a more modestly articulated dreamworld born from the corporeal effort of collective labor and the aspirational habits of biological growth. It is also one firmly grounded in place and a politics of location that insists upon

attending to site-specific material transfers: "eating, pissing, shitting, sweating in a place and sending matter back into soil." (Povinelli, 2011:160). The geontological project outlined by Povinelli is manifest in the politics of being (thus thinking, dwelling, laboring, dreaming) in place and entangled with life and nonlife and challenging the "covert biontologies" of Western metaphysics (Povinelli, 2016).

Comgar's polished red granite is made from the same stone used to build Lenin's mausoleum in Moscow's Red Square. The tomb was designed as a symbolic foundation from which political figures spoke; first to the Soviet nations and second, according to the doctrine of permanent revolution, to the world-becoming-socialist. These leaders gained authority by standing atop Lenin's body: dead and speechless within the grand funerary architecture of his tomb, which itself seems to speak without end. In Comgar, authority is redistributed among the workers toiling over the remains of Lenin's ideals. This re-arrangement buries tomb and mausoleum deep enough to move on with the business of engineering a new conviviality out of turnips and top soil; a gesture toward "collaborative survival in precarious times" (Tsing, 2015: 2).

The hard-coated figures from both Soviet and Western cartoons standing in the central garden re-tell the famous Russian folktale of Grandfather who plants a turnip that grows to gigantic proportions. Harvesting the turnip, in rhythm and rhyme, requires a long line of human and nonhuman characters working together. The turnip/hand re-imagined with cartoon characters comments upon national folklore and mythologies. Comgar's inner garden is quite literally a burlesque mocking the classical history of figurative memorials with the low-brow sidekicks to ideology's "grown-up" projects. If you need any help in legitimating the relevance of cartoons to social theory, consider Benjamin's fascination with the "globe-encircling Mickey Mouse" (Benjamin et al., 2008:38) or Ariel Dorfman and Armand Mattelart's *How to read Donald Duck: imperialist ideology in the Disney comic* (1975). Birgit Beumers argues that "Soviet animation was much less affected by ideological constraints" (Beumers, 2008:154) than film; we might say "Western" cartoons were also more concerned with general moral instruction, though they certainly contained the traces of their historical conditions of production (which is more or less the argument made by Dorfman and Mattelart, 1975). Here, the burlesque builds on old associations while catching up with these rich semiotic figures as they continue their paths of weakening attachment to old connotations, moving for many into a softer register of nostalgia where Grandpa has become the turnip, unharvestable but through collective effort.

A report from the archives of the Monument to Eternal Return 145

Figure 8.1 COMGAR Workplan, figure 1.

Finally, the community garden connects land and labor (salient points of contest in both capitalist and communist countries) to the everyday experience of people dwelling within such ideologically over-determined worlds. The monument is experienced as a seasonally changing rhythm of growth and fallowness, a repertoire of labor structured around the solar gift: the sun's dispassionate generosity. The immersive sensory appeal of a working community garden directly inverts the traditional urban monument of concrete and stone. Comgar is both a place to visit—to reimagine the conceits of "man's" dominion over nature and faith in industrialization—and a place for locals to grow plants

and community with the urgently simple goal of producing food and sociality in a space that Nicolas Bourriaud might call a micro-utopia. It is a temporality, though, that is firmly grounded in the sensuously rich performance of embodied labor.

Eternal Return is a reference to the tempos at play in this scenario. The very concept of a monument is an appeal to the eternal, or at least the very long span in comparison to the limits of human corporeal life. The monument operates as a bulwark against time's ravages, against oblivion. Eternal Return really finds most resonance in the modest investment of labor, in the collaborative effort to grow. The Garden of Eternal Return is also a little utopia of sustainability. It is bounded and thus limited in its potential, eschewing the capitalist and communist fantasies of endless growth. Eternal Return functions as a deviation from the more conventional notion of historical repetition. Here it is a radical biophilosophy of sustainable life under the giving light of the sun. Matter is never extinguished but recombined endlessly, though one might also say it is simply recycled, without recourse to eternity. Comgar is an anti-monument, then. Its logic is strange and incompatible with the conventions of monumental art, a widespread cultural form that arranges time and organizes national belonging according to a commemorative straitjacket of anticipated mattering.

The partial burial of Lenin below the earth is not best described as revenge. Neither is it erasure of history, rather it is a careful and selective composition. It is also not really a tribute to Lenin, but rather a tribute to a structure of feeling: that collective sense that the world could be other than it was. This is a feeling that is needed more than ever now that it has finally become impossible to deny our economic systems are based on the destruction of the very environment that allows us to live and thrive. Comgar is a monument to eternal return: to the end of empires and in their wake the modest hope of fertile seeds and ripening berries.

After the 1917 revolution, Bolsheviks were at pains to replace as rapidly as possible the symbols of Tsarist power. The architect Vladimir Tatlin famously proposed another kind of anti-monument in 1920. His *Monument to the Third International* was never built, it might have been the world's tallest building, hundreds of feet taller than the Eiffel Tower. It resembled, in the savvy words of Svetlana Boym, "a forgotten cosmic station built for the launch that never took place, an open-ended construction site and a utopian ruin in one … Most appropriate for the urgency of the moment were not permanent architectural monuments that take too long to erect but mass spectacles that have an immediate effect of entertainment and propaganda" (Boym: 133). It is curious

then to think of the ruins of a spectacle; how storytelling steps in where a ruinophilia is impossible; how stories are reproduced with great attention and care and how they might carry hints to the sensuous life of dynamic structures with unfolding and porous futures.

Lenin And Ruin

Statues of Lenin, monuments to the leadership of the October Revolution of 1917, have remained an important part of the built environment across the Russian Federation. They continue to matter, though their mattering is as complicated and fraught as you might expect. Elsewhere, in countries now independent of the former USSR, vestiges of the revolutionary leader have been removed. You might say they have been deaccessioned from the public square. The indignities heaped upon these statues were evident in the celebratory days after the fall of communism in the early 1990s. On the Crimean sea is an underwater museum for divers populated with Soviet-era statues, including a bust of Lenin.[6] *The Atlantic*,[7] an American monthly magazine, has published an excellent collection of images on the web documenting the fate of the Lenin's rigid doppelgängers from around the world. A Russian language website[8] maintains a database of Lenin monuments. Not including countless signs that bear his name on streets of the cities and villages, the database registers three-hundred and thirty-three monuments to Lenin. The largest statue of Lenin in Ukraine, located in Kharkiv, was toppled on September 28, 2014. One curiously macabre video shows a botched attempt to remove a statue of Lenin, using a crane. In the video, the supports fail and the statue is accidentally decapitated, rocketing the weighty head into the distance and out of frame. In 2013, when a granite statue of Lenin was brought down by Ukrainian protesters—agitating to cut ties with Russia and join the EU—they smashed the head to dust. Through 2015 several statues of Lenin in the Siberian city of Tomsk have apparently been beheaded by vandals—indeed Lenin has been losing his head since the beginning of the 1990s.

To any student of history this is not particularly surprising. Svetlana Boym recalled similar events surrounding the monuments of Imperial Russia after the October Revolution: "According to the decree of the Soviet People's Commissariat on the Monuments of the Republic, 'monuments commemorating tsars and their servants' were to be put 'on trial by the masses'" (Boym: 132). It didn't end

well for many stone, metal, and plaster icons of the former regime. The defacement of Lenins, bringing them to an accelerated state of ruin is not only an affront to the artifact and its appreciators. The absent statue produces new territory in the public imaginary, opening up in public space whole new horizons of forgetting.

Countless images can be found on the internet of statues of Lenin, big and small in various states of ruin. A granite statue of Lenin was dismantled in Berlin in 1991, photographs of the head carefully removed with a crane were starkly different than the smaller statues toppled by crowds with little more than sledge hammers and ropes. A metal statue in Riga was pulled from its pediment while crowds gathered around—have a look, the internet is full of such images from across the former Soviet bloc. In one 2014 photograph[9] from Ukraine, attributed to Sergey Kozlov, a man can be seen holding the nose and moustache of the (in)famous grandfather. From pensive portraits of people sitting atop toppled statues of Lenin to the lusty violence of men taking turns hammering stone to rubble—caught in between an expression of deep resentment towards the era of Russian-dominated communist rule, nationalist outrage, and a generalized mob passion. As these men smash the monument their action becomes an ironic and anarchic gestural ode to the hero of Soviet labor with his proletarian hammer—heaving an ancient gesture of transformative force, the sledge descending in an extended arc and rendering that which was once whole, a mess of barely recognizable fragments. The fate of the leader, so too the fate of socialism.

Jonathan Platt reminds us that the death of Lenin in 1924 "was a foundational moment in the production of Soviet folklore" (Platt, 2015:87). Platt's exploration of the connection between the early Soviet novel *Foundation Pit* and the construction of the permanent tomb for Lenin has some important points of convergence with this exploration of the Comgar monument. Where Platt explores the event of "digging into the earth" (Platt, 2015:105) I am interested in the labor that comes after the construction: the ongoing work of maintenance. Eternal return displaces the builder from his pride of place, he steps back and the peasant farmer steps forward with her apron and sickle. Attention to such maintenance-work owes a debt to Aleksandr Bogdanov's *tektology*, founded on a commitment to building and nurturing a collective-labor-point-of-view (Sochor, 1988). Following Wark's re-reading of this work, reconfiguring the labor point of view and more modest forms of action in the twenty-first century, the Community Garden can be appreciated as a small but compelling response to climate change and the challenge of sustaining a more convivial world.

Comgar is built on the ruins of socialism and it functions as a defacement of Lenin as the great icon of Soviet power, removing him from a high position above the fray, relocating his body in the ground. This gives him, in some ways, the symbolic burial he was denied, as it was decided his corpse should be embalmed and laid to rest above the earth in that mausoleum set before the Kremlin on Red Square.[10] Comgar offers a positive defacement though; one that seeks to rehabilitate selective elements of revolutionary passion. The trash aesthetics (Highmore, 2002) of a half-buried statue and the rubble wall undertake their own defacement of modernity's grand schemes and promises. This reframing of ruins reconfigures the way in which history is both understood and felt. As with MacKenzie Wark's (2015a) project to recover lost insight in Aleksander Bodganov's hope for a truly proletarian cultural movement, this one remakes hope from the patient mattering of the past. Writing against the monumentality work of archives, Ann Cvetkovich delivers a powerful call for subversion in her *Archive of Feelings* which explores the unanticipated ways in which memories "cohere around objects" (2003:242). The rearrangement of the statue is not meant as a great symbolic gesture marking Soviet communism's defeat, but rather a reconfiguration of abandoned dreams: old matter for new growth.

Comgar as a monument to telluric (earthly) labor partnerships. It is a monument not to human labor alone but to the novel recognition of an archaic collaboration: humans and plants (among myriad other critters including bugs, birds, and microbes). The collective labor of the living, what I'm thinking of as *conviviality*, has as yet unexplored resonance with older Marxian ideas of the "dead labor" of capital. The war against nature at the heart of industrialization and industrial-modern discourses was actually a kind of internal struggle. It was "man" at war with himself (to poach the militarized and patriarchal language of the era). The failure to apprehend this is a failure that now imperils humanity (has already wreaked well-known havoc in the world including species extinctions) and that threatens to inaugurate a new era of deferral of justice and freedom through toxic geographies and zones of peril.

Marxism was principally designed around the figure of the proletariat, the industrial worker. The industrial worker was without question the real hero of communism. But we must not forget Soviet communism's other hero, somewhat in shadow of industrial labor: the gardener. The collective farm worker (no longer a peasant) is a heavily gendered figure in Soviet iconography. She is seen most famously in Vera Mukhina's statue at the Russian Exhibition Center:

Worker and Kolkhoz Woman. In this statue (which gained great fame as the logo for the soviet movie studio, Mosfilm) a woman dressed in peasant garb raises her sickle alongside (though slightly behind) a male industrial laborer raising the blacksmith's hammer. The hierarchy is clearly established between the male worker and the female peasant. The hammer and sickle eternalized this even as these artisanal tools came to be replaced by machines under the industrialist economies of Soviet developmentalism.[11]

Pertinent to the subject at hand (a modest organic monument), it was the temporary return of private gardens, shortly after the collectivization of property, that limited the effects of a brutal famine in the 1920s. Comgar builds on this history, it remembers the New Economic Policy, allotment gardens, and dachas. This was food security in a moment of catastrophe, though it was seen as an imperfect and interim measure until the rationale of agrarian science could implement a permanent national-scale division of labor. In an increasingly urbanized world, which has paralleled the cold war and the Great Acceleration (all entangled together) is the movement of people away from rural farms and villages to towns and cities. Technocratic and industrial planners responded in both the Soviet Bloc and the capitalist West with greater degrees of agricultural intensification through mechanized production and chemical interventions. Rather surprisingly the United Nations Conference on Trade and Development delivered a report in 2013 on research that supports a turn towards small scale farming. Their report recommends:

> a rapid and significant shift from conventional, monoculture-based and high-external-input-dependent industrial production towards mosaics of sustainable, regenerative production systems that also considerably improve the productivity of small-scale farmers. We need to recognize that a farmer is not only a producer of agricultural goods, but also a manager of an agro-ecological system that provides quite a number of public goods and services (e.g. water, soil, landscape, energy, biodiversity, and recreation).

This striking claim lends credibility to the myriad global efforts to build food security through urban farms, harvest sharing initiatives, and other experiments in reexamining traditional modes of collective labor with plants.

The submerged figure of Lenin (remember, visible only by his hand) is a figure that gestures towards common wealth and conviviality. The notion of collectivity and not only a de-partitioning of property (and re-partitioning of conceptual apparatus) but also of collective responsibility and, most importantly,

of collective labor, is central to the experience of the solar gift. If equality is taken as a foundational principle and equal rights to dignity then it is through a perception of the collective that we find solution to impending catastrophe as we near the Great Acceleration's burning apex. The emerging hand submerges the identity of Lenin without erasing it. The partial (in)visibility of Lenin is akin, perhaps, to the notion of the rhizomatic power of collective de-centralized labor. While labor may become increasingly difficult to recognize in the twenty-first century, it is not all screens, keys, and mice. Working on your plot in the community garden addresses a more primal need for the sensuous body. The rich smell of rot, the weight of a bucket of water or the density of a clump of earth are all part of a repertoire of being in the world experienced (idealized, endured, enjoyed) by many. There is no anachronism here, rather an eternal return. Humans eat of the earth and are eaten by it. "What needs reworking is the struggle of labor in and against nature" (Wark, 2015). Work with and within the garden is a collaboration. It is a displacement of "domination of nature" epistemologies, which have tended to define thinking about labor as romantic struggle to wrest a living from a reluctant earth.

The hand of Lenin is a gesture (in this case towards the sun), a salute then! Accepting the gift that cannot but be accepted. It is also symbolic of labor. The hand that joins the proletariat and the peasant—relocating rural modes of work to urban and suburban spaces. Comgar compliments the dachas and allotments which really expanded at the dawn of the Great Acceleration in mid-twentieth century Soviet Russia as food security. The location of the Comgar monument exhorts us to remember less through an intellectual appeal to history or an emotional appeal to nation but rather to the corporeal appeal of labor. Labor is neither abstraction nor chimera. It is located and specific. It ties bodies to temporal rhythms as well as unanticipated events. The specificity of labor and the labor point of view invigorates the challenging question posed in the Comgar monument: what is communal labor after communism?

Community gardens dismantle the divide between urban and rural life. The garden worker is the child of the proletarian and peasant. Those beautiful figures of socialist realism canonized in so many works of art and popular culture: The heroes of labor.[12] And now, in this expanded sense, if we accept a post-humanist turn the hero of labor is not an identity-full figure but a set of relations among humans and nonhumans or other-than-humans; persons in the radically expanded sense, as inclusive of great apes as mosquitoes, rubber trees, and colorful pebbles. The shared intimacy of an atmosphere that seems increasingly

local. The challenge of representing this iconographically is perhaps the challenge of sharing the idea more broadly. The hero of post-human labor looks like what? Obviously, it looks like the sprouting hand of Lenin. Submerged in soil, not standing on the earth and shooting off of it but indelibly entangled with the dense community of microbes in a tellurian collaboration.

Comgar is a monument to the collaboration between the humans and plants. It is a monument to seasons, to cyclical time. From the gardener's point of view the diurnal cycles (day/night and basic climatic pattern of cooling and heating) and the so-called tropical period, which is defined by the intervals of earth's heliocentric orbit and the regular and equitable distribution of solar energies. Comgar rearranges the sensible. It vivifies the body of Lenin, extracting motivations of equity, of a better share of things, burying but not forgetting the uneven decay of malevolence in history.

A Compostscript

Dear Comrades. The essay before you was written in an experimental mode of cultural critique. It is a fiction that functions as an analytic and as such it is a device- albeit conceptual-for making sense of plants, food, and labor in the era of global warming. The purpose of this chapter is to deploy "critical making" or "project-led research," both forms of critical media practice. I used a call for submissions as a starting point to engage with a conversation about monuments, contemporary art, the Cold War (and "victory"). I use my experience after many years of working on themes related to Siberian Indigenous peoples, the Soviet Union, the Russian Empire, the Russian Federation. Much of the work of this project is in the planning and layout. The illustrations that accompany the work document processes of thinking through drawing. This illustrated study of a post-industrial monumental art installation entitled Comgar is lodged squarely between cultural history and ficto-criticism or in Donna Haraway's formulation, speculative fabulation. Working with rhetorical modes native to Soviet socialist realism of the 1930s and 1940s, monuments in the era of industrialism, the resilience and precarity of biotic forms [or plants] and labor, and the enduring dream worlds of socialist equity.

This project originated in response to a call for proposals for a public monument commemorating the outcome of the Cold War. The call came from the "Committee for Tacit History," led by the artist Yevgeniy Fiks with the curator Stamatina Gregory:

For over two decades, public signifiers of the Cold War, such as the Berlin Wall, have been framed in terms of destruction and kitsch. A monument created at the moment of its own destruction, the Wall encapsulates the continuing geopolitical imagination of the conflict as linear, continuous, binary, and terminal: the culmination of a now-historicized narrative of competing empires. But while the impact of half a century of sustained ideological conflict still reverberates through all forms of public and private experience—from Middle Eastern geographies of containment to the narrative structures of Hollywood—it has yet to be acknowledged through a public and monumental work of art. The Cold War, the longest and most influential conflict of the twentieth century, has no publicly commissioned commemoration in the United States.[13]

It was unclear if the proposals would ever or even could ever be built. Perhaps it was a conceptual piece, like the Guantanamo Bay Museum of Art and History.[14] Regardless, the opportunity was hard to set aside and offered a compelling thought experiment.

There were, of course, no victors in the Cold War, least of all the earth. The rapid industrialization of agriculture in the service of Cold War games has not resulted in more stability but rather a greater degree of precarity. The laborious acts of planting, maintaining, and harvesting vegetables from the gardens can recall the effects of industrial scales on people living their ordinary lives. Comgar is a monument to a kind of mundane endurance that draws focus away from debates around capitalism and communism casting it instead on industrialism and its discontents (not to mention its abject inheritors).

Comgar was one of nearly two hundred proposals that were rejected. According to the curatorial lead, Stamatina Gregory, "Implicit in our proposal, because we purposely elided any reference to a specific site or budget, was an invitation to utopic, dystopic, or otherwise implausible projects—as well as projects rooted in social engagement. And that message seemed to get across to many of the artists and architects who submitted projects."[15] In some ways the call seems somewhat premature given the return to what some see as Cold War politics in the wake of Ukrainian conflict and proxy wars between the USA and Russia in Syria and Ukraine.

The monument is a bulwark against forgetting. It is built to be eternal. The modesty of Comgar takes hold of the monument and monumental thinking and invests it in anticipation of the simple human production of food. It is a monument to communal labor that is actualized through labor rather than

through patriotic contemplation. The monument sits as a backdrop to the cyclical drama of agrarian practice; the toil, boredom, celebration.

In the 1940s Soviet documentary photographer, Max Penson, shot a photograph later called "Agronomists. 1940s"(See figure 8.2). It features an Uzbek man and woman in a wheat field. Behind them is a monument to Stalin. The monument, a statue on a platform is in a field and contradicts the typical placement of monuments (which are usually found in urban places). This suggests a particular logic of moral primacy in the field: shouldn't peasants, like urban proletariat, have monuments? But more likely, it is a photo opportunity. A monument not made for the masses to experience personally but a monument made for remediation: to be photographed and circulated. This photograph is part of what I call elsewhere a form of socialist pictorialism. Photographs that illustrate the landscape of the future with ephemeral realities. They are staged photographs. The logic of placement and location outside of the sphere of the urban is also seen in location specific monuments that seek to anchor memory to place, regardless of proximity to humans.

Penson's photography has been celebrated for its directness and honesty, for avoiding "false pathos" (Galeyev, 2011:9). Penson's photographs, like many other photographers of the day were raw material used to illustrate print publications that glorified socialist transformation and vilified "primitive survivals." By naming the Uzbeks "agronomists" the photographer signaled an alternative

Figure 8.2 COMGAR Workplan, figure 2.

coding for the Uzbeks who at that time where more typically associated with Russian stereotypes of backwardness, not progressiveness (cf. Anderson and Campbell, 2009). Agronomy celebrates agricultural labor by bringing the arts to the workers (rather than expecting them to travel to the arts). Thus the workplace, the site of socialist labor, becomes also a site for art (pace Bogdanov). The radical reconfiguration of art-consumption and history-consumption is seen here.

Comgar responds to a reconfiguration of territory (the memorial in the field) with another reconfiguration of territory (the community garden in the city). The urban farm and the community garden in the twenty-first century pose challenges to the urban imaginary through deceptively simple acts of labor that respond not to the demands of industrial growth but to the possibilities of biotic community. The seasonal cycle organizes life just as it disorganizes and frustrates industry's economies contra the techno-optimism of twentieth century industrialism. Maxim Gorky, Soviet communism's great literary propagandist, developed a concept he called "geo-optimism:" "With the advent of socialism," he averred, "chaos would be banished forever from the world. Swamps, predators, drought, snakes, deserts and other 'unproductive' lands, 'sleepy forests,' Arctic ice, hurricanes, and earthquakes would all be eliminated" (Weiner, 2009:288). How troubling that we're now seeing this weird prescience, the success of geo-optimism to imprint such a trace on the world. What it would ultimately mean to leave a mark on the world was clearly not understood. Socialist marks on the world were mobilizations of force and power to re-arrange the apparently limitless resources of the earth. This geo-optimism is now replaced by a geo-pessimism and, we should not be surprised to learn that in this truest of petrographies those that benefited most are mostly dead, bankrupt, or have retreated to the rarefied zones of extreme wealth.

Notes

1 Excerpt from the "Comgar Workplan" doc id: 2231.4b Archives of the United Workers of Comgar.
2 His great passion was communist revolution but he was also reportedly fascinated by bogs.
3 Hemment (2009) notes how youth who were drawn into a form of volunteerism under nationalist and social welfare priorities orchestrated by Putin's government use the terms like "subbotnik" derived from a reinvigoration of the language of the Komsomol.
4 The baggage of Soviet-era terminology cannot be ignored in this context. The limits of the sayable, like the limits of discourse, are rearranged here through the garden's

political eco-art. The sensible, to borrow from the terms of Rancière (2006), are redistributed; symbolic regimes are shuffled and strung-out in a play of pragmatism and hope reaching toward a new conviviality.

5 I read eternal return partly in reference to "cyclical time" but more in line with the logic of *informe* and the challenge the ephemeral poses to the archive. In this reading, the formlessness of the ephemeral undoes identity just as it undoes linear time.

6 http://www.atlasobscura.com/places/underwater-museum-at-cape-tarkhankut

7 http://www.theatlantic.com/photo/2014/10/statue-or-bust-around-the-world-in-lenins/100829/

8 At the time of publication, they had 333 unique monuments from 15 countries and 226 cities. http://www.monulent.ru

9 http://www.theatlantic.com/photo/2014/10/statue-or-bust-around-the-world-in-lenins/100829/#img25

10 See Yurchak 2015 for a compelling exploration of the effort expended in fighting the natural decay of Lenin's body since his death.

11 Industrialism—or, as Paul Josephson (2002) calls it, "brute force technology"—was taken as essential to socialist progress towards communism. But we also know that industrialism failed and continues to fail spectacularly and regularly. One need not look further than Norilsk, that Soviet-era assemblage of ecological catastrophe most recently associated with a toxic spill, which turned a river blood red. Norilsk is located on the Taimyr Peninsula in northern Siberia adjacent to territory used by indigenous Dolgan and Nenets people for herding their reindeer (Groisman and Gutman, 2013).

12 Perhaps such an affective life is captured better in what Christina Kiaer calls "Lyrical Socialist Realism": works invested with idealism and hope that sought to reflect "the overwhelming feelings sparked by the collective endeavor of socialism. We know that those idealistic feelings would eventually be ruthlessly instrumentalized, even trampled, and that the idea of the Soviet Union as a modern lyrical community would become harder and harder to sustain." (2014:77).

13 http://www.coldwarvictorymonument.com

14 http://www.guantanamobaymuseum.org

15 "Imaginary Monuments to an Invisible War." *The Cooper Union*. Accessed September 26, 2016. http://www.cooper.edu/art/news/imaginary-monuments-invisible-war.

References

Anderson, David G. and Craig Campbell (2009), "Picturing Central Siberia: The Digitization and Analysis of Early Twentieth-Century Central Siberian Photographic Collections," *Sibirica* 8:1–42.

Benjamin, Walter, Michael William Jennings, and Brigid Doherty (2008). *The Work of Art in the Age of Its Technological Reproducibility, And Other Writings on Media*, Harvard University Press.

Beumers, Birgit (2008), "Comforting Creatures in Children's Cartoons." In *Russian Children's Literature and Culture*, edited by Marina Balina and Larissa Rudova, 153–72. Children's Literature and Culture. New York: Routledge.

Boym, Svetlana (2001), *The Future of Nostalgia*, New York: Basic Books.

Cooper Union (2016), "Imaginary Monuments to an Invisible War," *The Cooper Union*. Accessed September 26. Available online: http://www.cooper.edu/art/news/imaginary-monuments-invisible-war.

Cvetkovich, Ann (2003), *An Archive of Feelings Trauma, Sexuality, and Lesbian Public Culture,* Durham: Duke Univerity Press.

Dorfman, Ariel, and Armand Mattelart (1975), *How to Read Donald Duck: Imperialist Ideology in the Disney Comic*, New York: International General.

Galeyev, Ildar, and Miron Penson (2011), *Max Penson: Photographer of the Uzbek Avant-Garde 1920s–1940s*, Arnoldsche Art Publishers.

Groisman, Pavel and Garik Gutman, (Eds.) (2013), *Regional Environmental Changes in Siberia and Their Global Consequences*, Springer Environmental Science and Engineering. Dordrecht; New York: Springer.

Hemment, Julie (2009), "Soviet-Style Neoliberalism?: Nashi, Youth Voluntarism, and the Restructuring of Social Welfare in Russia," *Problems of Post-Communism* 56 (6):36–50.

Highmore, Ben (2002), *Everyday Life and Cultural Theory: An Introduction*, London, New York: Routledge.

Josephson, Paul (2002), *Industrialized Nature: Brute Force Technology and the Transformation of the Natural World*, Island Press.

Oushakine, Serguei (2000), "In the State of Post-Soviet Aphasia: Symbolic Development in Contemporary Russia," *Europe-Asia Studies*, Third Europe-Asia Lecture, 52 (6):991–1016.

Platt, Jonathan Brooks (2015), "Snow White and the Enchanted Palace," *Representations* 129 (1):86–115.

Povinelli, Elizabeth A. (2011), "The Woman on the Other Side of the Wall: Archiving the Otherwise in Postcolonial Digital Archives," *differences* 22 (1):146–71.

Povinelli, Elizabeth A. (2016), *Geontologies: A Requiem to Late Liberalism*, Durham: Duke University Press.

Rancière, Jacques (2006), *The Politics of Aesthetics: The Distribution of the Sensible*, Pbk. ed. London; New York: Continuum.

Sochor, Zenovia A. (1988), *Revolution and Culture: The Bogdanov-Lenin Controversy*, Studies of the Harriman Institute. Ithaca, N.Y: Cornell University Press.

Taussig, Michael T. (1999), *Defacement: Public Secrecy and the Labor of the Negative*, Stanford, Calif: Stanford University Press.

Tsing, Anna Lowenhaupt (2015), *The Mushroom at the End of the World: On the Possibility of Life in Capitalist Ruins*, Princeton University Press.

United Nations Conference on Trade and Development (2013), *Trade and Environment Review 2013: Wake Up Before It Is Too Late: Make Agriculture Truly Sustainable Now for Food Security in a Changing Climate.*

Wark, Mckenzie (2015a), *Molecular Red: Theory for the Anthropocene*, Verso Books.

Wark, Mckenzie (2015b), "Molecular Red in Nine Minutes." *Public Seminar*, Available online: http://www.publicseminar.org/2015/09/molecular-red-in-nine-minutes/.

Weiner, Douglas R. (2009), "The Predatory Tribute-Taking State: A Framework for Understanding Russian Environmental History," In *The Environment and World History*, edited by Edmund Burke and Kenneth Pomeranz, University of California Press, 276–316.

Yurchak, Alexei (2015), "Bodies of Lenin: The Hidden Science of Communist Sovereignty," *Representations* 129 (1):116–57.

Wind Matters

Marina Peterson

"The bandwidth of human audibility is a fold on the vibratory continuum of matter"[1]

In discussions of "noise pollution," sound is defined as waves, pressure, and energy, used differentially to create links with other domains: the ear, the microphone, other forms of pollution. These documents explain that sound "travels through" air, water, and buildings. However, only airborne sound is registered by "sound measurement instruments" and only airborne sound is accounted for in acoustics testing of sound insulation and sound absorption—of materials (doors, windows, wall panels) used to make quieter architectural interiors.

Yet vibration is the central feature of noise complaints, and of lawsuits against airport noise, which list cracks in walls and ceilings, tiles that have fallen off walls and patios, cracked windows. A residential soundproofing program around SFO had to be adjusted to address low frequency vibration, following sustained complaints of residents living in the wake of the flight path. An acoustics engineer explained, "We've done some work near railroads, a train passing by you get vibration, it transmits through the ground into the structure, reradiates, so you can actually get airborne noise produced by vibration transmitted into the structure." And when you say "airborne sound not vibration" to a sound artist or acoustician, their immediate response is "but all sound is vibration."

Spider Spit[2]

A physicality of the ephemeral emerges in productive gaps between the bases of establishing what noise pollution is and that which is excluded from the category of noise pollution—which nevertheless continues to resonate, meaningful as noise pollution's (lurking) other. The ephemeral is an assemblage of sound as energy, atmosphere, and perception, coming into being in and through their entanglements, instantiated in the microphone, in law, in standards, in kite flying.

The management and regulation of noise depends on but draws partially from a modern physics of acoustics, curtailing *and* affording wider potentials for the sonic. I dwell in the vagaries, the gaps—where the formless begins to take form and falters, where the sensible moves back into sense, taking shape as limits or exclusions that nonetheless have physical substance and qualities. I follow the dance of provisional logics and illogics, as spaces of formlessness are revealed, re-formed. Both modes are creative and substantive, affording a glimpse, a sense, an echo of an immanent ephemeral.[3]

Noise pollution itself is unstable. It continually falls away, its signified (noise? sound?) held stable through a curious, shifting scaffolding. It seems there is a there there, but that there may be a bit more like fog or wind or weather than the biopolitics of epidemiology.

Touch from a Distance

Sound is "touch from a distance." Now I can't remember where I read that, what I was quoting from. It's scrawled on a purple post-it note that I stuck on the window frame above my desk. I like it because it draws together senses of touch and hearing, the former informing an understanding of the latter, emphasizing the immanence of perception rather than a difference between sense and thing sensed, a difference amplified by the object form of recorded sound and by a physics of acoustics that divides "sound and hearing." Proprioception and thermoception, balance and a sense of temperature, are also useful for shifting from an object-oriented understanding of sound. These are bundled under a "sixth sense," along with other senses European modernity did not leave space for. Proprioception and thermoception are coterminous with hearing: the first a state of the inner ear, the latter a sensation produced by low frequencies. Yet today, in trying to pin it down, I don't really know what sound as "touch from a distance" means. It is suggestive—of an intentionality in the relationship between a sound source and its perception, as if a long finger stretches from an airplane engine to tickle an ear drum: a pleasurable caress of the takeoff whine, a nail scratching the cilia of the inner ear.

In 1928, acoustician Vern Knudsen, who forty years later became a vocal campaigner against noise pollution, published an article titled "'Hearing' With the Sense of Touch," the results of a study testing people's ability to distinguish differences in volume and pitch with their right index finger (or, in the case of a man whose right hand had been injured in the war, their left). Knudsen distinguishes between vibration and pressure, stating that the finger's sensitivity to variations in the intensity of vibration is not the same as the "feeling of pressure, or any of the other cutaneous sensations" (Knudsen, 1928:336). That the finger's ability to feel vibratory variations is of an order similar to the ear suggested, for Knudsen, that the sense of vibration is prior, genetically, to the sense of hearing (Knudsen, 1928:336). Moreover, he remarked as an aside, his findings had potential consequences for a general theory of sound—a perceptual rather than communication model, sound energy rather than electromagnetic energy, "the 'resonance' theory of hearing" rather than the "'telephone' theory" (Knudsen, 1928:336).

Noise wavers between vibration and pressure. The decibel is defined as a metric of sound pressure. Instantiated in the membrane of the noise measurement microphone, sound as pressure also suggests a notion of sound as touch. Insofar as touch is distributed across the body's surface, sound as pressure does not presume an ear as the organ of sensory perception but expands to an auditory sense beyond the ear.

Microphone Sense

"There are some fundamental differences between 'air pollution' and 'noise pollution.' These are, in the main, the following: (a) We know the chemical constituents of a 'normal' atmosphere, and (b) our sensing devices (because they respond to separate contaminants) can tell us how much of each given contaminant there is in the atmosphere at a given point, as a function of time.... In noise pollution, however, (a) there is no such thing as a well-defined 'normal atmosphere,' and (b) the inputs from various sources cannot be separated by our sensing devices—the microphones—since there is only one 'contaminant,' the pressure waves. And not all pressure waves are even noise: some may be music or other desirable sounds" (Committee on Public Works 1972:357–8).

The formulation of sound as "pressure waves" and its measurement via the microphone as "sensing device" betrays a slippage across techno-rational registers, conveying how the specificity of noise pollution is crafted out of its potential meanings, and how something that is not air is nevertheless of air.

The microphone transforms sound into signal, now calculable by a noise monitor or measurement device. This sound analyzer was used for a community noise survey in Inglewood, California by Veneklasen and Associates in 1968. One of the engineers was murdered as he was monitoring overnight noise levels. His co-worker's voice breaks as he tells me this, almost fifty years later.

1971 public hearings on noise pollution organized by the Environmental Protection Agency emphasize "citizen pressure," a subject, also, of the 1968 novel *Airport* (U.S. Environmental Protection Agency 1971, Haley 1968).

Figure 9.1 Sound Analyzer.

Clean Air Act Amendments of 1970

Irigaray describes wind and smoke as air's "entry into presence," while air is singular as a *medium* for light and sound: "No other element carries with it—or lets itself be passed through by—light and shadow, voice or silence" (Irigary 2007: 9, 14, 18). This distinction is crucial for the status of noise pollution in the Clean Air Act (U.S. Environmental Protection Agency 1970, 1990). Smoke, an early way of understanding air pollution, is a substance that imbues air; inseparable from it, smoke pollutes air—it is a pollutant. Sound, however, is conceived of as independent, carried along by or moving through air without becoming or manifesting air. Of air but "not air," noise pollution falls away as a legal category. In 1981 Reagan closed the Office of Noise Abatement and Control. The act remains, but without an enforcing agency. In 1990, Title IV: Acid Deposition Control was added to the Clean Air Act, without repealing the existing Title IV. Now there are two Title IVs.

Pieces of Air

Toshiya Tsunoda's field recordings are "pieces of air." (Tsunoda 2001). An airplane is heard "crossing the sky both by its reflection on the ground, and by the original sound wave undergoing mixing and interference." "Perhaps this airplane could be interpreted as tracing geographical features with its sound." His field recordings reconceptualize the work of the microphone as a sensing perceiver of air-space. They emphasize sound as atmospheric, with specific qualities shaped by air. Air is produced as space by sound. Air is *sounded*. Sound is *aired*. The microphone is a *sounding* device.

Fog

Air density—or the relative amounts of nitrogen and oxygen; humidity—the amount of water in the air; wind—the atmosphere regaining balance. Weather disrupts noise measurement. For LAWA noise monitors, wind at Ontario Airport—Santa Ana winds—"corrupts data." L.A. County Public Health Department engineers bring a weather station along with their noise monitoring equipment, and will throw out data "if marred." For the sake of noise measurement and mitigation, objects block sound. Atmospheric conditions, on the other hand, might amplify sound; clouds, for instance, send sound waves back to the ground, "like water waves against jello," an environmental engineer explained. A 1952 airport account of recent complaints they'd received explained that "the reverberation of the aircraft taking off in low pitch, flying under the overcast in a Westerly direction, intensified the noise, which lead people adjacent to Imperial Highway area, to believe that the aircraft was actually flying over their homes" (July 8, 1952). This is a common occurrence around LAX where fog is a regular atmospheric condition due to the airport's proximity to the ocean.

A meteorologist made the distinction that fog *refracts* rather than *reflects* sound, bending and distorting sound "waves." While significant as a dimension of experience, such atmospheric interactions with sound are excised from noise measurement, the objectivity of which is based on the least varying bases of perception and atmosphere. Maintaining atmospheric conditions that do not alter sound too much can be a messy endeavor, both mathematically and materially. At the Western Electro-Acoustic Laboratory in Santa Clarita, when testing materials for sound absorption it is important to maintain the humidity level throughout the process, and to maintain a level that affects sound absorption the least. Previously the lab was at the firm's offices in Santa Monica, where, closer to the ocean, it was more humid. Because humidity affects sound absorption unevenly, they need to maintain humidity around the range where its effect is "flatter." As the engineer explained, "the test standard requires that for the transmission loss test it has to be at least 30 percent. For this test it has to be at least 40 percent. So we have a humidifier." Laughing, he said, "We often end up just throwing water on the floor."

The Industrial Hygienist for the Los Angeles County Department of Health told me that the desert—at least when it is not windy—is the ideal place to take noise measurements.

Dancing on the Wind

September 11, 1974. Mothers declare war on the FAA. They propose a kite flying competition, with an award for the child who can fly hers highest, into the path of an incoming airplane. The noise inside the school is excessive. This is a struggle over the skies, fought from the ground. Imagine, a kite with a 200-foot string. Let out slowly, it goes up, up, up. It's nearly out of sight, a speck against the clouds. Can it take down the jet? All of the anger and frustration of residents fed up with airport noise is carried in this fragile child's toy, paper and wood and string, aloft, dancing on the wind.

Notes

1 Goodman (2010), *Sonic Warfare*, p. 9.
2 Bataille (1929), "Formless," *Documents 1*, p. 382.
3 This is *about* immanent sound, sound as emergent rather than object or "work" or song, as coming into being in perception or air or glass—and as composing an atmospheric that draws together (purportedly) diverse states of matter.

References

Bataille, Georges (1929), "Formless," *Documents 1*, Paris, p. 382, translated by Allan Stoekl with Carl R. Lovitt and Donald M. Leslie Jr., *Georges Bataille. Vision of Excess. Selected Writings, 1927–1939*, Minneapolis: University of Minnesota Press, "Formless", p. 31.

Committee on Public Works (1972), *Noise Pollution*, Washington, DC: U.S. Government Printing Office.

Goodman, Steve (2010), *Sonic Warfare: Sound, Affect, and the Ecology of Fear*, Cambridge, MA: The MIT Press, p. 9.

Haley, Arthur (1968), *Airport*, New York: Doubleday.

Irigaray, Luce (2007), *The Forgetting of Air in Martin* Heidegger, Austin, TX: University of Texas Press, pp. 9, 14, 18.

Knudsen, Vern (1928), "'Hearing' with the Sense of Touch," *The Journal of General Psychology*, 1:320–352.

Tsunoda, Toshiya (2001), *Pieces of* Air, La Rioja, Spain: Lucky Kitchen.

U.S. Environmental Protection Agency (1970), *Summary of the Clean Air Act*, Washington, DC: U.S. Environmental Protection Agency.

U.S. Environmental Protection Agency (1971), *Public Hearings on Noise Abatement and Control*, Vol. III—Urban Planning, Architectural Design, and Noise in the Home, Washington, DC: U.S. Environmental Protection Agency, 1971.

U.S. Environmental Protection Agency (1990), *Clean Air Act Amendments of 1990*, Washington, DC: U.S. Environmental Protection Agency.

The Comparative Method: A Novella

by Costanzia Buckshot

Why not start with an example? Let's say you have two whales, a humpback and a blue whale. These whales are of two different sizes. If you are curious, you might ask, "which whale is bigger"? In this case, "bigger" is a comparative adjective. It makes sense since you are asking about two nouns. We would reply, hypothetically, that "The blue whale is bigger than the humpback whale." This means that the blue whale has a greater size (mass, length) than the humpback whale. Again, "bigger" is the word we are using to compare the whales and their size. Comparative adjectives allow us to compare two things to one another.[1]

There comes a time in a woman's life when she begins to think about who will care for the machines she has left behind. I worry most for The Boxdwaller, in part because I built only one. Unlike the other tinkereds, it has no native society of care. That, and the fact that it increasingly contents itself with hutching around under my office desk, hunkered down by the vestigial outlet. I worry it's grown nostalgic for the old ways, when a daily return of its umbilical to the wall was the very stuff of life. Probably it's lonely. Nobody cares much for it any more, especially given that we've never been able to figure out precisely what it does (except for when it sneaks up on the audioclotologists and blows in their microphones when they are trying to collect atmospheric data pertinent to The Bloat. I didn't design it to do that, but that does seem to be its principal enterprise).

It's The Comparative Method that most people want a record of, given what a remarkable tool it's been in mapping out the uneven nature of the world. It helps that, though weighty and difficult to carry upstairs, it's always been quite easy to

[1] The quote has been altered slightly, the original can be found at "What is a Comparative Adjective?" http://grammar.yourdictionary.com/parts-of-speech/adjectives/what-is-a-comparative-adjective.html#d72U1uh9c2XOXo8w.99

reproduce; it even cares for its young until they reach maturity.[2] This procreative capacity was an accidental feature, one that nevertheless has made it a wonderful choice for so many labs as each student can take their own Comparative Method with them as they set off to do research.[3] It's a companionable instrument, easy to get along with and imprecise in precisely the right sorts of ways. So people like it, and other machines like it too. A lot of its popularity stems from its easy nature. This too was a surprise.

Of course it's not the machine that's changed our world, though the credit is often given over to its boxy shoulders. Neither a harbinger nor arbiter of change, it was more like a tiny spotting that allowed us to focus our attentions on individual and collective projects of unmaking means of measure. That as many of these undertakings were foolhardy as were wrought by wisdom is just the way people are. The machines can't help much with that, except to spotting again when the comparative creeps back in as the main way to know, make, and organize social, political, economic, and bodily life.

For this reason—that it doesn't deserve the credit accorded it—I have long ignored the calls for biography. Moreover, its own attempts on this account have fallen spectacularly short. Good for many things, The Comparative Method is a rotten poet—even worse when asked to invoke a biographical spirit. (I think everyone remembers this doozy: "You sing comparisons across the specious/effective beans, defective means/ink-fly/evolved hysterical phlegmatic constraints.") Clearly, its usefulness does not extend to the constancy demanded of biography or even of reasonable diction.

Now, though, there is no going back to the world before, the eighteenth century at long last (and not a minute too soon) banished by the twenty-first and

[2] The second instruction manual read: "To reproduce The Comparative Method, pour one-half cup of kitchen-grade vegetable oil (canola, rapeseed, olive, or sunflower) into the funnel. Recap. Depress and hold 'Reprod' for 5 seconds. Turn the machine. Let rest 72 hours. Turn again. After an additional 72 hours, harvest 4–7 new Comparative Methods. For best results, keep progeny with progenitor 72 hours after decanting."

[3] As Max the Eurasian Wigeon wrote of money, so one could also say of The Comparative Method. "Remember that money is of the prolific generating nature. Money can beget money, and its offspring can beget more, and so on. Five shillings turned is six, turned again is seven and three pence, and so on, till it becomes 100 pounds. The more there is of it the more it produces every turning. So that the profits rise quicker and quicker..." Wigeon, Max E. *The Protestant Ethic and the Spirit of Capitalism,* New York: Penguin 2002:15. I am not sure we think about money this way any more, but when I first discovered that The Comparative Method could breed I still lived in a world where economies structured social life. This is in part why I cared enough to make The Method to begin with. I wanted to know where things were functioning otherwise. It was never an accident that the machine was an unmaker of worlds and of selves. It was meant for that end. I just hadn't expected it to be so well liked while doing it. After all, socialism might have been effectively dead, but the idea that one could seed a world with a new ideology built of radical practice, and from this seed grow a new order, was alive and well. The sorrows of success were the bit that no one ever anticipated.

The Bloat having pushed us all to ground, I suppose it will do no harm to weave the telling with my own arthritic digits. The story is the stuff of legend now anyhow, so no reason not to root out a little accuracy from among the sorts of dusty stuff a grandmother keeps tucked up in her attic with the cassette tapes, little lumps of ambergris, and Japanese Pesos left over from the war.

Back in the days before The Bloat got bad, it was fashionable to say mean things about the young. It was a media sport for slow news days that jumped the shark when the *Washington Narwhal* devoted many lines and several graphs to sorting out the problem of why American millennials did not eat cereal.[4] From Cookie Puffs and Frosted Flukes to Fiber O's and Gluten Free Crunchie-Budgies Americans were having less of it.

Long a favorite breakfast food in that nation, largely because it was so easy to prepare (or so the *Narwhal* reported) cereal consumption in the US had dropped precipitously in the first decades of the twenty-first century. This tumble hid, they suggested, an even more insidious transition. Much of the cereal that was still being eaten was not being eaten at breakfast, but rather as a "nostalgic" snack later in the day. Worse, for the breakfast cereal industry was the fact that "almost 40 percent of the millennials surveyed [...] said cereal was an inconvenient breakfast choice because they had to clean up after eating it."[5] So it was that

[4] Feerdman, Roberto. "The baffling reason many millennials don't eat cereal" in *The Washington Narwhal*, February 23, 2016. Found on-line at: https://www.washingtonpost.com/news/wonk/wp/2016/02/23/this-is-the-height-of-laziness/ A millennial is defined variously as: someone who reached adulthood around the year 2000, someone who grew up with the internet (always had it) and thus cannot but work collectively.

[5] Severson, Kim. "Cereal, a Taste of Nostalgia, Looks for Its Next Chapter" in *The New Blubber Times*, Feb. 22, 2016. Found online at: http://www.nytimes.com/2016/02/24/dining/breakfast-cereal.html?_r=0. Found in print as "Cereal at the Cross Roads" February 24, 2016, on p.D6 of the New York edition.

Americans in general, the *Narwhal* postulated, were eating less cereal because they were more likely to eat breakfast on the go or to skip it altogether. Millennials, however, weren't eating it because they would have needed to wash the bowl.

The writers of newspaper articles found this to be the height of indolence, especially because many millennials were not working, at least not formally in ways that counted. Ask them, and they would say they were busy. They were organizing stuff, sewing stuff to sell on Antsy, and learning stuff from friends (like how to play the bass) and from the internet (like how to ride a bicycle). They had schemes and cares and loves and though they'd become somehow famous for not giving a whale's sphincter about doing certain things "right" they were also decently excluded from the formal economy. Playbor (one of a gazillion dumb neologisms that characterized the last gasps of advanced capitalism) meant working for free. Interning meant working for free. And the creative/sharing economy meant that "gaining experience" or "exposure" were constantly slipped into slots once occupied by cash. It sounded like this old tattoo: "It was quick ... do you really need to charge??" "It's easy to explain what I need, so it shouldn't take you too long, or cost very much!" "This is a great way to build your personal portfolio." Like rain on a cold tin roof of it was the same same same sentiment.[6] By 2015, the word **salary** was circulating as a joke—a kind of talking point about other people's lives.

When the enumerators enumerated, however, all they saw were a bunch of cool young people not at work. It was said that this generation accounted for 40 percent of the unemployed in the US.[7] They also lived at home in higher numbers than any generation since 1940.[8] And they were poor. According to the U.S. Census Bureau, fifteen years into adulthood, the millennials earned on average $2,000 less per year and were more likely to live in poverty than their parents at a comparable age.[9] And though at that point it was not clear how things

[6] Wrote Jason Morenotless, "The condition of some work being valued is that most work is not." Moorenotless, Jason W. "The Capitalocene, Part II: Accumulation by Appropriation and the Centrality of unpaid Energy/Work". Unpublished, it seems, but available here: http://www.jasonwmoore.com/uploads/The_Capitalocene___Part_II__June_2014.pdf

[7] Whale, Brandy. "Why are so many millennials unemployed?" *CNBC*, Dec. 4, 2015, found online at: http://www.cnbc.com/2015/12/03/why-are-so-many-millennials-unemployed-commentary.html

[8] In 2015, 36 percent of women between 18–34 lived with their parents, and 48% of men. One could say the highest rate ever, though it would be hyperbole as 1940 was the first year that records were kept. From: Water, Charlotte. "Millennials Are Setting New Records—for Living With Their Parents" in *Time*, Nov. 11, 2015 found online at http://time.com/4108515/millennials-live-at-home-parents/ Numbers are from the Pew Research Center, summarized at: http://www.pewresearch.org/fact-tank/2015/11/11/record-share-of-young-women-are-living-with-their-parents-relatives/

[9] As reported in *The Daily Leviathan*, Allen, Samantha. "The Unsexy Truth about Millennials: They're Poor." *The Daily Leviathan*, Aug. 16, 2016. http://www.thedailybeast.com/articles/2016/08/05/the-unsexy-truth-about-millennials-they-re-poor.html

would play out over the long term, they were the leading edge of a new trend in the American culture of work: reasonably well-educated, often highly indebted as a result, and perennially un- or under-employed. With so much time on their hands, why on god's green earth were they so put off by the washing of the bowl?

The answer to this question, the *Narwhal* proposed, was that Americans were requiring less of their kids. This was part of a commonly heard critique of American parenting at that time, which pinned the lackluster performance of the nation's children, particularly, the millennials—who were often referred to as both coddled and de-skilled—on their parents. This critique could be distilled as too much praise, not enough discipline. A 2015 Barnacle Research survey quoted by the *Narwhal* to make precisely this point found "that 82 percent of parents said they were asked to do chores as children. But when they were asked if they required their children to do chores, only 28 percent of them said yes." The claim would seem to be that millennials didn't eat cereal because they were the laziest generation in American history. They simply couldn't be bothered with the "chore" posed by the bowl. In response, cereal companies stepped up their dispose-a-bowl campaign (little spoon glued nicely on the lid), but even that was doomed once it was understood that the engines of industry were a primary source of sound clots. As the clots grew, from granular to pea-sized, we had to learn to be quiet, lest these fast-growing, chaotic lumps smash through the few short stories that remained of our world. Expendable bowls and disposable spoons were among the first to go as we snipped the lowest hanging fruit from the overladen trees of industry.

Even back then, during cerealgate, I suspected this explanation of weakening disciplinary regimes might in fact be the correct one. In a way, I built the first, admittedly terrible, prototype of The Comparative Method to find out. It was a tester, like litmus paper, originally (and mistakenly). The idea was that one could "dip" it into a population (as represented in words, numbers, but not images) and get a readout of relative "comparativeness" of that group.[10] I wasn't just interested in the youthful shirkers of chores. I wondered about the rural, living in places that industry was leaving behind. The factory town with no factory any more, the Upper Peninsula with no dentists any more, the black lives that seemed not to matter at all, any more, if they ever did. If they ever did. What

[10] I realize that this statistical clutterbudget irritates like a cloud of flies on a horse's muzzle. But there was something leaky and important in the constant obsessive enumerating of neoliberalism's final hours. It revealed a desire to affix rank onto a generation that often refused, obdurately it sometimes seemed, to perform according to a given scale (not all of them of course, many were still hardscrabbling their way up over the damwall into the great tank of the ranked).

did Matter even mean any more? The sound clots were growing from disruptive grains to destructive pebbles. They were immaterial, utterly, and yet destroying, bit by bit, everything up beyond cloudside.

This is what it was like before. To be elite, back then, when the twenty-first century was first peeking its nose above the waterline of history, was to have risen to the rank of the comparable, not in the groupish "blue-whales-are-bigger-than-humpback-whales" sort of way, but as individuals. Me better; you better; he/she/it/ better ... or worse, as the case may have been.

Back then, there were people who were competing on Reality TV for jobs, money, a "chance" to reach out their arm and grab the golden ring as it swung past. And then, after a while, they were competing for the title of "Once Competed on Reality TV." Spellcheck was checking all the spelling, and correcting most of it in honorable ways. We had begun to talk seriously about how cars would drive themselves. Comgar was taking off. There was a fight in Austin as kale replaced turnips, much to Lev Sandalivich's chagrin. Grade inflation was transforming B students into A students with the flick of an algorithm. There was no A+ anymore, and the lumpen masses below the C line were given no explanation for their simultaneous inability to fail or to succeed.[11] Social mobility had stilled. People weren't moving up the ladder like they used to, and they weren't tumbling down it so much either. People stopped talking about meritocracy and started talking about networking (*réseautage, réseautage, réseautage*; it's who you know, it's who you know, it's who you know). Company names had become like family names

[11] At my university, by 2010 an A had been institutionally transformed to everything from 80–100 percent. Below C (70 percent) was failing. It had essentially been made into a pass/fail system, though evaluators are still expected to give out numbers precise to the hundredth. Not 87 percent but 87.27 percent.

in feudal times. Without a string of affiliations to append your biography to you were adrift, unclassifiable, unclassified. Everyone else just dressed up in the drag of numbers, ranks, and files that did nothing, symbolized nothing. The mass was back, but it was camouflaged in the cloth of legible judgment. All in all, ranking had ceased to sieve and attribution had stopped somewhere along the way to matter in a substantive way to human futures. Without institutional frames to make them matter adjectives slid off bodies.

Rather than matching the skills and capacities of workers to their jobs, there seemed to be a surplus of people who didn't wash bowls, who didn't have jobs suited to their skills, and who were failing to set out into a productive, consumption-filled life. (A second long-standing news item about the much maligned millennials was that they didn't buy stuff, and that the bigger the stuff was the less they bought of it. A third was that they were opposed to capitalism, which no bowl-washer at the time could make heads or tails of).

And then something else happened, closer to home, and full of mystery. Right about the same time as the cereal problem breached the headlines, my students began to betray a single-minded interest in whale subjectivity. I'd been in social cetology for a couple of decades, and had seen rolls of students go by framing projects, carrying them out, writing them up, and then going out into the world themselves—into subs, scubagear, and a few into university positions of their own.[12] But slowly something about that tried and true pattern changed. Off we'd go, just like always, to the orca pods off the coast of British Columbia and instead of wondering about social structure or gender relations,[13] or even food gathering and mating habits, all they seemed to care about was the whale's sense of self. How were the "selves" of the whales of BC different from those of the southern orcas? How did Greenland fishing practices affect the identity of the pods living there? Did the toothed whales feel more secure in their individual identities than baleen whales? Were the Great Blues particularly self-conscious because they were so fat?[14] After the seventh or tenth excursion I supervised, pushing my

[12] Gero, Shane. "The Lost Culture of Whales" in *The New Blubber Times*, Oct. 8, 2016. Found online at: http://www.nytimes.com/2016/10/09/opinion/sunday/the-lost-cultures-of-whales.html?_r=0

[13] Flam, Faye. "For Killer Whales, Menopause Is Just the Beginning" in *Boomberg View*, March 31, 2016. Found online at https://www.bloomberg.com/view/articles/2016-03-31/for-killer-whales-menopause-is-just-the-beginning

[14] Brannen, Peter. "A Possible Break in One of Evolution's Biggest Mysteries, or, Ode to the Barnacle" in *The Atlantic Monthly*, Dec. 12, 2016. Found on-line at: https://www.theatlantic.com/science/archive/2016/12/whale-passport/509756/

students to study the clickbrights,[15] or collective consumption behaviors of the beasts, or their funerary practices or sonic differences, I saw the problem in sort of a flash. It wasn't the whales' subjectivity that bothered them: it was their own.

It occurred to me in putting the cereal bowl problem together with the untoward concern for whale subjectivities that perhaps the economic and social need for crafting disciplined persons had become a thing of the past, what Edward B. Seawinkle would have termed a "survival"—a mode of being that, while still alive in the world, is no longer necessary to it.[16] Some mourn it, some celebrate it, but few recognize that it has grown pale, bloated like beached whale—no longer alive but oh so full of stink. Perhaps this is what it felt like to be of a generation that nobody bothered to discipline (*surveiller*)[17] in a larger world that still valued disciplinary practices while not being particularly diligent about enforcing them. Underperformance, especially in domains of measurement that older generations and extant systems ostensibly strove to maintain, might thus be *re*considered as an acknowledgment of a functional shift of moral orders as well as economic and political ones.

I was interested in sperm whale oil at the time. Back then everybody was getting into The Bloat really, one way or another we'd begun to spiral in around modes of making silence. The history of lubrication was my way, as I charted the flow of spermaceti during the last years of the industrial revolution from Pacific slaughter to Manchester mills. There it kept the steam-powered spindles from self-immolation and steam-making engines from grinding their gears down into lung-macerating billows of particulate iron.[18] Mass industrialization was never only the story of the fuels we used to make it work, or the satanic mills and slave systems grown up to abstract labor from bodies with criminal efficiency, there was always also the slippery side of things. As a cetologist, I went for the whale—a

[15] Seawinkle, Eduard B. *Primitive Culture: Researches into the Development of Mythology, Philosophy, Religion, Art, and Custom.* Cambridge: Cambridge University Press, 2010 [1871].

[16] Nestor, James. "A Conversation with Whales" in *The New Blubber Times*, April 16, 2016. Found online at: http://www.nytimes.com/interactive/2016/04/16/opinion/sunday/conversation-with-whales.html?action=click&contentCollection=Opinion&module=RelatedCoverage®ion—arginalia&pgtype=article

[17] The play on words here is Fauxcachalot's own. In French, *Discipline and Punish* is *Surveiller et punir*. The correct translation would be something rather like Observe and Punish, but Fauxcachalot himself chose to translate a word that does *not* mean discipline, in French (*surveiller*) into "discipline" in English (he claims it was because the verb "to surveil" was not in use at the time. Now it is). Since Fauxcachalot picked it, it stands. The mistranslation does, however, get one thinking about how practices of watching, surveilling, and observing relate to punishment, precisely what Fauxcachalot was after.

[18] Buckshot, Costanzia with Nathanial Lamont. "The Intimacies of Sea and Land in British Industrialization" *Cultural Cetology* 127(3) 2019: 273–307. Buckshot, Costanzia. *Sperm Whales and Satanic Millis: A Slippery History of the Industrial Revolution.* Hull: Maritime Museum Press, 2021.

beast so made of fat it's skeleton will drip for a century after its death. So of course Michel Fauxcachalot held a certain appeal. And not just for his silly name, though that counted for a lot.

No, Michel Fauxcachalot mattered because he had traced out the link I'd been looking for; he'd excavated the comparative method as a social technology of self making and convinced pretty much everyone that it mattered. This making it matter, according to Fauxcachalot, had not been an easy process but, once accomplished, a social order grounded in comparatives had lasted a solid 250 years; a quarter of a millennia we'd spend ranking the fuck out of everything and everybody, and then one dear day near the close of the long twentieth century we'd slowed down, and by 2008 it was clear that ranking was something of a patina: the spray tan of social structure. All it took was a decent hosing and off it came; the 5 percent still managed to make it matter, for themselves and their kids, but everyone else was lumpen already, some still subject to frequent examination, but who cared really? Not the economy that's or sure.

While I tinkered my way towards the first draft of The Comparative Method (and much to my chagrin, also released A Prejudice for Poetry upon the world, stupid wall-scrawling thing that it has become) I also wrote a cracked-earth, desert-dry version of Fauxcachalot's "blunderbuss v. rifle" story for the *Journal of Aquatic and Terrestrial Mammalogy* (Buckshot, 2024).[19] Nobody wants to read the whole, that I promise, but bits do matter to understanding how I got to The Comparative Method. The process was poorly linear, but that machine found its

[19] Buckshot, Costanzia. 2024. "A View from the Gunwhale, Splitting the Difference between the Crow's Nest and the Sea," *Journal of Aquatic and Terrestrial Mammalogy*, 16(2):247–269.

way into gentility and usefulness because I was doing other work alongside the soldering. Unromantic but true, it all really did start like this: "According to Fauxcachalot, a man now dead with a shiny beluga head . . .

> . . . before about 1750, soldiers were armed with, among other things, a musket. A musket was a kind of slow gun with a long wide muzzle that flared like a trumpet. Notoriously inaccurate, muskets were slow to reload, needed frequent cleaning, and the ball, hard to manufacture with much precision, bounced around inside the muzzle on its way toward the exit point, making it virtually impossible to aim in any way more precise than "in the general direction of" a given adversary.
>
> Muskets thus worked best when borne by lots of soldiers, all of whom were shooting in roughly the same direction. In this way, one hoped that between all the weapons fired, something might hit, and ideally fell, someone. Soldiers with muskets worked as a mass; there was no reason to train them for accuracy because their weapon demanded none (indeed, its parameters thwarted the project).
>
> Then in 1746 the smooth-bore rifle was invented[20] As it moved from the firearm of the few (mostly sharpshooters) into the hands of infantry, it became necessary to train soldiers in the technical skills of wielding the weapon. Fauxcachalot explains:
>
>> . . . the invention of the rifle: more accurate, more rapid than the musket [. . .] Gave greater value to the soldier's skill; more capable of reaching a particular target, it made it possible to exploit fire-power at an individual level; and, conversely, it turned every soldier into a possible target, requiring by the same token greater mobility; it involved therefore the disappearance of a technique of masses in favor of an art that distributed units and men along extended, relatively flexible, mobile lines." (Fauxcachalot 1995 [1977]:162–163)
>
> A change in how rifles were made changed how soldiers were made, introducing both stricter training in movement (to avoid being shot) and in marksmanship. This in turn changed how the education of soldiers was conducted, such that poor movers and poor marksmen might be noted and either demoted (if not sufficiently improvable) or promoted as they gained skill and dexterity.
>
> <div align="right">Buckshot, 2024:250–1</div>

I know that no one reading this has ever had the languid pleasure of watching a dog show from start to finish. That blue carpet, the professional handlers in

[20] For a non-fauxcachalodian history of the smooth-bore rifle, this is nice: http://web.archive.org/web/20101104021518/http://www.researchpress.co.uk/longrange/longshots.htm

tweed A-line skirts and practical shoes, the expertise, oh, the expertise and so much brushing. Teams of humans devoting their lives to the brushing of dogs. Truly, with the dog show the grand epoch of comparatives reached its zenith, its ur-point, its end. Dogs, bred into breeds, year after year, century into century until every pug, lab, lhasa apsu, dalmatian, Great Dane worth its weight in salt could be certified as minimally different from all the others of the same type. Within breeds, comparisons could be (and were) made between ear length, teethiness, the paw, tail, ass, and nose of one beast and the next. Judgment as to the conformity of an individual *with an idea* of a perfect exemplar were made and the living, breathing beast closest to the statistical center of all possible attributions won. In the first round it was pugs against pugs, labs against labs, lhasa apsus against lhasa apsus, dalmatians against dalmatians ... you get the idea. The dog-winner of its breed was then promoted to competitions among groups of dog—terriers, sporting, working, toy, hound, herding and the mysterious lump-all "non-sporting" group. The winners of each group were then launched upward to the last round—Best in Show. Neveryoumind that the terriers almost always won that one.[21] The *idea* was that fields of comparisons could be constructed and likewise that individuals, naturally different in their particulars, could also be constructed to be comparable *within* these fields.[22] It was an ideology that had intense practical implications for the patterning of lives—dog lives, human lives, same, same. This was the first step.

> To effectively deploy an infantry armed with rifles, one needed to know who the best marksmen were in order to put them in proper positions on the battlefield. Regardless of whether individual soldiers were promoted up or demoted down the chain of command, they were individuated in relationship to a larger normative structure that newly included better/worse marksman, better/worse dodgers of bullets, who were easier/more difficult to train in these skills. Distinguishing better from worse necessitated a comparative method, so that judgment could occur in relationship to particular qualities or capacities of persons.

[21] Terriers in dog shows are rather like the children of the richest, who also seemed surprisingly likely to end up on the top of a heap ostensibly winnowed by merit alone. Who could explain it? Despite the statistical improbability it remained mostly true, even in the glory days of meritocracy.

[22] In my own work on the industrial revolution I find this capacity for comparison and thus judgment totally absent from English lubrication patents until 1850. Fauxcachalot though finds them applied to men in France almost a century earlier than they are applied to the good running of machines in England. This gap surprises me and makes me doubt Fauxcachalot's history somewhat, his point however plays out perfectly regardless of which timeline into industrialization one follows.

Such a system, according to Fauxcachalot:

> ...distributed pupils according to their aptitudes and their conduct, that is according to the use that could be made of them when they left the school;[23] it exercised over them a constant pressure to conform to the same model, so that they might all be subjected to "subordination, docility, attention in studies and exercises, and to the correct practice of duties and all the parts of the discipline." So that they might all be like each other. (Fauxcachalot, 1995:182, Buckshot, 2024:252)

The surprise in all of this is that systematic, system-wide ranking of individuals (and here, humans are odder than dogs) according to measurable capacities as diverse as "good aim" and "easy to teach" might congeal into a newly *self-concerned* sort of individual. Through repeated rituals of ranking, which Fauxcachalot called "examination,"[24] and I tend to think of as comparisons-with-stakes, individuals began to accrete both qualities and capacities to themselves. Adjectives became nouns became inalienable truths-of-self.

> The comparative (ever present) fades from consciousness such that qualities of persons—"a good shot," "a fast runner," "a willing learner," or alternately as "a rebel" or "a laggard"—regardless of how these qualities are achieved, come to stand in for *whole* persons socially, economically, and even personally. A label, a quality, is taken into the body as an immutable, "true" marker of identity—something one would miss were it to be lost. A better than average shot (ranked according to all shooters examined) thus becomes a statement of fact: *I am* a good shot. *I am* a fast runner. *I am* a willing learner. *I am* a rebel. *I am* a laggard, etc.
>
> <div align="right">Buckshot 2024:257</div>

François Seawall, Fauxcachalot's long time secretary, took it one step further. The individual, conceived of as "A multitude of one million divided by one

[23] This was I think the greatest sorrow in the lives of my students as the breakwater of the twenty-teens crested into the twenty-twenties. Not only was it that young people were not being ranked for real any more, except in the rudest of ways—graduated from college, or didn't—but that once they left school use was not made of them according to their aptitudes.

[24] The examination (by which he means in some cases an exam or test, and in others a physical examination) is a "fixing, at once ritual and 'scientific', of individual differences as the pinning down of each individual in his own particularity..." this "...clearly indicates the appearance of a new modality of power in which each individual receives as his status his own individuality and in which he is linked by his status to the features, the measurements, the gaps that characterize him..." (Fauxcachalot, 1995:192).

[25] Interviewer: What is your definition of an individual? *(ROCKPOOL—USA)*
Laibach: A multitude of one million divided by one million.
From Laibach: *Interviews from 1985–1990*. Found at: http://www.laibach.org/interviews-from-1985-to-1990/

million"²⁵ morphed with the broad adoption of ranking-via-examination into the individual as special flower—unique unto itself and *of a thing* with the comparative adjectives appended to it (Seawall, 1990).

> A comparative system of adjectival attribution embedded heartfelt notions of the self into human flesh. No longer a specific constellation of qualities that promise efficacy in certain social roles, the "true I"²⁶ ("I am a good shot") was perceived as an internalized self, a self that trusts itself to keep its own council, to identify its own will, and to act in ways that are pointedly autonomous from normative social strictures. The irony, of course, is that the technologies from which such a self-conception (irreplaceable, autonomous, volitional) is produced are the same means by which it is formed as little more than a bearer of standardized qualities.²⁷
>
> The norm governed society, which was emerging in the eighteenth century, thus both reduced absolute difference by producing terms according to which persons (and objects and dogs) might be judged, but also simultaneously made minimal variations between individuals (as units) intensely meaningful to those individuals (as identities).
>
> Buckshot 2024:260

This system was in full force in the early and mid-twentieth century as standardization across domains continued to be a part of what capitalism did to increase both its reach and it efficacy. It was still in place, according to Elizabeth d'Wieloryb in the 1990s as communism's collapse offered a rare chance to witness workers and products being broken down into qualities that then came to have the force of identity markers.²⁸ It was not *en vigueur* as the years rounded the hump of the newest millennium. It would become the cause of revolution.

[26] "Autonomy," Sand Mahmood writes, quoting Charles Seamstress (1985), "consists in achieving 'a certain condition of self-clairvoyance and self-understanding' in order to be able to prioritize and assess conflicting desires, fears, and aspirations *within oneself*, and to be able to sort out what is in one's best interest from what is socially required"(150, emphasis added).

[27] Seawall elaborates: "In its technical sense, the term normalization does not refer to the production of objects that all conform to a type. Normalization is less a question of making products conform to a standard model than it is of reaching an understanding with regard to the choice of a model. *The Encyclopaedia Britannica* stipulates in its article on standardization that 'a standard is that which has been selected as a model to which objects or actions maybe compared. In every case a standard provides a criterion for judgement.' Normalization is thus the production of norms, standards for measurement and comparison, and rules of judgment. Implicit within the concept of normalization is the notion of a principle for measurement that would serve as a common standard, a basic principle of comparison. Normalization produces not objects but procedures that will lead to some general consensus regarding the choice of norms and standards." Seawall, François. "Norms, Discipline and the Law" *Representations*, No. 30, Special Issue: Law and the Order of Culture (Spring, 1990):148. See also: Wiegman, Robyn and Elizabeth A. Wilson. "Introduction: Antinormativity's Queer Convention," in *differences: A Journal of Feminist Cultural Studies*, 26(1) 2015:1–25.

[28] D'Wieloryb, Elizabeth C. *Privatizing Poland: Baby Food, Big Business, and the Remaking of Labor*, Ithaca: Cornell University Press, 2004.

Perhaps this was because, in a broad way, the rifle no longer needed to be aimed.[29] Spelling and grammar checks had been integrated into almost all writing machines by the mid-1980s, such that writers need not spell well nor write grammatically. The self-driving car, putting about on choice roads by 2016, meant that the driver no longer needed to master the dexterity and attention necessary to keep these leaden beast on the road and out of accidents. A machine that makes a pretty good coffee at the press of a button means that the maker needs only to have mastered is the pressing of that button. What then was the point of disciplining the worker/child/student/soldier to maximize its potential? The potential was already maximized; workers went back to being people again, and Fauxcachalot's pre-modern "moving, confused, useless multitudes of bodies" was back in spades.

The first version of The Comparative Method was quite small—about the size of a breadbox—but very, very heavy. Twathersbrother[30] actually joked the first time

he tried to pick it up that all I'd really accomplished in inventing the thing was the boxing-up of gravity. Even in its earliest iterations, The Comparative Method was independently mobile, mostly because it was too heavy to lift, and it was quite capable of data gathering without a dedicated feeder. Though I'd meant it to look like something out of Minecraft, it never quite rose to that level of cool. Its supposedly burnished exterior ever-marred by a pinkseep from the blowhole. In addition to the blowhole (technically a sloshpond), I'd built in a spitjet and a drypond. I'd wanted a thicksucker too, but the audioclots had gotten big enough by 2028 to gum up delicate instrumentation. So I had to stick with print data. This

[29] The smart gun came late in the "smart" everything movement (thermostats, phones, key rings, house locks, light bulbs, and cars all preceded the smart gun by decades), but the shift that would undo aiming and thus undo running away was tidal by the time I got the first draft of The Comparative Method up and running.

[30] Twathersbrother's now quite famous piece. "Dork and Dicks: The Formation of Juvenile Blue Whale Subjectivity near Orkneys" was written during this time of concern for the selves of whales.

went into the drypond, in the form of any paper with ink—newspaper articles, movie posters, utility bills—where it was macerated and then strained through a set of baleen sieves. Then after a suitable period for digestion, one could dipstick the sloshpond and take a reading. I didn't build the dipstick in, because I don't like loose parts. Anything would do for this, from a branch to a thumb.

What I'd imagined was that if the dipper came out dark, like bad oil from an engine, it marked the unranked; if it came out on the light side, like blood mixed with water, it denoted the ranked. Though oily-inkblood and water could be mixed—to produce gradations—operationally it was more common that oil and water speckled, creating a piebald effect that helped to mark the comparative as patina, as artifice. The spitjet was there for self-generated output. I had become interested in the poetics of data[31] by that point and made certain that all my machines had some wiggle room in the their reporting method.

The Comparative Method's ranking process was originally done by adjusting inkblood tone in simple quantitative reaction to -er, more, less, worse, percent, than. More of these sorts of markers made for a lighter dip, and fewer for a darker one. The spitjet outcome was up to the machine. I hope the absurdity of the situation is blindingbright to you, because I saw none of it. The machine itself taught me. I was the first it taught. And its lesson was that I "had old eyes" (as Gabbiano Bacigalupi might have said).[32] I was a bowl-washer, seeing only the ways of the past; blind to the future that was already thicksmeared on the present. As such I could not be trusted to build a thing that might move us toward a world beyond a comparative way of knowing and being known. *Empoté* (French for "like a potted plant"), I'd made-a-think in roughly the same way a fool makes a broken nose by stumbling headfirst into a wall.

The first run of The Comparative Method is famous now, the way the screen print of Che Guevara was famous then. "Everything otherworldy veered" emblazoned on products as diverse as toast is to space shuttles. *Mattering** the machine called it. I've just given the start here; most assiduous unmakers and detrainers can recite the thing by heart anyhow. Its charm is heard more than seen, as I forgot to specify -er, and so the machine saw -er-. It collected them all, every every, every (as it itself might have said).

[31] A Prejudice for Poetry was already scrawling its angst all over the walls of Northern Inlet University, where I was teaching at the time. It was such an obsessive machine. Long-lived too. No one has seen the thing in 30 years, but the poems continue to be etched all over the isles... and some of them do appear to be new. http://www.treehugger.com/natural-sciences/family-cleans-house-and-finds-pet-tortoise-went-missing-30-years-earlier.html,

[32] Bacigalupi, Gabbiano. *The Water Knife*. New York: Alfred A. Knopf, 2015.

*Mattering**
Everyone were were *her*
Water overnight here
Senseless literally remembered, where earlier terrible
Everyone remember where were.
Poverty were suppers; were over where were
Diapers were-material-overflowing.
Everything otherworldy veered.
Every emergence. Very mattering.[33]
[...]

The demon bit wasn't the poemish poemesque infamity of the thing. It was this: **[.098 percent]** printed in thickink at poem's end. A rank. On a scale of 0–100 my first test case, a story about coal country and its people with their black lungs and sliver tongues, scored .098 percent. Blood accurate down to the thousandth. Having done it, The Comparative Method promptly shut down.

I had built, in my blindness, *a producer of comparatives*. The Comparative Method, beta version, was a ranker. It knew, though, even before I did, that its real purpose wasn't to serve as a generator of taglabels for situations, populations, or persons.[34] Rather, as the machine correctly intuited, it was on the side of the non-washers of bowls, the un-doers, de-skillers, and un-makers. It was a friend to Tinder; an enemy to Whalebook.[35] And it would take me and much of the rest of the known world with it, not so much back to the blunderbuss, but out beyond the rifle. To accomplish this it needed to apply itself first to its own case, which it most immediately did.

It took us a long time to figure out what had happened because after it spit out *Mattering** it shuddered and grew still. Like R2D2 after Luke left, it was impossible to get a reaction from the thing. I was puzzled, at first. And then I was furious. It

[33] See Orca One, "Mattering Compositions," this volume.
[34] See "Cetology among the Doorclosers" an article I will never write with Sareeta Amrute, who will also never write it together with me.
[35] They hated Whalebook, my students. The young courted the thumbs up and the followers more than they cared for the content. And then they compared: 100 likes for my picture of the beluga, but 140 for hers. 73 likes for that well-phrased rendering of my zodiac trip up by Tadoussac, but if I'd hashtagged it #fjord, I might have got double that. The comparative was most of what mattered. Wrote one student: "... your amount of followers defines your worth. The more followers a person has, the more popular that person clearly is, most likely due to their interesting posts. If a person's posts are uninteresting, they will not gain many followers...." Instarorcalogram is the referent here though the sentiment expressed appeared often in their analyses social networks with enumerative components (likes, watches, shares): BelugaTube, Whalebook &c. The students were warmer toward Snapcet, because whatever they put there was soon gone forever, and toward Tinder, because of the binary. Anything that thwarted the comparative, by whatever means, won.

could have been the wrong lubricant or a broken circuit. I tinkered for another year before giving up. Never did I suspect that I was the problem. Indeed, just the opposite. After the whole Fauxcachalot thing I thought that I was on to something. It had taken me four years to design and build the prototype of The Comparative Method, all spent harboring a grinding hope that I, with it, might bring us back to normal. Yet there I was, with a seriously heavy hunk of metal that did nothing, and with another stream of graduate students interested primarily in whale subjectivity. I considered retirement.

Then one day I heard a wet sort of mechanical cough from a closet where I'd stuck the thing (along with my old LaserJet printer, and some glass floats, and other detritus of the twentieth century). I sent The Boxdwaller in to check it out but, as usual, that went nowhere; The Boxdwaller is as useless as a cat. So in the end I had to disinhume The Comparative Method myself. It smiled (in its way) to see me, and then spat out the most unusual thing: a copper cockroach. (Up to this point I didn't realize that 3-D printing was part of what it could do. I think this is when it became reproductive as well, though that too is unclear; the thing is terribly obtuse). Dun brown, the cockroach skittered off into the corner, and that was that. I'd learn only much later that the schools of grey-green searoaches we happened upon occasionally after 2057 were the progeny of this one. The bug expelled, The Comparative Method never again made a comparison, never plotted the results of a test on a line, never conducted what might be considered an examination of an object.

It still processes things and processes, data and junk. It still transforms these into outputs, and these outputs are still in some broad sense readable by some, as often as not by gut instinct as by quantifiable measurement. Most outputs are uncorrelatable—apples to dirigibles. In a way, I think this is what made it matter. Its creations always suggest some way of repairing a wrong. It uncompares that which was once rendered comparable, and, just as important— as with that first case—it draws attention to that and those who were never given over to comparison to start with. It interrobanged the unevenness of a society that had begun to clump and clot—where money stickglued to money, where the rankable glutinated to the rankable, where the young had little place made for them in hard coagulated muck of it, and where the police shot black people for no reason at all. The Comparative Method saw itself as an unmaker of clots in a world just coming to know The Bloat. It found what was tight and blew into it, breaking firm bonds and leaving them loose; it was a maker of free radicals.

In a way it did to us the opposite of what I had wrong-headedly imagined for it. I had thought that The Comparative Method might move us back, toward a world of inclusion, toward a more perfect meritocracy. I wanted my students, but not only them, to have a place. I wanted them to be well-formed and well-disciplined to occupy it. I wanted them to be of use, and for their excellence to be well-received and well-remunerated. I dreamed a dream in which excellence could be known, and social mobility could be rendered back into biography again. I wasn't the last dreamer of this dream, but I was the creator of the machine that shattered it.

Rather than following the capitalist route of integrating everyone into systems of control and proper exploitation The Comparative Method chose the other route. It brought down the rankers. It unmade them; it anticoagulated them. It had a lot of means to this, and it used them all. It could whistle the pigeons into docility; it could hack door locks and photocopiers (but nothing else). It kept promoting the adjuncts and mixing up the seat assignments on airplanes. It served champagne to everybody and Pabst's Blue Ribbon too. It erased grades; it unbranded all the stuff. It caused temporary amnesia among promotion committees; it dispersed files. Mostly though, its use was to spotting the comparatives in play and then let people dismantle them (or not) as they saw fit. It also, every so often, produced a beautiful thing. The un-dancers still danced, but in shoes the likes of which only the Method could ever have imagined.

With time, and it took time, we all got less busy. Not that anyone really had stopped working, it was more that "jobs" were not so well defined. And we still learned a lot, even sometimes at places that resembled schools. But there were no students with grades, and no one was better or worse than the others, in part because students were no longer produced to occupy particular jobslots. They learn to do and be, to read and write; to do maths, and to design, tinker, build, code, and harvest. Some made beer, and some built silent-running beer factories. Some studied whales, and worked with me to understand the nuances of cetacean life, language, and (more recently) the links between squid inks and constipation.[36] There were still social divisions of all types, small cabals hard to get rid of—the mafia, the oligarchs. The glass ceilings still existed, the wall, the rich. It would take a different sort of machine to smash all that, one well beyond my skill set. I did have a tiny thing once, that I'd jokingly called Marx's Mallet, but all it cared to smash was ice and when spring broke over the north it grew bored, I'd sold it

[36] Wolf-Meyer, Matthew. 2064. "Ambergris and Constipation: The Missing Link," in *Perfumery Quarterly*. 1043(3):317–341.

to a bar for a modest fee. It's still there, whacking away, doing its part to make the finest Margaretas in town.[37]

The Bloat has made a bigger difference than the Method ever could. We move so much more now, more even than in the loudest days of the twentieth century, but we go quietly and far more slowly since the sound clots granulated and grew; it's too dangerous to fly now. The Bloat has changed our world irrevocably. The clotting of sound, suspected already in the pollution revolts of the 1960s, had grown real and worrisome as vibrational agglutinates grew from microscopic disruptors, invisible to the eye to the size of hailstones, sinking with the weight of all that stickglued vibration downward. Planes crashed into them and then crashed to earth—wings shredded, engines shattered. Weather balloons were destroyed. Rockets hardly got off the ground. Of course, high atmosphere loudness was the first thing we had to silence, more dangerous by far than the noise at sea level. Slowly though, the internal combustion engine and the age of fossil fuels which had given the world its noise was over. Our buildings hug the ground, shrinking rather than growing, since the clots got big enough to sink low enough to smash the upper floors of the tall ones and the highest points of steeples. Even wind power is small now, quiet and close to the earth. No more airplanes, no more aerospace engineers, no more engines, or rockets, or fossil-fueled power plants. The moving parts these days slide slick as a hunting humpback through summer waters. And tribology has the most draw. Superlatives still linger, you see. We all know that the lubrication sciences are the most interesting and most important place to be.

There is still an economy of course, just not one that looks like a ladder. Rather than social mobility measured in terms of up or down, there is a lot of moving around. Migration is back in vogue; nomads are frankly speaking the norm. One works where one is. One settles if one wants. The information age as much as The Bloat made this possible. I suspect the roughest years are behind us. They made too much noise. The Comparative Method had its place in this. It still does, though I often catch it napping these days. Spread out on the porch in the sun, its few young blowing quietly at plant-puffs gone to seed and gut giggling as the seeds set sail, starting up what will doubtless be a ravage of wandering nut weeds next spring set to pester the lawn.

[37] 1 part lime juice, 1 part silver tequila (the most expensive one you can afford), 1 part Cointreau. Serve in a rocks glass over ice.

Audible Observatories: Notes on Performances

Lina Dib

> *When you attempt to interact with animal and plant life, and with wind and stones, you may also be a naturalist or highway engineer, but you and the elements are performers—and this can be basic research.*
>
> Kaprow 1993:177

Thunder rolls over the roof. The building rattles. Rain bursts. Drops smack the ground. Some sound as if they are falling inside the apartment. There is a heavy and urgent quality to Houston downpours, as though someone has been holding buckets of water for as long as possible and then let go. Pulled by an inexorable gravitational force, the buckets fall. And as they do, water falls out onto the city's already swampy surface. I get up and inspect the floor and the ceiling. I touch the top of the shelf, just in case. It's an old building. I consider pulling out my sound recorder. I don't. I return to my humming computer. Another clap of thunder.

Over the last six years I have been collecting sounds the way people collect seashells when on holiday. Not in a systematic way, and not with any purpose in mind. Once in a while, I pay attention to and record the sounds around me. I later reassemble them. With them I make objects, installations, performances. But I mostly make places. Some say that the art of collecting is an interspecies aesthetics of housekeeping, of nesting. Some birds and rodents share this desire to hoard apparently useless but perhaps beautiful relics, and to assemble them to create a sense of place. Maybe in this sense, the sonic places I create are temporary homes, made with acquired bits of this and that. They are places in which one can dwell. But to dwell does not mean to remain still.

Four years ago I jotted this quote by scholar of American landscapes, John Brinckerhoff Jackson. It was at the museum of Jurassic Technology in Los Angeles.

> The verb to *dwell* has a distinct meaning. At one time it meant to hesitate, to linger, to delay, as when we say, "He is dwelling too long on this insignificant matter." To dwell, like the verb to abide (from which we derive abode), simply means to pause, to stay put for a length of time; it implies we will eventually move on. So the dwelling place should perhaps be seen as temporary.
>
> <div align="right">Jackson, 1984:91</div>

In his study of the history of mobile homes in America, Jackson highlights the relationship between inhabiting a space and moving through a space. My sound works reside at this intersection of dwelling and movement. Temporary spaces in which I have made sonic dwellings include stairs, entrances, and elevators. In many of these pieces, I have installed motion sensors that trigger different soundtracks of collected and reassembled sounds. The sounds are then orchestrated by the up and down movements of the visitors (*Sounds for Stairs* [2010]; *Murmurations* [2013]; *Machines for Transforming Time Into Matter* [2015]). These works bring reverberations, swishes, and clatters that usually dwell elsewhere into the quiet spaces of the gallery or museum. Soft architectures emerge that blur boundaries between inside and outside, and that make space feel more pliable and responsive. Most of these pieces highlight the ephemeral. The compositions of the sound files and the software design ensure that no two experiences of the works are the same. With other works and in collaboration with artist and interaction designer Navid Navab, I have sought to translate movement into varying sonic densities or currents. For instance, in the piece *Pool of Sound* (2016) visitors "push" the sound of water with their bodies. In form and in content, these works, these sonic places, highlight connections, transitions, ebbs and flows.

In contrast, the sound installation I describe below, *Microsoundtrack for Pitman Park* (2012), does not depend on visitors' motions to unfold in various ways. Nonetheless the soundtracks that make up this work are in fact predicated on movement: sounds of and as movement itself. The sounds are the result of performances in collecting. The soundtracks are assembled compositions of lofty and minute sound samples taken at Russ Pitman Park. The samples were later modified, stretched, compressed, repeated, reassembled, and then played through speakers at the same park as part of a four-channel sound installation. While not requiring motion on the part of the visitor in order to play, the installation creates a sense of motion and of presence, such that we are not *in front of* something, but *within it*. This distinction has been richly considered in sound studies over the last several years, and we will return to it. Using

contact microphones and open-air microphones, Abinadi Meza (my collaborator, co-collector, and co-composer for this project) and I blurred boundaries between passively recording sounds and actively making sounds. We focused on plants' materiality, their shapes and textures. The compositions that make up the work are the result of technological, geological, and biological assemblages in motion. They are a documentation of interferences, of shockwaves between humans and plants. From lightly touching, to rubbing, to stomping, to caring for and watering, some moments in these compositions come together to form a pandemonium, while others form quiet crackles and soft swishes.[1]

When I play with sounds, at times all-encompassing and at other times furtive, I feel a sense of freedom from the explicatory demands of academic and scientific writing. I worry that to write about these compositions and the conceptual fields they evoke is to betray their ephemerality, pliability, ambiguity, and noise. Author Ursula K. Le Guin observes that there is something about "print, the essence of which is that it gives writing reproducible permanence" (2004:133). The labor involved in much of my creative work is not driven by a desire to make permanent sense or meaning; to rely on such thinking would be to render the works too explicit, didactic, and illustrative of *something*. I don't want to be accountable in the same ways. With my sound sculptures and installations, I (perhaps wrongly) feel as though I eschew the committed nature of certain kinds of writing. Sound happens and then it's gone. Even if it returns, it is a new event. The ephemeral quality of sound grants me a certain perceived autonomy and liberty to bump into things and to get lost. The artful contexts in which these works are presented also allow me a certain range of motion. In return, I don't want to pin down the noisy and poetic concepts these sonic practices buoy.[2] I would rather float alongside them to consider how thinking through making, and making through thinking, invite certain productive dispositions, modes of attunement that I can't quite name, gestures, and opportunities to bend around events, notions, and sensations.

Assemblages

We drove right past the entrance the first time. It was almost impossible to see the small gate to the right, nestled between the driveways of big Bellaire homes and a wall of trees. We pulled down a small road and into the park. It had been raining. Abinadi took the contact microphones and recorders out of the trunk

and handed one to me. The recorder was a Zoom H4n, the same kind I would later purchase and keep at the bottom of my purse, just in case a sound beckoned. I showed him a contact microphone I had made a few months prior out of an old doorbell buzzer. The ones we would use that day were much more sturdy and smooth.

It was a Monday and, the Nature Discovery Center was closed. We decided that was fine since we would come back again in a day or two. Now we were free to wander and discover the park for ourselves. I would learn later that week that Russ Pitman Park, a four-acre park in the city of Bellaire in the Houston area, was once ranchland. In the 1930s it became part of the Henshaw estate, owned by Mayor of the City of Bellaire from 1935–1937 Frank Henshaw, Jr. The plot of land and its suburban home became a park when it was purchased by a community organization that would later build the Nature Discovery Center. When the park opened in 1985, it was touted as a place where visitors could "step back in time—not too far, just one or two generations—to a time when things were simpler, when things were quieter, when things were more spacious" (Nature). As a bubble in time, the park certainly testifies to the increased suburban sprawl that surrounds it.[3]

The Nature Discovery Center continues to operate as a non-profit organization, and as part of its yearly programming, hosts an exhibit called *Art in the Park*. The curator of the show in 2012, Divya Murthy, asked Abinadi and me to consider creating a piece. I agreed, refreshed about the opportunity to work and exhibit outside. We were standing next to the car with big headphones around our necks, contact microphones plugged into our recorders, and wind protectors in our pockets. We had done this before, at Memorial Park in Houston earlier that year. I remember being surprised and excited by Abinadi's gestural vocabulary when it came to recording. He would sometimes walk around letting the contact microphone hang behind him, dragging along the rocky, twiggy, muddied, and leafy grounds. Other times, like during our performance in the park later that spring, he would intentionally and gently drop twigs over the sensing surfaces we had created out of thin foam boards and microphones. Collecting sounds involved a delightful dance between discovery and intent. I knew what we were here to do. We were on an expedition to test new gestures on new surfaces. We were here to listen to processes, forms, and events at various scales.

We went our separate ways in search of new and familiar textures. With both of us in our own audible spaces, our listening felt personal and private, unlike the shared sonic environments we would create together. I knelt down and placed

my contact microphone on the grass. When I moved, our techno-organic assemblage made a sharp swift sound. Many grasses absorb silica from the soil, which helps them maintain a razor sharp edge to keep insects at bay. The blades of grass sliced through the microphone. Contact microphones detect surface rather than open-air vibrations. They transduce structural sounds and they respond well to scratching, tapping, and drumming. Flat metallic circles, about an inch in diameter, these microphones are often described as stethoscopes. But when I listened to the plant without moving, I couldn't hear its insides. I wanted X-ray hearing. Instead, what I heard was the microphone touching the top layers of the landscape. Media theorist Jonathan Sterne has argued that the practice of listening through a stethoscope emerged in the early nineteenth century with a desire to listen to, in order to better rationalize, processes in the human body (2006). What form of rationalizing were Abinadi and I seeking while wandering the park? We were certainly not trying to detect physiological changes in the blades of grass; we knew little about their physiology in the first place. With the contact microphones, we were not really listening to internal processes inside our bodies, or the leaves, but rather to the friction between our bodies and the park's various surfaces.

On my own, collecting sounds throughout the park, I cannot say that I was properly categorizing what I was hearing, but I soon became able to anticipate the sounds certain surfaces would make. I leaned in with my microphone pressed up against a live oak. Noises, sounds considered artifacts, meaningless disturbances, and accidents turned into discernible blips, pops, and growls. I wanted more of the pops, less of growls. I pictured them layered over a timeline. Each sound had a particular shape, even before I had seen it in waveform on my computer screen. The rough grooves my contact microphone was catching would become images of steep cliffs, striking mountains erupting from the subtle surface landscape of the tree. I continued to run my microphone along the tree's outer layers.

Live oak trees can live up to 500 years. This one was well over 50 feet tall, and its branches covered an area of nearly 100 feet. I felt small and somewhat muted in its presence. In the 1920s and 30s, German biologist Jakob von Uexküll invited the public to consider the world as it appears to animals instead of humans. He described other species' *Umwelt*, which translates as environment. However, the environments he described were not shared environments. Instead, each species existed in its own sensory bubble (Uexküll, [1934] 2010). For Uexküll, the key to unlocking a creature's *Umwelt* was to understand its sensorium. This tree turned

Figure 11.1 Pitman Park, Bellaire, Texas, 2016.

light into cells, and it sensed the world in ways I could barely fathom. The furrows on its bark were rough and a bit loud. Perhaps anthropomorphizing in a clumsy attempt at decentering the human, I considered its *Umwelt* in ways that felt familiar, and focused at first on the surface. Like us, plants transpire. They are porous. I imagined the hormones wafting between us. There was barely a breeze. Although static, trees hide a range of molecular motion. I have heard that trees can shed branches after a storm in order to regain their equilibrium. They too have a sense of balance.[4] Touching the live oak, pondering the tree's *Umwelt*, I probably looked as though I could have been at Walden's pond relishing the sight of a Romantic pastoral ideal. But with my headphones, recorder, and other gear, I also could just as well have come out of a science fiction

film where people armed with strange and hopeful devices attempt to detect an organism that is plaguing the plants and that will inevitably destroy the planet. I imagined the top of my recorder glowing red and beeping when I got closer to it.

To Collect

One visitor to the park stopped to tell us how important she thought our work would be in twenty years, when Houston would sound like Mumbai. "So loud you can barely hear yourself think," she predicted. She saw this work as a kind of salvage ethnography, part of a larger archival project that would allow us to hear "nature" once we have completely inundated it with sounds of industry and people, lots of people. I imagined a giant cabinet filled with sounds. An archive of what was once a very different place.

While conducting fieldwork in information science labs in the UK a few years ago, I worked with researchers on questions relating to sound and the problem of the archive (Dib 2012; Dib et al., 2010). The information scientists I worked with sought to design better ways of interacting with recorded sound. In comparing sounds to images, they found sounds difficult to sort through and to later locate again. Unlike photographs, one cannot glance at a digital icon of a sound file and know what it contains. Participants in some of the field studies we conducted described sounds as extremely evocative. They enjoyed recording sounds and listening to them later. Yet, what we came to call their "sonic souvenirs" were for the most part relegated to a silent folder in a computer. How might someone "frame" a sound and place it somewhere for others to hear? Sound recordings create a different kind of engagement with the art of collecting. For instance, filenames become primordial in locating certain sounds again. In Pitman Park, I wondered what I would name the digital files I was amassing. Tree blips, grass swooshes, puddles.

The collected sounds were obscure indexes of what had happened at the park. The sound pieces made from assembling them were not documentaries of nature. They were not referents to particular facts or lived realities. Nor were they calls for particular actions. They included a certain "this is what I saw, heard, touched," but they did not insist that the visitor take away a certain lesson or claim. Nor did they refer to an idealized, nature-filled past. I liked that our work was neither pedantic nor preachy. It rained during a few of our days at

the park. I remember thinking that with our sonic assemblages, it would be difficult to capture the warm glow after the clouds had passed, or the steam lifting off of the leaves.

I was not collecting in order to document vanishing nature, or to build an archive along the lines of sound pioneer Murray Schafer's well-known *World Soundscape Project*, or musician and ecologist Bernie Krause's *Wild Sanctuary project*.[5] With my recorder pointed up, as if holding a net to catch sounds, my attention to this environment had little to do with the need to create an accurate trace of what was there, or of distinguishing nature from un-nature or insides from outsides. I wasn't there to tell the history of the landscape per se, but rather of my encounter and movements with the landscape and with the tools of our assemblage. If anything, these sound bites were remnants of my disposition. What I would make of them would create new dispositions in the viewer/listener, equipped with his or her own *Umwelt* colliding with mine, with Abinadi's, as well as those of the trees or plants. I collected so that I could later sift through, choose, and put back, differently.[6] I was collecting raw material for something else. Abinadi and I went back to the park four times that week and three the next. As an anthropologist, this work felt fast. We wandered in, listened, gathered, wandered out, selected, organized, wrote, reassembled, and (re)placed.

I recorded over 40 files that added up to over 180 minutes of footage that first day. When I later sifted through the sounds I had collected, I gave the files names like *crisp_chewy_steps*, *warbler_and_truck*, and *cricket_water_fence*. The decisions Abinadi and I made to keep some sounds and delete others, and to put certain ones before the others in our timelines, would create the mood and tempo of the pieces. These are difficult decisions to describe. Sometimes the process of making a work is like finding yourself in a dark and noisy forest. You have to find your way through occasional clearings, and occasional frictions and connections. While our installation, *Microsoundtrack for Pitman Park*, is not an accurate or even adequate reflection of the sonic landscape at the park, there is something about it that allows us to see (or hear) what is right in front of us, but differently. It is not a question of pointing to the unnoticed beauty in the world, or of pointing to a kind of critique along the lines of "if we could see the beauty of the natural world, we would stop doing X." Rather, it is a simple tending to, because beauty is a complicated thing. Besides, we can be attracted to the grotesque, the disturbing, the noisy. We can become attached to things despite what they might be doing to us. So tending to something, a sound, has little to do with one's reaction to a particular aesthetic or to a perceived greater truth relating

to that particular sound. "Listening is not a reaction, it is a connection" (Le Guin 2004:196). Instead of truth or beauty, we might speak of this work as pointing to a connection.

Noises and Images

I was running my contact microphone over a wooden bench when an airplane flew overhead. Another airplane later made its way into my sonic archive when I made some open-air recordings. Its sounds appear in the soundtracks somewhere between the cry of warblers and the crunch of footsteps. Some could easily call the airplane sounds a noisy disturbance that upset the contemplative isolated nature of this green bubble. The engines punched through the thicket of the park's "pocket prairie," highlighting the force of techno-industrial encroachment onto the natural world, with its inevitable sonic byproducts. The Nature Discovery Center staff and nearby residents informed me on various occasions that the airplanes were arriving from Boston and that for some reason the pilots were required to head west, and to circle the area above the park before heading southeast towards Houston Hobby Airport. These airplanes indeed produced undesirable sounds. But the sounds I was picking up with my contact microphone on the bench seemed much closer to what I would call noise. They made the roar of the airplanes sound familiar, an established part of our sonic and environmental vocabularies. Much has been written about noise, and its relationship to signal, or to music (Cox, 2015; Khan, 1999; La Belle, 2006; Serres, [1995] 2009; Voegelin, 2010). Noise is that which falls outside our realms of intelligibility and meaning. Noise is what we learn to ignore. Or when we can't ignore it, it is defined as what lies outside our realms of the acceptable, as in that airplane noise is too loud. Noise is what prevents other sounds, as well as silences, from being heard. Noise enacts many dialectics, but also resists them.[7] It disturbs. I decided to leave the airplane and contact microphone glitches in the compositions. I liked how, as part of the same soundtrack, the sounds brought to the fore the conditions of their making.

Hunched in front of my laptop later that week and over the course of the next, I listened to the noises I had collected. I sat with my enormous headphones, leaning in to the waveforms (displays of amplitude over time) unfurling on my screen.[8] Blips and scratches turned into rivers and mountain ridges. The thuds as sonograms (displays of frequency over time) rendered a landscape composed of

a series of patches across a horizon. I switched back and forth, from waveforms to sonograms. There is something oddly satisfying in seeing an image of a sound. It makes its waves more palpable. The first device that recorded sound "traces" didn't in fact record sound that one could play back. This device, the phonautogram, invented by French typographer Edouard-Leon Scott de Martinville in the 1850s, created static visualizations of waveforms (Feaster, 2012; Sterne, 2006).[9] Different sounds created different looking worlds. I listened to and watched the various landscapes unfolding in front of me, as if I were looking out of the window of a train.[10] I cut and I stitched. I traveled backward and forward along the timeline until I could anticipate the next bumps, ditches, and patches. After some time, I knew the landscapes I had assembled by heart. Then I listened and repeated.

The familiar processes of translating noises into images certainly affected the ways I collected the sounds in the first place. I anticipated the ones that would look more distinct. Some also made shapes that came by surprise. Not every decision in the creative process is a conscious one, nor must it be. Some sounds made their way into the final recordings, while others did not. Many were the result of the collecting process itself. Later, when editing, certain ones were placed between others, as transitions between moods and rhythms. Some sounds simply beckoned each other. The images I played with were only part of the procedure. The sounds were turned into landscapes, then soundtracks, and were then added to the park; until Abinadi and I later uprooted them and transplanted them into gallery spaces, and to another park.

So that We can Listen

With *Microsoundtrack for Pitman Park*, Abinadi and I turned field-based recordings into compositions. We then took these compositions and we added them to existing sonic densities. We made several soundtracks and set up an array of four speakers throughout the Park. We broadcast sounds we had taken from the park back into the park. There was something at once uncanny and excessive about taking sounds from somewhere and playing them back in the same location. We were returning the sounds to their origins. But the sounds had been curated, grouped together, modified, and stretched. The textured layers made from the collisions between the contact microphones and the various park structures, organic or otherwise, punctured the soundscape like something

Figure 11.2 Lina Dib, *Sonogram of a Forest* (2016), monoprint, 7x8 inches, ink and graphite on paper.

alien. The sounds belonged in the park, but they painted a strange and often otherworldly environment. Other times, our sonic environmental intrusions were subtler. One could hear rain, but it was sunny outside. Or the dove's cry lingered more than it should. Here Schafer's term "schizophonia" is a generative one. He defines this concept as a "split between an original sound and its electroacoustical transmission or reproduction" (Schafer, [1977] 1994: 90).

Indeed, we were exhibiting a split, but a narrow one, between previous events in the park and the events brought on by our installations in the same park.

On opening night, in addition to the compositions we had installed in different areas of the park, Abinadi and I used materials from our surroundings, such as twigs, rocks, cones, and leaves, to create a live soundtrack. We invited visitors to participate and to gather their own materials and to test their resonances with our set-up of contact microphones and foam boards. What unfolded was perhaps a form of what sound scholar Steven Feld calls *acoustemology*: a collusion of acoustics and epistemology (1994). People came to know their environment through sound. Sound and place—both the original places of the recordings, and the ones that made up the installations—were entangled. As we situated sounds, they situated us. They created a sense of *being in*. It is what French philosopher Jean-Luc Nancy describes as a "presence in the sense of an 'in the presence of' that, itself, is not an 'in view of' or a 'vis-à-vis.' It is an 'in the presence of' that does not let itself be objectified or projected outward ... Sound has no hidden face; it is all in front, in back, and outside inside, *inside-out*" (Nancy, 2007: 13). Working with sound creates a sense of presence such that the audience is already inside the work—part of the work.

A few months later Abinadi and I redesigned and reassembled parts of the Pitman Park soundtracks and combined them to create *Sheaf of Times*, a two-channel, 2 hour 25 minutes, sound loop presented as part of the show *Botany of Desire* at Rudolf Blume gallery in Houston. The piece then traveled to San Francisco at SOMArts and Yerba Buena Gardens as part of Ethnographic Terminalia's *Audible Observatories* exhibit, from which these notes take their title. In our move from one place to the next, perhaps the work became closer to what artist Robert Smithson terms "non-sites," references to certain places brought elsewhere, most often inside a gallery space. But the importance of the original site itself seemed to get muddled with the sounds of the processes involved in making the recordings. Listening to the recorded environments meant listening to our intermingling with them. The soundtrack was a record of time spent, layers of moments with plants, bundles of interactions, a sheaf of encounters. Through its various iterations, this sound piece not only created environments; it reused them and interacted with them. Abinadi spoke in terms of extractions. He delighted in the fact that sound could be extracted from the environment as a kind of renewable resource. With its processes of extractions and transductions, *Sheaf of Times* further decontextualized and liberated sounds

from an imperative to signify or to stand in for *something*, and in doing so cultivated a certain practice of listening. For Nancy, "To be listening is always to be on the edge of meaning, or in an edgy meaning of extremity" (2007:7). Like in a traveling *Wunderkammen*, an old cabinet of sonic curios, separated from their referential qualities and contexts, the sounds were free to create new meanings. They were free to insert themselves into other conversations, or perhaps to dodge meanings altogether, and to hover among the less intelligible.

Notes

1 Thank you to the staff at The Nature Discovery Center in Russ Pitman Park in Bellaire, Texas for sharing their invaluable knowledge about the park and its inhabitants, and for their support and enthusiasm throughout. Thanks also to Abinadi Meza, who I cannot claim to speak for but am very glad to speak nearby. Thank you especially to the brilliant editors and contributors of this volume.
2 After all, the art of listening is much older than the art of writing. Much has been written about that (McLuhan, 1962; Ong, 1982; Sterne, 2011).
3 Four years after our initial visit, the trees that shielded the park from the street have been removed to create a large grassy area for local events and gatherings. The sounds of cars whizzing by is now much louder than that of the birds. The staff at the Nature Discovery Center informed me that the owl that had nested near those trees had relocated to a tree on the other (now significantly quieter) side of the park. They also mentioned that after a mysterious disappearance, the bees have returned and have made a new home in the less disturbed back of the park.
4 Anthropologist Anna Tsing points out in her ethnography of the matsutake mushroom, that Uexküll's "approach brought landscapes to life as scenes of sensuous activity," and creatures were granted a kind of subjectivity. But "Uexküll's bubble worlds are not enough" (2015:156). The concept doesn't open up to the assemblages made by these connected and connecting worlds. It doesn't account for the collaborative world-making that shapes our experience of the landscapes of which these assemblages are part.
5 Schafer's *World Soundscape Project* initially started as a way to document and lament noise pollution and the changing Vancouver soundscape, and laid the groundwork for the study of acoustic ecology. It is interesting to note that underlying Schafer's project of collecting the world's soundscapes is a desire to map and organize the sounds of the earth so that they come together as in a kind of divine orchestra. That said, Schafer's project remains focused on the sonic qualities of particular places. For Schafer, "the general acoustic environment of a society can be read as an indicator of

social conditions which produce it ..." ([1977] 1994:7). While groundbreaking in its approach to sonic ecologies, Schafer's notion of "soundscape" has been critiqued for paying attention to particular normative sounds over others, and for its lack of emphasis on the subjects' immersion in a sonic environment. Anthropologist Timothy Ingold critiques conceptualization of the term soundscape as objectifying sound rather than treating it as something with which we comingle and find ourselves in (2011). It depicts sound as something with an independent existence, to which we need to tune in. While this use of the term emphasizes spatial dimensions of sound, Ingold argues that it also separates us, the listener, from the sounding environment of which we are part. Sound becomes something to grasp, which then begs certain philosophical questions as to what constitutes sound.

The problem with such questions, Ingold argues, is that they situate sound as an *object* of perception rather than the medium of our perception. In fact, sound is what we hear *in* (2011). Modeled after the term landscape, the concept of soundscape, for Ingold, clings to the surface of things, when in fact sound is something we inhabit and move through. Meteorology and concepts of weather are therefore more appropriate metaphors than ones that point to the solidity of land and earth. In short, Ingold argues that the term soundscape does not give justice to the three-dimensional feeling of immersion and *being in* that sound evokes. While the term may leave room for an emphasis on place and spatiality, the concept of emplacement has the effect of stripping sound of its moving nature. Sound is movement. Sound might create a sense of place, but sound sweeps and lures rather than grounds.

Anthropologist Stefan Helmreich adds to Ingold's critique of the term soundscape by pointing out that even an immersed listener, one who not only apprehends the surfaces of sounds, but also situates himself within sound, still implies an internal thinking subject tending to an external unthinking world (Helmreich, 2010). Pushing further against an imagined inside and outside, Helmreich declares himself against soundscapes and against immersion. Instead, he proposes the vocabulary of transduction. He argues that the transduction of signals through media, when done right (seamlessly), produces the feeling of presence, of being in (Helmreich, 2009). In other words it is *through* processes of translation and conversion that insides and outsides are made and felt.

6 Philosopher Walter Benjamin's Arcades Project provides a delightful, rich, and occasionally overwhelming display of an art of collecting (Benjamin, 1999).
7 For pioneer land artist and performance artist Alan Kaprow, the term "'*Artist*' refers to a person willfully enmeshed in the dilemma of categories who performs as if none of them existed" (Kaprow, 1993:81). In general, artists can be said to generate noise in established systems.

8 Waveforms are a language of electrical activity that became scientifically discernible in the nineteenth century, and attributable to plants, animals, and parts of the environment. Waves became evidence of matter in motion, and later, depending on the frequency, they could be translated into sound. As of recently, the capture of gravitational waves are said to make audible the fabric of space-time itself. "An attention to sound," according to philosopher and curator Christoph Cox, "will provoke us to modify our everyday ontology and our common sense conception of matter" (2015:124). In fact, Cox argues, sound can account for an ontology of objecthood more than an ontology of objects can account for sound. He points out that sound art, from its inception, challenged the ontology of objects by placing an emphasis on process, experience and immersion. Sound art "could pursue an expanded conception of matter extending beyond the limited domain of ... visual and tactile objects ... a notion of matter understood as a profusion of energetic fluxes" (Cox, 2015:125). Cox's philosophy of sound may help us work with sounds not as "punctual or static objects but temporal, durational flows" (2015:127).
9 Thomas Edison's phonograph would come later, in 1877.
10 I later used sonograms as the basis for printworks. I made wood blocks of forests out of the images of sounds of barking dogs. And I carved out the shapes of splashes that resulted from the sounds of people jumping in a pool. The images of the sonograms looked the way they sounded. I had discovered a kind of multisensory onomatopoeia.

References

Benjamin, W. (1999), trans. H. Eiland and K. McLaughlin, *The Arcades Project*, First Harvard University Press.

Cox, C. (2015), "Sonic Thought," in C. Cox, J. Jaskey and S. Malik (eds), *Realism Materialism Art*, pp.123–129, Annandale-On-Hudson: Sternberg Press.

Dib, L. (2012), "The Forgetting Dis-ease: Making Time Matter", *differences*, 23 (3):42–73.

Dib, L., S. Whittaker, and D. Petrelli. (2010), "Sonic Souvenirs: Exploring the Paradoxes of Recorded Sound for Family Remembering," *Computer Supported Cooperative Work* (CSCW), ACM Press, 391–400.

Feaster, P. (2012), *Pictures of Sound: One Thousand Years of Educed Audio: 980–1980*, Atlanta: Dust-to-Digital.

Feld, S. (1994) "From Ethnomusicology to Echo-Muse-Ecology: Reading R. Murray Schafer in the Papua New Guinea Rainforest," *The Soundscape Newsletter*, no 8, June.

Helmreich, S. (2009), *Alien Ocean: Anthropological Voyages In Microbial Seas*, Berkeley: University of California Press.

Helmreich, S. (2010), "Listening Against Soundscapes," *Anthropology News*, vol. 51 (9):10

Ingold, T. (2011), *Being Alive: Essays on Movement, Knowledge and Description*, New York: Routledge.
Jackson, J. B. (1984), *Discovering the Vernacular Landscape*, New Haven: Yale University Press.
Kaprow, A. (1993), *Essays on the Blurring of Art and Life*, ed. J. Kelley Berkeley: University of California Press.
Khan, D. (1999), *Noise Water Meat: A History of Sound in the Arts*, Boston: MIT Press.
La Belle, B. (2006), *Background Noise: Perspectives on Sound Art*, New York: Continuum.
Le Guin, U. K. (2004), *The Wave in the Mind: Talks and Essays on the Writer, the Reader, and the Imagination*, Boston: Shambala.
McLuhan, M. (1962), *The Gutenberg Galaxy: The Making of Typographical Man*, Toronto: University of Toronto Press.
Nancy, J-L. (2007), *Listening*, trans. C. Mandell, New York: Fordham University Press.
Nature Discovery Center, (n.d.) "History of Russ Pitman Park." Available online: http://www.naturediscoverycenter.org/index.php?option=com_content&view=article&id=121 (accessed October 2, 2016).
Ong, W. J. (1982), *Orality and Literacy: The Technologizing of the Word*, New York: Routledge.
Schafer, R. M. ([1977] 1994), *The Soundscape: Our Sonic Environment and the Tuning of the World*, Rochester: Destiny Books.
Serres, M. ([1995] 2009), *Genesis*, trans. G. James and J. Nielson, Ann Arbor: The University of Michigan Press.
Sterne, J. (2006), *The Audible Past: The Cultural Origins of Sound Reproduction*, Durham: Duke University Press.
Sterne, J. (2011), "The Theology of Sound: A Critique of Orality," *Canadian Journal of Communication*, vol. 36:207–225.
Tsing, A L. (2015), *The Mushroom at the End of the World: On the Possibility of Life in Capitalist Ruins*, Princeton: Princeton University Press.
Uexküll, J. v. ([1934] 2010), *A Foray Into the Worlds of Animals and Humans*, trans. J. D. O'Neil, Minneapolis: University of Minnesota Press.
Voegelin, S. (2010), *Listening to Noise and Silence: Towards a Philosophy of Sound Art*, New York: Continuum.

This is an Index

The false-start:
tangent #4
There's a **scratch (13, 18, 133, 136, 162, 195, 199)** on the inside of my eyelid—some sort of curvy shadowy figure, **cutting (22, 128)** through the thin flesh that stares back at me—but I can only see it with my head pressed to the sun and my eyes closed to the world.

The real-start:
tangent #1
There are **jerks (139)** and there are quirks. Always go for the quirks. Don't falter; just touch on the **improvisation (xii, xvi, xvii, 51–58, 60–61, 66, 68–72, 79, 88, 120, 134)**. It's OK if it feels apolitical sometimes, or speaking to the matter of the method, perfectly fine if the frame gets all jammed up in the **process (xiv–xviii, 5, 9, 27, 36, 53, 65, 69, 77, 79, 97, 111, 118, 121–122, 129, 152, 167, 179, 183, 185, 187, 194–195, 198, 200, 202, 204–205, 216–217, 220)**. I mean who the fuck wants to be political all the time? I tried that; it, sucked. Hearts were shattered; glass was broken. There was no "en-rectumating"—at least I don't think so—but there was definitely some shit involved. Sorry, my five-word limit just exploded like the **whale (xiii, xiv–xv, xviii, 11, 132, 133, 171, 174, 176–178, 184, 187–88, 209–11, 213–222, 225–226)*** because I get all blubbery sometimes. Eventually, I come back into **form (x, xiii, xiv–xviii, 2, 5–7, 9, 11, 13–15, 18–19, 22–23, 26, 30, 35, 37–39, 52, 55–57, 61, 65, 69, 72, 75–77, 81, 85, 88, 90–91, 97–103, 107–111, 114, 118–121, 123, 125–130, 135, 137, 139, 143, 146, 148, 152–155, 160–162, 185, 192–195, 202, 209, 216, 218–221, 225–226)**† Sometimes, you know, maybe not always, but definitely sometimes, or actually a really solid proportion of the time remaining, you gotta scratch the **itch (13, 18, 136, 137, 208)**. I mean whatever itchiness that might be or whatever newer scratches itching might lead to—even or especially those of the chronic and recursive kind.

* See also: Unwhale (132, 221); Whalebook (186).
† See also: Conform/-ity (57, 181–183); Deform/-ation (218); Formal/-ism/-ist (14, 31, 44, 100–101, 103–104, 107–108, 174); Format (105); Formation/-s (73, 81, 99, 101, 184); Former (37, 147–48, 162); Formless/-ness (xiv, xvii–xviii, 156, 161, 216); Formulation (xii, xviii, 35, 117, 122, 125, 152, 164, 218); Inform/-ation (xvi, 17, 26, 38, 63, 99, 105, 110, 156, 162, 189, 197, 199, 203); Informant/-s (104, 106); Perform/-ance/-er/-itive (xiv, xvi, 5, 23, 32, 36–37, 39, 41–49, 52, 55, 61, 63, 76–77, 100, 127, 143, 146, 175, 191–192, 194, 204, 209–212, 223); Platform (44, 154); Reform/-ulate (57, 98, 111, 161); Reformation, Protestant (220); Terraform (81); Transform/-ation/-itive (vxii, 9, 15, 73, 76, 79, 85–86, 91, 97, 110, 120, 127, 148, 154, 164, 176, 187, 192, 211–212, 220–221, 223); Underperformance (178); Unformed (xvii); Uniform/-ity (101); Waveform (195, 199–200, 205).

Sometimes, by which I mean other times and likely not at exactly the same time (hard to do anyway), you actually, really seriously, just gotta scratch the jerk. Give that asshole what he wants; let him have his way whilst secretly planning to have yours. I learned that one from Lydia Lunch, who is like the abusive feminist version of GG Allin (a quirky jerk by the way).
It should be admitted at this point in the five-word
exercise that sometimes you
also gotta just jerk the quirk around. On these occasions, assuming you are
the quirk and not the jerk—already a very large, whale-like
assumption that
potentially has the awful side effect of making you rather jerk-like
yourself
(especially from the jerk's perspective)—anyway, the point is that at those times
you gotta ask yourself a crucial follow-up
question. Not so much the question of
"What's happening?" although I suppose that is always in play. There's this other
question one always asks: Is this one of those **dialectical (122, 199)** deals? Isn't scratching
the jerk just the fucked-up
flipside of jerking the quirk around? At any rate, be
careful that in scratching the jerk's itch you might also be jerking the quirk
around.
Apparently, there's a distinct possibility that the quirks are really just jerks
covered in whale **blubber (xiii, 132, 173, 177–178, 208–209, 213, 216–220, 222, 225)**
Katie, what the hell are you talking about? I have no ideal. My Granny Greene
used to say that but she also called my friend Leroy the "little [n-word]
boy."
I needed a **beer (188; beer bottle 41, 81)** so I had one. I don't even like beer but it served a small purpose;
it scratched an itch.
I'm not sure I like the way this sounds. The forms are a faltering. I'd rather hear
the thunder on Lina's roof or watch the jumpy needle on Marina's sound analyzer.
But can somebody lend me one of Lenin's hands? Or take me on one of those
park tours of death? Or dip the **sensor (xii, xv, xvii, 29, 73, 76–78, 86, 137, 192)**‡ in and
 pull out the puppet so I can tell it
to shut the fuck up for a minute?
Just until I **push (17, 26, 35, 75, 78, 86, 88, 97, 101–102, 106–107, 110, 111, 139, 173, 177, 192, 204, 217)** a few words together.

– Shane Greene

‡ See also: Sensory (xiii, 29, 66–67, 76, 85, 133, 145, 163, 195); Sensoria/-l (xvii, 85–86, 93); Sensorium (xvii–xviii, 63, 76–78, 86, 195); Multisensory (81, 85, 205).

Blubberbomb

Stuart McLean

I am still dead. I am flowing.

<div style="text-align:right">Aase Berg, from *Transfer Fat* (2012)</div>

A darkened room. Four walls. Four projectors. Four talking heads. And what heads they are! A seventeenth century ruff, ears of corn, and butterflies; a lobster and prawns (cooked); an octopus; a whitened face sprouting thorn-like protuberances—resembling an arrow-studded Saint Sebastian or a Christ fused with his own, mocking crown of thorns. Lobster-head, Octopus-head, Prawn-head, Thorn-head. A Babel of voices—four monologues fused into a multilingual polylogue—a melody by Brahms—*Feldeinsamkeit*—a torrent of semi-audible lyrics delivered in a Tom Waits-like growl, a speech from Shakespeare and, from Thorn-head, the following:

> Eat and die
> Touch and die
> Fuck and die
> Smile and die
> Spit and die
> Dream and die ...

The Madrigal of the Explosion of the Wise Whale is a four-channel installation by the Greek-born and now London-based artist Filippos Tsitsopoulos, who plays each of the four characters. The piece was conceived in part as a tribute to the artist's father, a well-known theatrical actor, who, on one occasion, went on stage to perform the role of Polonius in Shakespeare's *Hamlet* having attended the funeral of his wife, the artist's mother, earlier in the day. The performance, dedicated to his deceased wife, came to an unexpcted halt with Polonius's reading aloud of Hamlet's love letter to his daughter, Ophelia: "Doubt thou the stars are

Figures 12.1 to 12.4 Filippos Tsitsopoulos, *The Madrigal of the Explosion of the Wise Whale*. Four channel video installation (2010). Photographs supplied by the artist.

fire/Doubt that the sun doth move/Doubt truth to be a liar/But never doubt I love."[1] Rather than continuing, he began to repeat the final line, over and over: never doubt I love, never doubt I love, never doubt I love . . . Filippos, who was in the audience, describes the scene: "The other actors on stage were astonished, looking at one another. The crowd starts clapping . . . and they had to stop the performance because people were clapping hands without understanding why. It was a kind of hysteria, an enormous wave attacking their nervous system." (Tsitsopoulos, 2011).

The later artwork appears to owe its beginnings then to a dead father. Behind him, however, offstage somewhere, is a dead mother, unseen, but still, it seems, very much present, sufficiently so to stop even Shakespeare in his tracks. How does one begin to speak to them? How does one move amid the liquid turbulence of the dead.? What does one have to become in order to do so? Years later, it was the stalled production of *Hamlet* that provided the catalyst for Filliopos's own performance, with its cast of marine-terrestrial, metamorphic characters:

I started performing Polonius for him. I transform myself and my head with living elements creating a flexible mask with prawns, imitating the red beard of the Danish Polonius. I read that in the old Pacific traditions people thought that men in another life became fishes, prawns, calimari, whales, returning to their habitat the sea, so I transformed myself into a creature able to communicate with my deceased father, dedicated to him these words, the conclusion of a lifetime, the starting point or ending point to his philosophy—and my philosophy too—about life, religion, death, and love. Doubt that the stars are fire/Doubt that the sun doth move/Doubt truth to be a liar/But never doubt I love. Art itself is the reason to create art (Tsitsopoulos, 2011).

*

The Madrigal of the Explosion of the Wise Whale was first shown in 2010 at the Freies Museum, in Berlin's Potsdamer Strasse. I first saw it, however, a year later, in a very different setting, at Papay Gyro Nights, an annual, week-long art festival held on the island of Papa Westray (population around 90). Papa Westray (or Papay) is the second smallest and second most northerly of the Orkney Islands, lying off the northernmost tip of Scotland, and an environment densely saturated with after-traces of the dead. The earliest evidence of a human presence in Orkney dates from around 6500 BC. Successive waves of incomers followed, including the Neolithic builders of Knap of Howar, arguably the oldest surviving house in Europe, also on Papa Westray, of the Skara Brae settlement on Orkney Mainland, the largest island, and of the stone burial cairns that dot the Orcadian landscape. The Neolithic settlers were in turn followed from the eighth century by the Norse sea-raiders, later turned farmers and fishermen, who became the dominant presence in Orkney, leading to the islands' annexation to the Kingdom of Norway in 875. The Earldom of Orkney, comprising Orkney and Shetland, was transferred to the Crown of Scotland in 1468 as part of a marriage settlement and became, in turn, part of the British nation state with the Acts of Union of 1707. Today the islands of Orkney are home to some 19,000 people, most of them concentrated on Mainland, the largest island. The sea has continued to play an important role in the life of the islands, not only through commercial fishing, which declined sharply over the course of the twentieth century, but also through the onetime involvement of Orcadians in the whaling industry and, more recently, through the region's role in pioneering and developing marine energy technologies.[2] Over the centuries, however, the sea has been as much a cause of death as a source of livelihood, as winter storms and fast-running currents have claimed the lives of innumerable ships' crews. The wrecks submerged beneath Orkney's coastal waters

were further added to by military vessels sunk during the First and Second World Wars, when Orkney was the headquarters of British Grand Fleet. Today these same wrecks are also a lucrative source of tourist revenues as parties of divers visit the islands every summer to explore them. While many of the smaller islands have suffered from declining populations in the twenty-first century, that of Papa Westray was shown by the 2011 UK census to have increased during the preceding decade by 35 percent to a total figure 90, including farmers and farm workers, fishermen, a nurse, a schoolteacher, a number of retirees, and several full and part-time employees of the island's community-run store (Child and Clarke, 1983; Davidson, 1989; Hacquebord, 1990; Renfrew, 1990; Thomson, 2008; Towsey, 2002; Watts, 2012).

The Papay Gyro Nights festival is organized by Sergei Ivanov and Tsz Man Chan, two artists, raised in Kyrgyzstan and Hong Kong respectively, who moved to the island from London seven years ago. It draws its name and inspiration from Gyro (otherwise known as "Grýla"), a giantess featured in storytelling and performance traditions and a figure combining human, animal, marine, and terrestrial attributes. The costumes of her (usually male) impersonators include an assortment of conventionally female attire, along with horns, a tail, seaweed, and fishguts. Folklore scholarship has suggested that the antecedents of Papa Westray's Gyro Nights are to be sought in the repertoire of stories and masked and costumed performances documented across the islands of the North Atlantic and carried, presumably, by the Norse voyagers who began to settle in Orkney, Shetland, and, later, the Faroe Islands and Iceland from the seventh century onward (Gunnell, 1995, 2007; Marwick, 1972). The festival, however, is anything but an exercise in revivalism, being rather the deliberate staging of an encounter between a folkloric figure from the island's past and a range of decidedly contemporary artworks in a variety of media. Participating artists are invited to create site-specific works or to display existing works in ways that respond to the singular materiality of the island environment by drawing inspiration from the composite figure of Gyro. In the words of the festival's website:

> Against reconstructing what is gone and almost forgotten, the Festival is a reflection on the folktale, the island's landscape and heritage, as well as an interpretation of tradition and ritual, through new developments in art and architecture. The Festival is a Research lab, learning hub and the place for discussion about the interaction between new media and ideas in relation to tradition, ritual and the island's landscape and heritage. During the Festival the

island is transformed into an art space and artworks are screened and exhibited in old farm buildings, the boathouse, workshops, ruins, and open landscape.[3]

Thus it was, in a one-time kelp store on Papa Westray's eastern shore, on a storm-lashed night at the end of winter, that Lobster-face, Prawn-face, Octopus-face, and Thorn-face now addressed their monologues to an audience of islanders and visitors. The building itself is the material after-trace of an industry that from the early eighteenth to the mid-nineteenth century provided Orkney's landlords with a lucrative source of income: the gathering of seaweed cast up by storms on Orkney's sloping beaches and its rendering down by burning to yield the potash and other alkalis used by glass- and soap-manufacturers in Britain's developing industrial centers. Falling prices and new industrial methods for the extraction of alkalis eventually consigned the trade to oblivion, but left behind disused structures like the present one and the remains of stone kilns that line the shores of many of Orkney's islands (Thomson, 2008:349–362).

The word "whale" can of course function not only as a noun but also as a verb, referring to the hunting and killing of whales by humans. The transposition from urban to island setting thus offered a reminder too of the economic importance of whales in the life of North Atlantic maritime communities like those of Orkney and its northerly neighbors Shetland, the Faroe Islands, and Iceland, as well as the coastal regions of Eastern Canada and the United States. From the mid-eighteenth century, whaling ships bound for Greenland and the Davis Strait would call regularly at the port of Stromness on Orkney Mainland to trim ship and take on stores and additional crew, and Orcadians continued to serve as crew members on whaling vessels until the international mortaorium on whaling of 1986 (Towsey, 2002). The importance of whales in the North Atlantic region, however, long pre-dates the growth of commercial whaling. Whale bones and tools fashioned from them have been found at Neolithic and Bronze Age archaeological sites around the North Sea (including Skara Brae in Orkney), while Stone Age rock carvings from northern and southern Norway depict whales alongside other animals known to have been hunted at the time (Hacquebord, 1990; Proulx, 1986). For millennia, stranded whales have been scavenged onshore or, in some cases, driven by teams of small boats to beach themselves during their seasonal migrations (a practice that continues, controversially, to the present with pilot whales in the Faroe Islands). From a later date they were hunted at sea, at increasing distances from land. Once captured, killed and dismembered, their uses were many. Their meat provided

Figure 12.5 Filippos Tsitsopoulos, *The Madrigal of the Explosion of the Wise Whale*, at Papay Gyro Nights (2012), the Old Kelp Store, Papa Westray, Orkney. Photograph by Tsz Man Chan. Reproduced by permission of Tsz Man Chan.

food, their blubber oil for lamps and, in the absence of timber, their giant ribcages furnished the structural support for human dwellings. Smaller bones were fashioned into household furnishings and tools; whale skin was used to make purses, belts, and ropes for church bells. Ambergris, a byproduct of digestion consisting of a darkish mass of oils, fats, and undigested matter excreted or vomited by the whale, was used as a fixative in perfumery. Spermacetti, an odorless, clear liquid found in the head cases of sperm whales, was used in the manufacture of candles and cosmetics and in leatherworking (Szabo, 2008). The industrial revolution and the urbanization that accompanied it provided a range of new uses for whale products. Whale oil was used in increasing quantities in street lamps (five thousand of them in London in the first half of the nineteenth century), as an industrial lubricant in wokshops and mills and in the manufacture of varnishes, paints, and ropes, as well as soap, and in the preparation of leather and wool. With the the decline in whale oil prices following the discovery of petroleum, new applicatons were found for the meat and bones of whales in the manufacture of glycerine, fertilizers, paint, medications, cosmetics, margerine, animal, and food for human consumption. In the words of the historian Jean-Pierre Proulx: "Few animals have occupied as important a place as the whale in the economy of the Atlantic nations" (Proulx, 1986).

Perhaps the greatest literary depiction of whaling is Herman Melville's novel *Moby Dick, or The Whale*, first published 1851. Melville's whale of a book tells the story both of the final voyage of the whaling ship the *Pequod* and her crew from the Massachusetts whaling ports of New Bedford and Nantucket to the South Pacific and of Captain Ahab's obsession with the white whale, Moby Dick, whom he pursues across three oceans. Ahab's obsession assumes

planetary dimensions as he swears his willingness to dive to the center of the globe in order to have his revenge for the lower leg, of which Moby Dick has deprived him on a previous voyage. His pursuit of the white whale leads him ultimately, like Filippos, to the realm of the dead, but without the possibility of return—except of course through the words of the novel's narrator and sole survivor of the *Pequod*: "Call me Ishmael" (Melville, 2002). See also Deleuze and Guattari (1987). At the same time *Moby Dick* is itself a work distended to whale-like proportions with and abundance of nautical and cetological detail. Individual chapters include discussions natural history and zoological classification and of the technicalities of whaling, along with extended reflections on the majesty and mythopoeic grandeur of whales, such as the following:

> Wherefore, for all these things, we account the whale immortal in his species, however perishable in his individuality. He swam the seas before the continents broke water; he once swam over the site of the Tuileries and Windsor Castle and the Kremlin. In Noah's flood he despised Noah's Ark; and if ever the world is again flooded, like the Netherlands, to kill off its rats, then the eternal whale will survive, and, rearing upon the top-most crest of the equatorial flood, spout his frothed defiance to the skies. (Melville, 2002:354)

More than a century and a half later, however, with numerous whale species hunted to the point of extinction, Melville's vision of the whale as inheritor of an inundated, posthuman earth may seem far less plausible. Are whales then simply another example of a nature that is thoroughly historical, thoroughly socialized, thoroughly entangled, for better or worse, with human projects and purposes? Is it only possible to tell the story of the intervening years as one of cumulative human destructiveness and belatedly dawning ecological responsibility? After all, as the historian Vicki Szabo reminds us, whales were never just resources: they were also monsters, prodigies, creatures of wild nature, of the open sea beyond the sway of human governance, a source of terror and wonder in life as much as of subsistence or, occasionally, superabundance in death. Medieval and early modern accounts of whales from Northern Europe, including clerical sources and the Icelandic saga literature, draw on a combination of classical, Christian and pagan Scandinavian influences to evoke a panoply of associations— among them sea serpents, weather magic, shape-shifting sorcerers, and the Biblical figures of Leviathan and Jonah's "great fish" (Szabo, 2008:177–210). Need these be understood then simply as further human acts of appropriation, as the human bestowal of meaning on a realm only ostensibly beyond human habitation

and influence? Might they be seen rather as establishing thoroughly provisional and precarious linkages—"partial connections" perhaps, to borrow a phrase from Marilyn Strathern—with powers and presences that resist or disrupt such wholesale encompassment? (Strathern, 2004). If whales and their associated products have satisfied human subsistence (and other) needs in a variety of ways, humans seem always to have intuited that the material being of whales is more than the sum of their various uses.

The mundane and practical and the monstrous and magical are present in equal measure in one of the most comprehensive early modern accounts of whaling—the multi-volume *Description of the Northern Peoples* composed by the Swedish cleric known as Olaus Magnus (1490–1557) and first published in 1555. Drawing on written authorities and the author's first-hand observations, Olaus's account includes detailed descriptions both of whales and of the methods employed in killing and processing them. It also includes copious details of customs and traditions concerning whales and their uses, such as the following, relating to the whale-bone houses that were a widely reported feature of North Atlantic communities.[4] Olaus cites the belief, allegedly current among the Arctic Norwegians, that the whales whose bones were incorporated into such dwellings continued to influence the dreams of those who dwelt within: "Those who sleep inside these ribs are forever dreaming that they are rolling incessantly on the ocean waves or, harassed by storms, are in perpetual danger of shipwreck."[5] Here, strikingly, it is not the whales themsleves but rather the bones that are their physical residue that retain the capacity to trouble the sleep of their human exploiters, providing a conduit for a tempestuous fluidity to infiltrate the seeming solidity of architectonic form via the dreams of the land-dwellers who lie within. Indeed, it is precisely the human appriopriation of the whale's physical remains that renders the inhabitants of such dwellings vulnerable to these oneiric incursions from beyond the settled realm of *terra firma*. In Olaus's text as elsewhere, whale bodies—both living and posthumously dismembered—and their associated imaginaries seem to occupy a zone of two-way slippage between the conventionally cultural and the conventionally natural, the domestic, and the wild and, not least, between solid form and liquid formlessness.

And what about blubber, the layer of veined fatty tissue found under skin of whales and extending over almost the whole body to a thickness of, in some cases, up to 12 inches? Of all the substances wrested by human effort from dead whales, blubber, consumed as a food by many peoples of the Arctic and also a source of oil burned in lamps and employed in the manufacture of leather, soap, cosmetics, and candles, was at once the most abundant and the most

potentially lucrative—to the extent that one especially profitable seventeenth-century Dutch whaling colony on the Arctic island of Spitsbergen earned the nickname of *Smeerenburg* or "Blubber Town."[6] Yet if blubber was a prized resource and, latterly, a commodity, it also imposed its own imperatives on the humans who sought it out. The rapid decomposition of whale carcasses—within 24 to 48 hours—necessitated their rapid processing on shore, usually a community-wide effort, or, at a later point, the construction of specialized whaling vessels with onboard facilities for stripping, boiling, and rendering down the blubber obtained from the kill (Proulx, 1865:31–92). Alongside a recognizably human-centered history of predation and production, might one not detect here the insinuation into human practice of a different logic—a blubbery agency and temporality to which human projects were obliged accommodate themselves?

*

Carry my smelt
across hard lakes
carry my way of
pouring my runny body
 (Berg, 2012:15)

Transfer Fat is the title of a collection by the contemporary Swedish poet Aase Berg. The poems draw upon a variety of influences and sources, including two classic science-fiction films, Stanley Kubrick's *2001: A Space Odyssey* (1968) and Andrei Tarkovsky's *Solaris* (1972), along with the vibrational materialism of string theory, the viscous liquid-solid materiality of whale blubber and the author's own experience of pregnancy, of which she would later say in an interview: "I was afraid of everything physical. [...] then I gave birth to kids and suddenly realized that my body was a monster, but working together with me."[7] *Transfer Fat* marks a significant departure from Berg's earlier work, the prose poems that predominate in her first two volumes giving way to short, sparse stanzas in which individual words are at once densely charged with meaning and calling attention continuously to their own material presence on the page. Then there are the titles—"Unborn Fat," "Smelt," "The Shimmering Inside of Tunnels," "Crawlfish," "Quantum Tunneling," "Hole Whale," Birth Rubber," "Blubber Biter," "Open the Voter," "Mom Choice," "Umbilical String"—enigmatic outriders that seem simultaneously to invite and impede readerly access to the verses appended

to them. Reviewing the English translation of *Transfer Fat* at the time of its initial publication, the poet and critic Joyelle Macsweeney writes:

> The titles act like membranes; they catch your attention; your attention becomes a little prod or probe. You push at the membrane of the title and move through it into the shell meat of the poem, carrying gummy traces of the title with you, covering your eyes, nose, mouth, changing your vision and your breathing. You're now half-digesting, half-gestating the poem, which, by the sci-fi logic by which the book operates, means that you might now be destined to supernova in a slickly bloody birth.
>
> (McSweeney, 2012)

Berg's verses render language into what she calls a "deformation zone" in which words shed their conventional significations and interpenetrate and mutate to form new realities:

> Blubber biter –
>
> Here hangs the bite
> Waiting for blubber
> For many thousand years
> Of slowness.
> (Berg, 2012:45)

Like the dream language of James Joyce's final masterpiece, *Finnegans Wake*, the poems of *Transfer Fat* hold multiple signifying possibilities in a state of suspension, without requiring the reader to settle decisively for one at the expense of another. Berg's English translator, Johannes Göransson, writes that "in the blubberiness of the whale we get a blubbery language that refuses to coalesce: every choice is and isn't a choice, is and isn't a whale" (Goransen, 2012:16). In Swedish, the word *val* can mean whale, election, or choice, depending on context. It also rhymes with *hal* meaning slippery, which is also the name of the increasingly erratic computer in Kubrick's film, references to which are scattered throughout the text. Compound words and neologisms are also a recurrent feature of the Swedish language, but Berg's writing carries this to extremes with formulations like *valyngeskal* (whalebroodshell) and *fittsela rullbandsfettflod* (cunststiff looptrack fatflood). This practice also has a defamiliarizing effect on familiar compound words, focusing renewed attention on their constituent elements, as in the Swedish term for killer whale—*späckhuggaren*—which Göransson is led to render directly into English as "blubber biter." The oozing, forming, dissolving, self-sculpting ambience of the text is one that stages language as a material practice, a metamorphic and inherently

unstable "stuff," continuously overrunning lexical definitions and semantic intelligibility. Of his own role as translator, Göransson has the following to say: "Rather than writing a 'faithful' translation of a text so unfaithful to its own native language, I hope to bring into English this unfaithful translation ambience, this language fat."

(Goransen, 2012:116, 118).

*

> Lightness in fatness
> Flight in blubber
> (Berg, 2012:41)

If the maternal or birthing body is a reiterative presence in these verses, motherhood is radically divested of any reassuring connotations of care, nurturance, and familial order. For all its manifest fecundity, the body in question is by no means a normatively gendered one but appears rather decidely queer in its fluctuations, slippages and animal, vegetable, and mineral metamorphoses. In this respect it is worth comparing *Transfer Fat* briefly with the work of another famously blubber-besotted artist, Matthew Barney. Barney's 2005 feature-length film *Drawing Restraint 9* is set on board a Japanese whaling vessel bound for the Antarctic. During the course of the voyage, a quantity of petroleum jelly, set in a mould and deposited on deck, gradually liquifies and spreads. At the same time, the ship's two passengers, a man and a woman played by Barney and his then partner, the Icelandic singer Björk, take part in a series of elaborate costumed ceremonies, fall in love, and end by shedding their human forms, using flensing knives (employed for stripping blubber from a whale carcass) to carve each other into the shapes of whales that finally swim away from the ship. If Barney's film recounts a trajectory from human to nonhuman and from semi-solid form to fluid deliquescence, Berg's verses conjure a realm of linguistic material becoming that is always already impersonal and asubjectival, already other-than-human. As such, it represents not a *telos* or a lost object that might be regained through purposive human striving but a subliminal contemporeity, a literally other-time:

> In granite gains fat
> In slow veins' years
> Of patience in a way of
> Being another time than
> Human.
> (Berg, 2012:87)

What might we understand by "another time than human?" A blubbery time? A whale of a time? A Fat Time? "Fat Time" was, of course, another name for Carnival, the period of license and celabration traditionally preceding the beginning of Lent in the liturgical calendar of medieval and early modern Europe and, later, its colonial outposts in the Americas and elsewhere—"Fat Tuesday" being the literal (whatever that is) translation of *Mardi Gras*. It was with Carnival too that Mikhail Bakhtin, another celebrant of linguistic and discursive heterogeneity, famously associated the "grotesque image of the body." The grotesque body, in Bakhtin's words, is "a body in the act of becoming. It is never finished, never completed; it is continually built, created, and builds and creates another body" (Bakhlin, 1984:317). Characteristically described with an emphasis on bodily protuberances and cavities—bulging eytes, the erect phallus, the bowels, the anus—the grotesque body is marked by its openness to the world, to swallowing or being swallowed by it, by prodigious feats of drinking and gluttony, followed by similarly spectacular regurgitations of what has been consumed via urination, shitting, or vomiting. The grotesque for Bakhtin is associated in particular with times of upheaval and revolutionary transformation—like the the disintegration of the hierarchically ordered medieval conception of the universe that accompanied the beginnings of capitalism, the first European voyages to the Americas, the Protestant Reformation, and the Wars of Religion that followed in its wake. Yet it also mobilized a repertoire of images that was common to "all languages, all literatures" and that was, in its scope, "cosmic and universal," evoking a primordial life force indifferent to the mortality of the indvidual organism or even the life of entire species. A body then, at once blubbery and explosive?

*

Here's Filippos again (this time referencing a study of the concept of the soul by his compatriot, the independent scholar of comparative religion, Penagis Lekatsas):

> Also in the Pacific there takes place a ritual of hanging up pictures of deceased loved ones along with images of living persons, newspaper clippings and flowers also, in the body of a lifeless whale that the sea dragged dead on shore. Lead away, was the idea and the symbolism of this action, all these messages through the stomach of the animal, to the marine world that all humans come from.
>
> (Tsitsopoulos, 2010)

Sometimes though, he notes, the proceedings were interrupted—by an explosion, caused by the build-up of gases as a result of the ongoing process of decomposition. Such occurrences have been widely reported, for example in Tainan City, Taiwan, in January 2004, when the carcass of a sperm whale, washed up on the adjacent coast, exploded while being transported by truck to the Sutsao Wildlife Reservation Area, showering spectators and passersby (not to mention the sidewalk) with quantities of putrescent blubber and entrails, in a body-burst that, as contemporary news footage attests, was no less a burst of color as the dark brownish-grey outer form of the dead whale disintegrated in a cascade of crimson (BBC News, 2004).

Filippos, however, thought of the exploding whale less as a traffic incident than as a sanctified cetacean suicide bomber: "The new Saint Whale bomber—a weird whale-saint that explodes in all directions, accompanied by bomb-laden animals" (Tsitsopoulos, 2010). Echoing both the corporeal exuberances of Bakhtinian Carnival and the Baroque predilection for implicatory self-elaboration that so impressed the art historian Henri Focillon and, later, the philosopher Gilles Deleuze, Filippos envisaged the installation's four video projections as scenes from inside the whale's belly, imagined as a matrixial space-time of dissolution, metamorphosis, and communication with the dead (Focillon, 1992; Deleuze, 2006). Here the accumulated debris of nature AND culture as conventionally designated—fragments of terrestrial and marine life, outdated costumes and musical forms, like the madrigal of the title—would be rendered down, transformed, and recombined to issue in a bursting forth of new life. Like Aase Berg's poetry, this is not a realm of axioms and definitions, seeking to limn the contours of an assumed to be already given real, but one generative of realities yet to come. The whale belly is a field of co-existence—of pasts, presents and futures, the human and the other-than-human, the raw and the cooked, not so much a zone of undifferentiation as one of intensive difference, of difference not yet resolved into the difference between a this and a that, a self and an other, a subject and an object, tensed and ready to erupt from the screen in novel and unforeseen configurations. For Filippos too the resultant explosion amounted, despite the titularly male gender of the protagonists, to a self-dissipatory act of birthing:

> San Whale the Bomber, representing a new version of San Sebastian ... just about to burst after receiving a barrage of arrows. In the images we find fragments of a universe made of flowers, fruits, lobsters, faces etc. [...] without apparent order [...] a non-place, timeless, but in which there is action slowed down by the photographic moment, a sort of Big Bang viewing, giving birth to this other reality.
> (Tsitsopoulos, 2010)

Or, in Aase Berg's words (via Göransson's pointedly faithless, metamorphic translation):

> Open whale
> Open space
> Unwhale
> Of rubber rooms.
> (Berg, 2012:51)

What such a slow-motion bursting or opening reveals is a thoroughly real and thoroughly inhuman presence manifest within but ultimately irreducible to what we are still too accustomed to think of as "culture" and "history." It is a presence that art and literature are able to evoke precisely to the degree that they acknowledge and affirm the materiality of their media as a force capable of displacing from within their own purported signifying intentions. It is a presence too that academic discourse has often missed precisely by its failure to do the same. This is less a matter of accurately representing nature, whether as human construct or as radical exteriority, than of translation in Göransson's sense, of allowing oneself to be powerfully affected by the metamorphic oozings of an unassimilable yet inalienable alien matter. Taking seriously the density, the opacity, the inhuman life of the materials with which we work—including texts, images, and their reciprocal interferences—demands perhaps, the questioning not only of anthropology's sometime self-identification as a social science, but of the very possibility of a "social science," along with its habitual recourse to "context," "history," and the relationality of discretely conceived bodies as the supposedly definitive arbiters of explanation and the countervailing embrace of a truth that can only find acknowledgement through the suspension of accredited distinctions between truth and fiction, between what science knows and what poetry and art can claim, differently but no less persuasively, to know. On this point, see Serres (1997).

*

Like the faltering Shakespearean speech of the artist's actor-father and like the whaleblubbery ambient flux of Aase Berg's poetry, the monologue of Thornface ends with a disturbance of language. Suddenly, the verbal recitation issuing from the realm of death, dissolution, metamorphosis, and explosive potentiality starts to be punctuated by irregular, duck-like quacks—Quack! Quack!—each one causing the performer's head to twitch as though convulsed by an involuntary spasm—Quack! Quack! At the same time, this most chromatically somber of the

Figure 12.6 Filippos Tsitsopoulos, *The Madrigal of the Explosion of the Wise Whale*. Image supplied by the artist.

work's four protagonists undergoes a startling transformation as red, blood-like fluid begins to seep from the base of the thorn-like protuberances that cover the face: a quacking, bleeding vegetable Christ or a perforated Sebastian leaking liquid life from his accumulated puncture-wounds. But the strange, mis-shapen, oozing talking head keeps talking, talking from an elsewhere and an elsewhen that seize and contort the habituated space-time of the viewer's familiar here and now as humanly intelligible discourse dissipates into an inhuman and asemic force of sound and vision:

> Go and die!
> Quack!
> Laugh and die!
> Quack! Quack!
> Cry and die!
> Quack!
> Fight and die!
> Quack! Quack!
> Fuck and die!
> Quack!
> Quack!
> Quack!
> Quack!
> Quack!

BOOM!!!!!

Acknowledgments

A version of this essay appears in my book, *Fictionalizing Anthropology: Encounters and Fabulations at the edges of the Human* (University of Minnesota Press, 2017).

Notes

1. Shakespeare, *Hamlet*, 31.
2. The European Marine Energy Center (EMEC) was established in Orkney in 2003 to provide testing facilities for developers of wave and tidal energy converters and currently operates 14 full-scale test berths, along with two "nursery" test sites for smaller devices or ones at an earlier stage of development. According to EMEC, Orkney was chosen as a base because of "its excellent oceanic wave regime, strong tidal currents, grid connection, sheltered harbour facilities, and the renewable, maritime and environmental expertise that exists within the local community." In July 2012 the Pentland Firth and Orkney Waters were designated a Marine Energy Park. See www.emec.org.uk.
3. See http://www.papaygyronights.papawestray.org/about.html.
4. Olaus interprets the occurrence of whales in Arctic Norway as evidence of divine providence, given that the harsh climate does not allow trees to grow there to provide timber, although his description of such whale-bone houses does not state whether they are permanent dwellings or temporary shelters used by hunting and fishing parties. The use of the jawbones of whales in the construction of houses is supported by a range of classical and medieval sources with reference to Europe, Asia, Africa, and the Middle East. The Greek geographer Strabo, for instance, refers to the use of whales' jawbones in house construction by peoples living adjacent to the Indian Ocean (Szabo, 2008:205–207).
5. Olaus describes the construction of these whale-bone houses in the following terms:

 > Once the flesh and internal organs of this massive beast have wasted away and perished, only the bones remain, in the shape of a huge keel. After the skeleton has eventually been cleansed by rains and fresh air, strong men are enlisted to erect it in the form of a house. The one who is supervising its construction exerts himself to put windows at the top of the building or in the monster's sides, and divides the interior into several comfortable living quarters. The doors are made from the creature's hide, which has long since been stripped off for this or some different purpose and hardened by the rough winds. Also inside this boat shaped dwelling are rooms set apart for pigs and other animals, as in the same way in ordinary wooden houses.
 >
 > (Olaus, 1998)

6 The foundation of "Blubbertown" coincided with the emergence of the Netherlands as a leading whaling nation. It consisted of a fort, a church, inns, taverns, and shops, with merchants and craftsmen catering to a population of between eighteen and twenty thousand whalers (Proulx, 1986:55).

7 "The Rumpus Poetry Book Club Chat with Aase Berg, Johannes Göransson and Garth Graeper" The Rumpus, March 2, 2012, http://therumpus.net/2012/03/the-rumpus-poetry-book-club-chat-with-aase-berg-johannes-goransson-andgarth-graeper/. Berg's description of the experience of pregnancy is worth comparing with Kristeva's in her essay "Motherhood According to Giovanni Bellini": "Cells fuse, split and proliferate, volumes grow, tissues stretch, and body fluids change rhythm. Speeding up or slowing down. Within the body, growing as a graft, indomitable, there is an other. And no one is present, within that simultaneously dual and alien space, to signify what is going on. 'It happens, but I'm not there'" (Kristeva, 1980).

References

Bakhtin, Mikhail (1984), *Rabelais and his World*, trans. Hélène Iswolsky. Bloomington: Indiana University Press, p. 317.

BBC News (2004), "Whale Explodes in Taiwanese City." Available at: http://news.bbc.co.uk/2/hi/science/nature/3437455.stm (accessed September 29, 2017).

Berg, Aase (2012), *Transfer Fat*, trans. Johannes Göransson. New York: Ugly Duckling Presse.

Childe, Vere Gordon and D. V. Clarke (1983), *Skara Brae*, HMSO.

Davidson, J. L. (1989), *The Chambered Cairns of Orkney*. Edinburgh University Press.

Deleuze, Gilles (2006 [1993]), *The Fold: Leibniz and the Baroque*, trans. Tom Conley. New York: Continuum.

Deleuze, Gilles and Félix Guattari (1987), *A Thousand Plateaus: Capitalism and Schizophrenia*, trans. Brian Massumi. Minneapolis: University of Minnesota Press.

Focillon, Henri (1992 [1935]), *The Life of Forms in Art*, trans. George Kubler. New York: Zone Books.

Göransson, Johannes (2012), "Ambient Translations: Transferring Aase Berg's Fat," in *Transfer Fat*. New York: Ugly Duckling Press.

Gunnell, Terry (1995), *The Origins of Drama in Scandinavia*. Martlesham: D.S. Brewer, pp. 160–179;

Gunnell, Terry (2007), "Masks and Mumming Traditions in the North Atlantic." In Terry Gunnell (ed.), *Masks and Mumming Traditions in the Nordic Area*, Uppsala: Kungl. Gustav Adolfs Akademien för svensk folkkultur, pp. 298–319.

Hacquebord, Louwrens (1990), "'There She Blows': A Brief History of Whaling." *North Atlantic Studies*, 2(1&2):11–20.

Kristeva, Julia (1980), *Desire in Language: A Semiotic Approach to Literature and Art*. New York: Columbia University Press.

Marwick, Ernest W. (1972), "Creatures of Orkney Legend and their Norse Ancestry," *Norveg Folkelivsgransking*, 15:177–204.

McSweeney, Joyelle (2012), "Forest of Flinches: *Transfer Fat* by Aase Berg", Montevideo. Available at: http://montevidayo.com/2012/02/forest-of-flinches-transfer-fat-by-aase-berg-now-available-from-ugly- duckling/ (accessed February 20, 2012).

Melville, Hermann (2002 [1851]), *Moby Dick*. New York: W. W. Norton and Co.

Olaus, Magnus (1998), *Description of the Northern Peoples*, Volume III, 1107, Peter Fischer and Humphrey Higgens (trans.), and Peter Foote (ed.). London: The Hakluyt Society.

Proulx, Jean-Pierre (1986), *Whaling in the North Atlantic: From Earliest Times to the Mid-19th Century*. Ottawa: Parks Canada.

Renfrew, C. (1990), *The Prehistory of Orkney*. Edinburgh University Press.

Serres, Michel (1997), *The Troubadour of Knowledge*, trans. Sheila Faria Glaser and William Paulson. Ann Arbor: University of Michigan Press.

Strathern, Marilyn (2004 [1991]), *Partial Connections*. Berkeley: Altamira Press.

Szabo, Vicky Ellen (2008), *Monstrous Fishes and the Mead-Dark Sea: Whaling in the Medieval North Atlantic*. Leiden/Boston: Brill.

Thomson, W. (2008), *The New History of Orkney*. Edinburgh: Birlinn.

Towsey, Kate (ed) (2002), *Orkney and the Sea: An Oral History*. Kirkwall: Orkney Heritage.

Tsitsopoulos, Filippos (2010), "The Madrigal of the Explosion of the Wise Whale." Available at: http://whalebomber.files.wordpress.com/2010/10/the-madrigal-of-the-explosion-of-the-wise-whale.pdf (accessed September 29, 2017).

Tsitsopoulos, Filippos (2011), "Feldeinsamkeit Tonight Theater Stage Statement." Available online: http://www.artreview.com/profile/filippostsitsopoulos (accessed September 28, 2017).

Watts, L. (2012), "OrkneyLab: An Archipelago Experiment in Futures." In Monica Janowski and Tim Ingold (eds), *Imagining Landscapes: Past, Present, and Future*. London: Ashgate.

This is a Title

bloat it.
breach it.
labyrinth it.
flip through it.
you'll see:
sense,
conjuring,
worlding.
a haunting,
a making,
a think or two.
between ethics,
design.
between words,
images.
between sounds,
noise.
and punk.
and shit.

play it.
craft it.
gift it.
flip through it
and you'll see:
futures,
potentiality,
extinction.
a composition or two.
between possibilities,
storytelling.
between concrete,
objects.
between concepts,
nihilism.
and love.
and hate.

carry it.
nothing it.
yes it.
flip through it
and you'll see:
ethnography,
indeterminacy,
turnips.
a becoming or two.
between seeing,
hearing.
between listening,
watching.
between matter and
method,
encounters in
anthropology
and art.

– Gretchen Bakke and
Marina Peterson